Quick & Clever
Watercolours

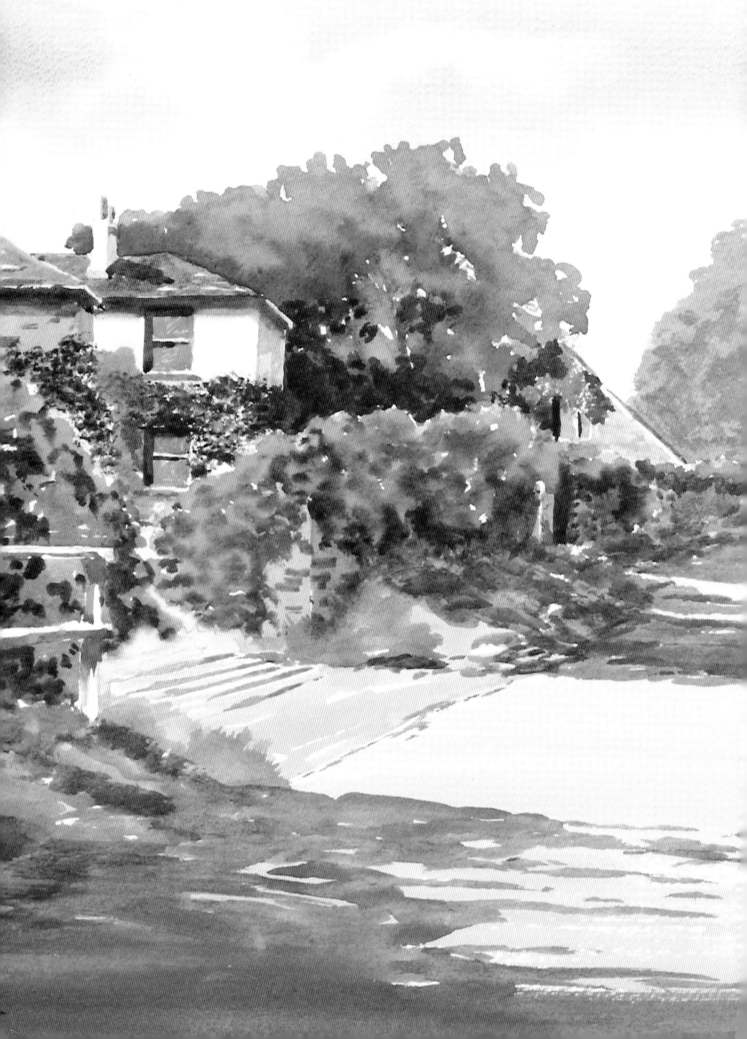

Quick & Clever Watercolours

Charles Evans

D&C
David and Charles

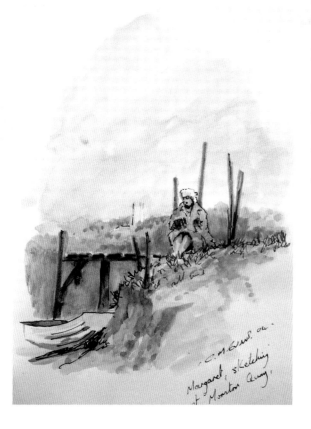

This book is dedicated to the memory of Margaret Abbey, who is seen here sketching at Morston Quay. This was the last time I saw her at her happiest, on a painting holiday; it was a pleasure to have known her, and the world is a sadder place without her.

A DAVID & CHARLES BOOK
Copyright © David & Charles Limited 2011

First published in the UK in 2011

Copyright © Charles Evans 2011

David & Charles is an F + W Media, Inc. company
4700 East Galbraith Road
Cincinnati, OH 45236

Charles Evans has asserted his right to be identified as author of this work in accordance with the Copyright, Designs and Patents Act, 1988.

A catalogue record for this book is available from the British Library.

ISBN 13:978-0-7153-3853-7 paperback
ISBN 10: 0-7153-3853-6 paperback

Printed in China by RR Donnelley
for David & Charles
Brunel House Newton Abbot Devon

Senior Acquisitions Editor Freya Dangerfield
Editor Sarah Callard
Project Editors Ian Kearey and Ame Verso
Art Editor Charly Bailey
Production Controller Kelly Smith

Photography by Karl Adamson

David & Charles publish high-quality books on a wide range of subjects. For more great book ideas visit our website at www.rubooks.co.uk

Contents

Introduction

My kind of painting is not about fiddling or messing about with lots of complex processes and tiny brushes – it's about slapping on paint using big brushes, scribbling messily with watercolour pencils, getting dirty and having fun. The point is that this is all supposed to be about fun and enjoyment – that's why we start painting.

The one thing I can promise in this book is that you won't be bogged down by jargon or confusing terms; instead there will be words and phrases such as 'slap it on', 'a daub', 'squiggly bits' and 'splat'. This is about as technical as I usually get, although I have included a few more technical phrases so you can recognize them when you need to.

I have always had tremendous passion and enjoyment for painting. People say, 'You always make it look so easy', but if you are using big brushes, having fun and slapping on the paint, then results certainly do come quickly and you have definitely enjoyed yourself; and that is what it's all about.

A quick look at the contents of this book will show that it's not the type where you have to start at the easy beginning and work your way through to the complex end, missing out sections at your peril. The name of the game is to get you painting the subjects that you want to paint, so you can dip in and out as suits you best. (But that's not to say you can't work from beginning to end if you want to, of course.)

The exercises are designed to be very quick and easy, and should help you build up the confidence to tackle the parts and details that people often find difficult – trees, boats, skies, buildings, people and animals. The projects incorporate all the exercise themes, and also introduce new ideas and solutions that you can work with and use in your own paintings.

If you glean anything from this book, it will hopefully not be, as we are told so many times, that watercolours are the most difficult painting medium; it will be that they are the most enjoyable one, with the most instant effects. In addition, the usual trauma of making a mistake can be eased by the fact that this is not the ruination or the ending of the painting; if you blunder, simply wash it out and do it again. So sit back, relax – and enjoy!

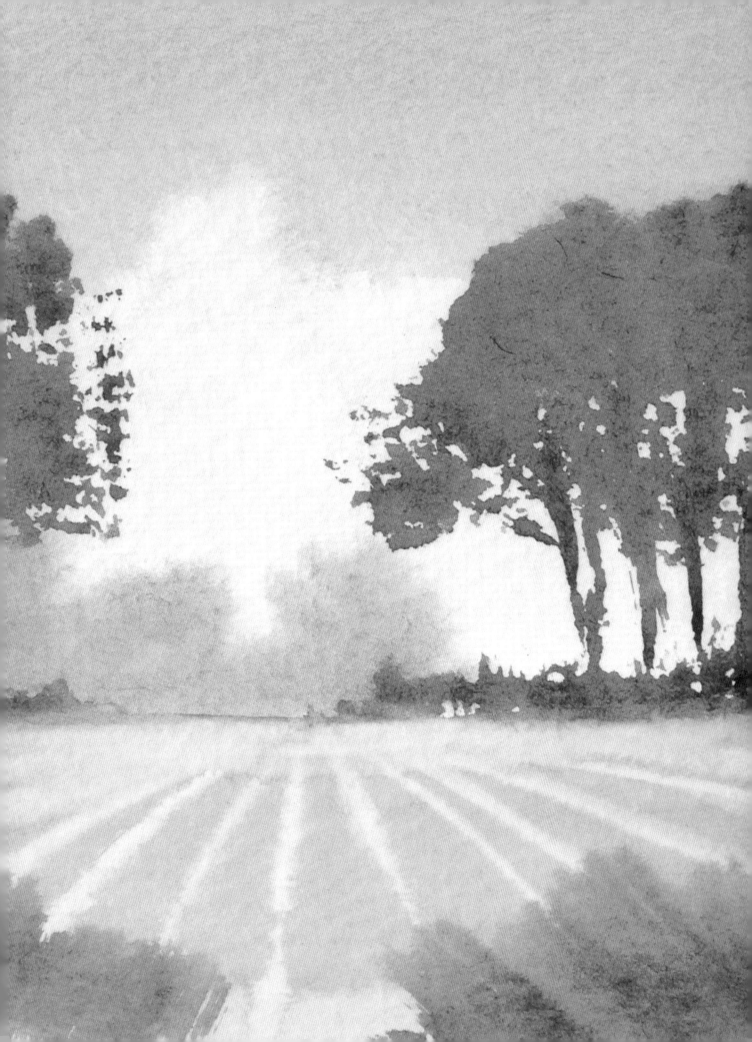

Materials & Equipment

All the materials that I use are made by Daler-Rowney. It's usually the case that you tend to use what your superiors used before you, such as course tutors or college lecturers. So you stick with what you are used to. For me, allied to this is the fact that Daler-Rowney products have an exceptionally long tradition and were always used by the great J.M.W. Turner – which is good enough for me!

Whether or not you decide to use the same materials as I do, remember that part of the title of this book is 'quick'; the big rule here is not to burden yourself down with all sorts of stuff that you'll never use and that just gets in the way. Use the guidelines I've given in this section, keep equipment to a minimum, and you won't go far wrong.

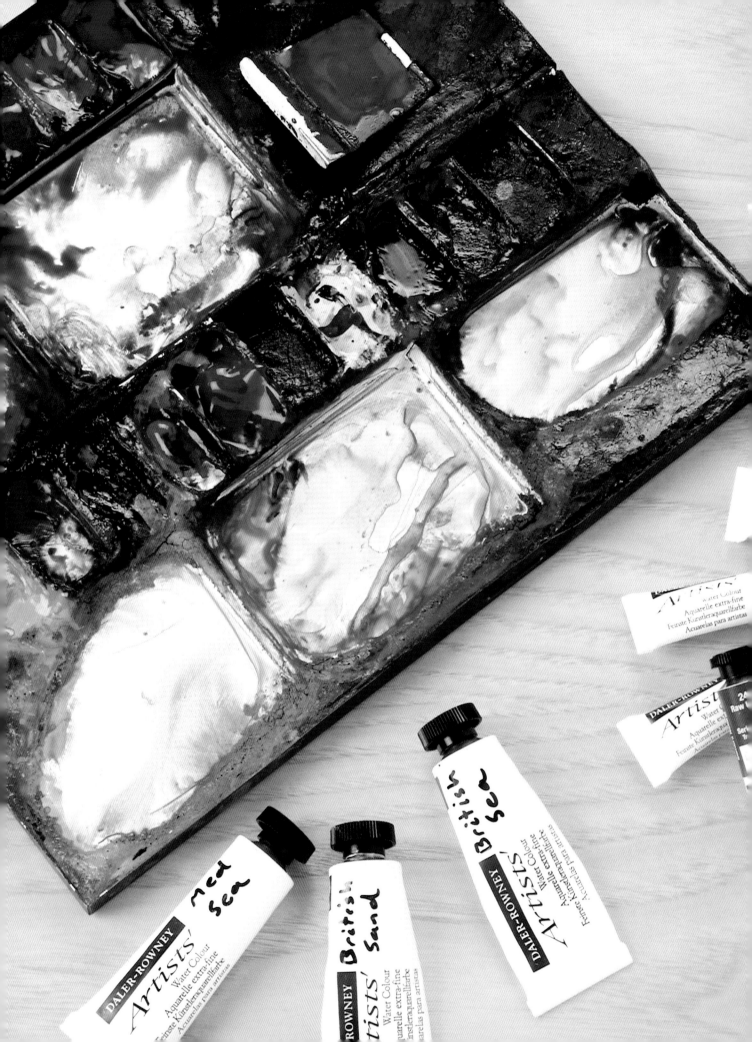

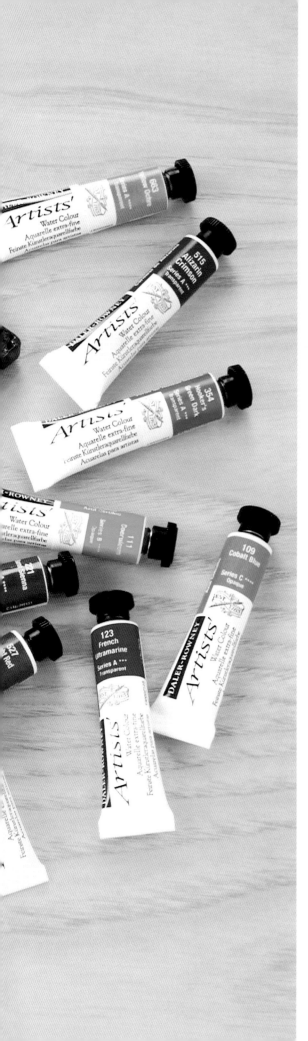

Paint

The paints I use are all artists' quality: French ultramarine, burnt sienna, yellow ochre, raw umber, Hooker's green (dark), cerulean or cobalt blue, alizarin crimson and light red.

Three new paint colours are introduced for the first time in this book, the Charles Evans range: British sea, Mediterranean sea, and British sand, all produced by Daler-Rowney to my specifications. They are ready-mixed colours to make it easier for you to capture the colour of water: you can use them straight from the tubes or play around, mix and match and experiment.

The first two are called sea colours, but if you stick plenty of water in them, especially British sea, this will do for any stretch of water, be it a lake or river. If you want to adjust the colour slightly, I would suggest adding a tiny touch of Hooker's green, which will change the colour sufficiently for a beautiful lake type of water that catches a hint of surrounding greenery.

Obviously, as with any other colour, these colours can be stronger or weaker depending on the amount of water added. Mediterranean sea is a beautiful warm colour, and if you want to deepen it ever so slightly, to make it even warmer and stronger, add a tiny tint of alizarin crimson – but it's just as good on its own, straight from the tube.

You can warm up the sand colour with the addition of a hint of burnt sienna, cool it down with a tiny touch of French ultramarine, or make it brighter with a similar amount of yellow ochre; for a very neutral beach, just use it straight from the tube.

Another very useful feature of the sand colour is that you can use it for mixing in place of white: when you mix white paint with a colour to make it lighter, you end up with an opaque colour because white is totally opaque – if you use the sand colour instead, its neutrality and transparency will lighten everything without making the mixed colour opaque.

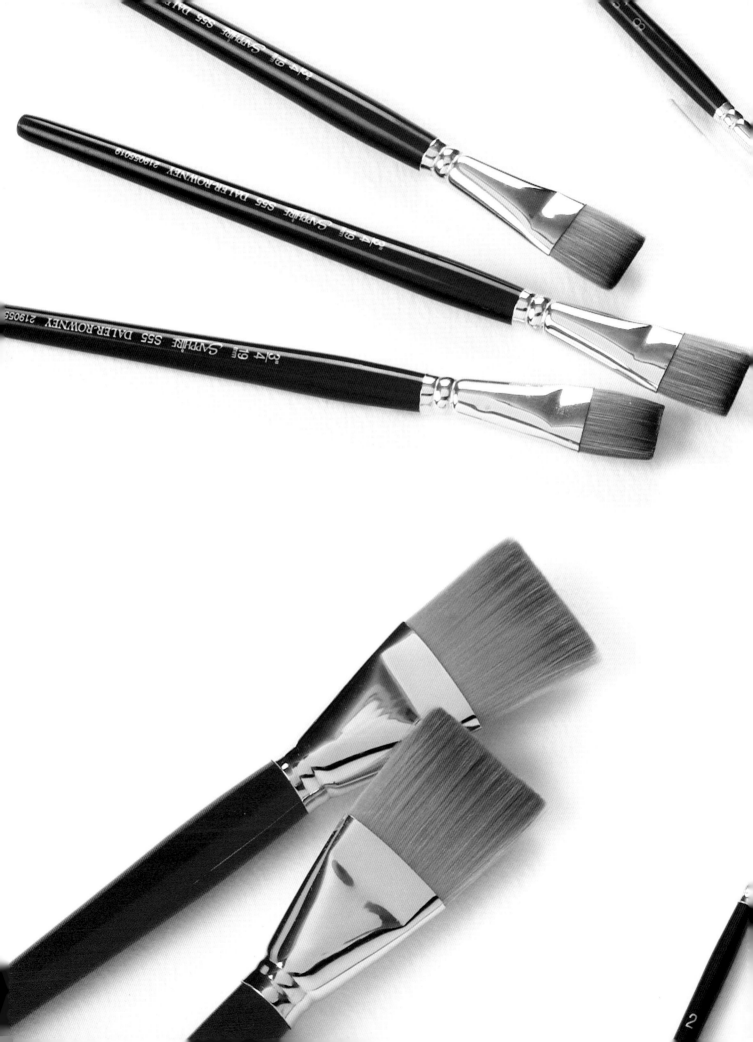

Brushes and Paper

The biggest brush I use is a 1½in Dalon, a totally synthetic brush that has been abused for about the last 10 years. It looks well used and is also bent, bitter and twisted, but it does a really good job. My other three brushes are all Sapphire, which is a blend of best quality sable and synthetic and can thus have the qualities of both kinds of bristle. These are a ¾in flat wash brush, a No. 8 round and a No. 3 rigger.

So you see, I only ever use four brushes in total – there are no great rafts of equipment and brush rolls bursting out at the seams, most of which are never used. If I can't hold it in my hand or keep it in my bucket, then it's surplus to requirements.

The paper I normally use, and have used throughout this book, is Langton Rough. This is only 300gsm (140lb) in weight, and both sides are identical – there's no wrong side, therefore, and you can't really go wrong with it. I never pre-stretch or mess about with the paper; I just chop a sheet in half and tape it to the board using ordinary masking tape. As you can see in the projects, I also use tinted paper for some work; this comes from a pad of Bockingford tinted papers.

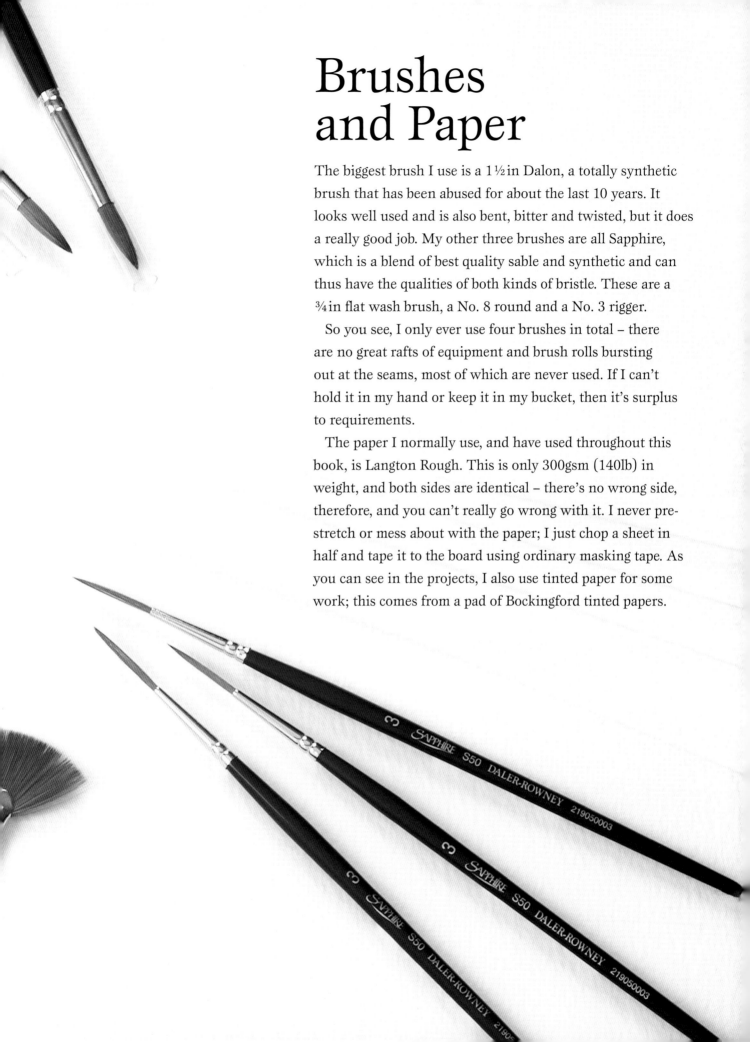

Watercolour Pencils, Pens and Water

The pencils I use are Daler-Rowney's range of high-quality watercolour pencils, which use very strong artists'-quality pigments. As you'll see in this book, I don't use a huge amount of different colours, but the pencils aren't expensive and it's nice to have a particular colour for when you need it, even if this is once a year.

A very important thing to remember with watercolour pencils is that if you use a penknife or craft knife to sharpen them – not a pencil sharpener – the points don't become brittle or snap easily, and thus last a lot longer.

For sketching outdoors, a useful tip is to wrap a bit of masking tape around the pencil where your fingers hold it: this stops the pencil getting any sweat off your fingers on a hot day or moisture from the atmosphere on a wet one, both of which can make the pencil slip around alarmingly. You can see that I've done this for the projects in this book.

I don't use an eraser, because if you make a mistake in your outline drawing – as I frequently do – remember that the pencil is a watercolour one; all you have to do is stroke water over it, and the offending line vanishes!

A few pens are useful, and I often use a plain black ballpoint or fine fibre-tip pen; this isn't line and wash work – once the washes are dry, I simply use the pen to make some squiggles here and there to pull out details and firm up some lines.

Most of the time I don't take any water with me on sketching trips – there's always a puddle, a stream or river or the sea, and on early mornings there is dew on leaves and grass: one dip of the brush or pencil, and I'm away! One advantage of staying in most hotels, as I do a lot when touring and giving demonstrations, is the little bottles of cheap shampoo the hotels supply – just pour out the shampoo, rinse out the bottle and fill it up, then put it in your pocket and you have a day's worth of water.

Artists GRAPHITE HB

Artists GRAPHIC 8B

Artists WATERCOLOUR Yellow Ochre 663

Artists WATERCOLOUR Cadmium Ye

Artists WATERCOLOUR Cad

Artists WATERCOLOUR Perylene Red 529

Artists WATERCOLOUR French Ultramarine 123

Artists WATERCOLOUR Cadmium Yellow (Hue) 620

36 Artists' watercolour pencils

DALER~ROWNEY

Artists WATERCOLOUR Cadmium Yellow (Hue) 620

12 Artists' watercolour pencils

colour palette

Other Materials

The 'lead' pencil that I use can be anything – basically, whatever I can pinch from my nephew's chalkbox – because there is never, ever going to be crosshatching or shading; I always just use a simple outline. The only time I do use fancy pencils is when I'm doing outdoor sketching, and for this I use a selection of Derwent watercolour pencils.

My easel is a Westminster easel, which is metal. It is good and sturdy, and is well equipped to handle the rigours of airport luggage handlers. When I'm out on location and the wind is blowing, I simply pull out the rubber plugs at the bottom of the legs and whack the legs into the ground.

I use a hardback sketchbook, A4 size. I stress the 'hardback' bit because the books are properly string bound, and therefore the pages don't fall out, no matter how much they are bashed. I always carry a penknife, because I never sharpen my pencils with a pencil sharpener.

My board is no more than a piece of MDF, smoothed and rounded at the edges. I use ordinary masking tape to stick the paper to the board.

And that's it – now let's get on with some painting!

Technique:
Laying a Foundation

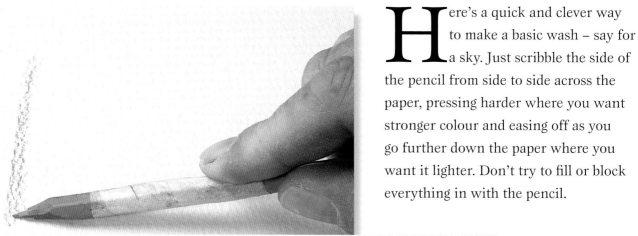

Here's a quick and clever way to make a basic wash – say for a sky. Just scribble the side of the pencil from side to side across the paper, pressing harder where you want stronger colour and easing off as you go further down the paper where you want it lighter. Don't try to fill or block everything in with the pencil.

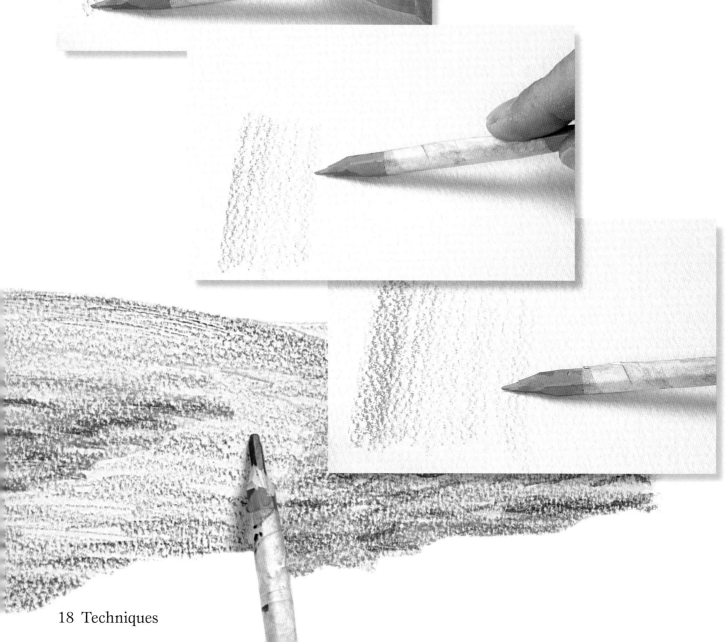

Technique:
Making a Wash

Here comes the magic – dip a brush into clean water and gently stroke it over the pencil marks, again going from side to side. Make sure not to overwork the brush, but rinse it and apply more clean water as you go down the paper; this will give you a weaker colour and make the wash into a graduated one.

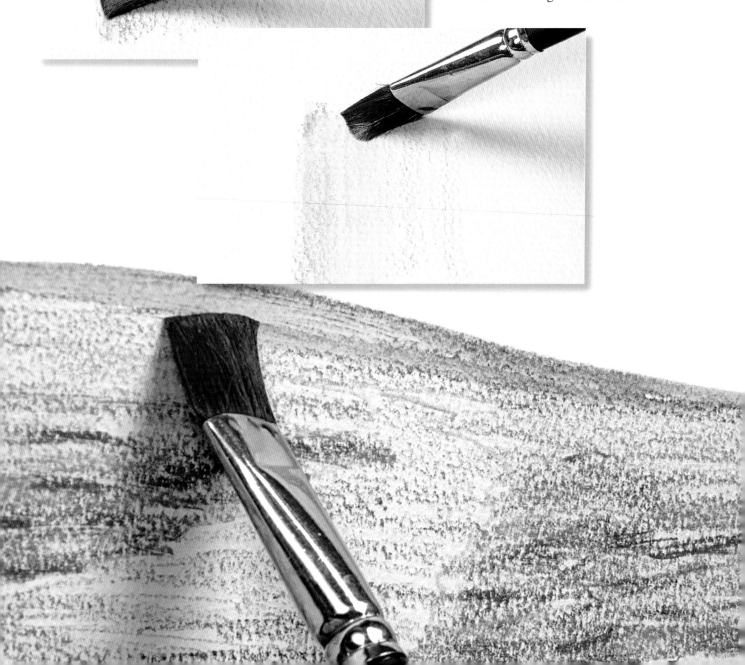

Technique:
Adding Dry to Wet

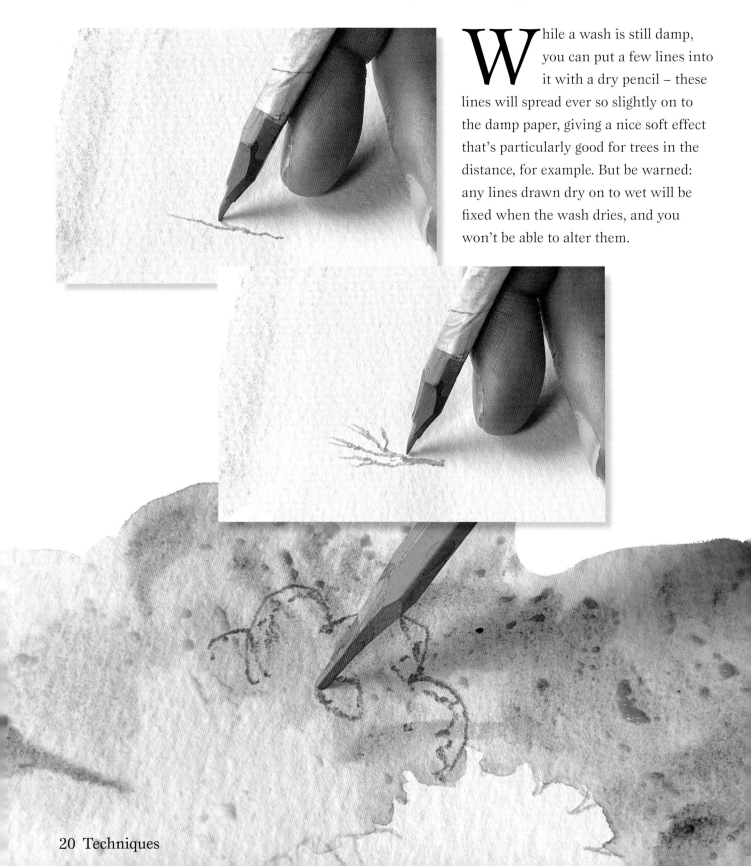

W hile a wash is still damp, you can put a few lines into it with a dry pencil – these lines will spread ever so slightly on to the damp paper, giving a nice soft effect that's particularly good for trees in the distance, for example. But be warned: any lines drawn dry on to wet will be fixed when the wash dries, and you won't be able to alter them.

Technique:
Adding Wet Marks

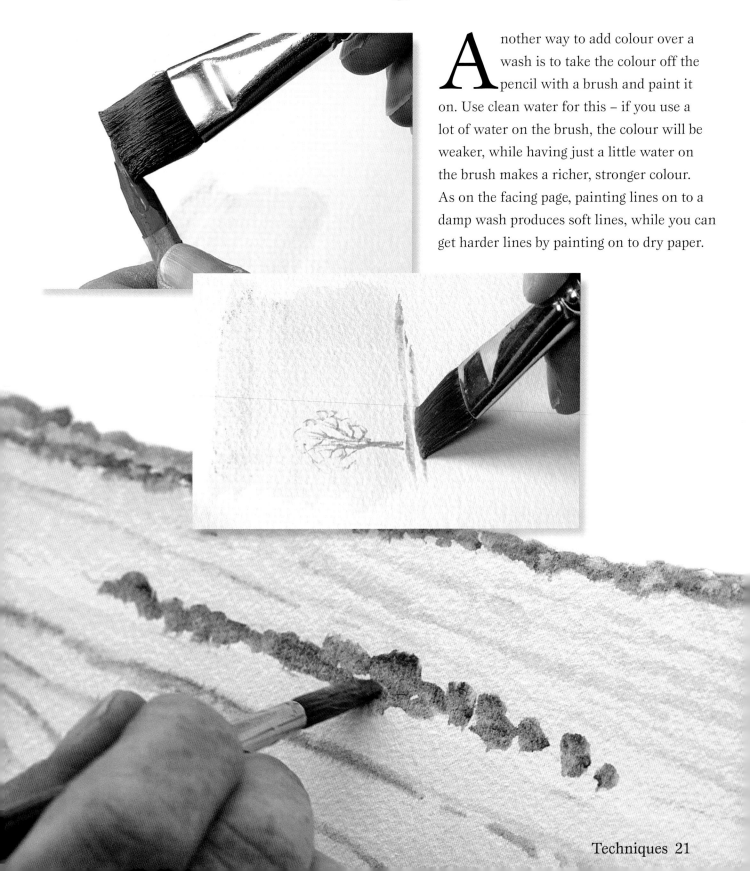

Another way to add colour over a wash is to take the colour off the pencil with a brush and paint it on. Use clean water for this – if you use a lot of water on the brush, the colour will be weaker, while having just a little water on the brush makes a richer, stronger colour. As on the facing page, painting lines on to a damp wash produces soft lines, while you can get harder lines by painting on to dry paper.

Technique:
Blending on Paper

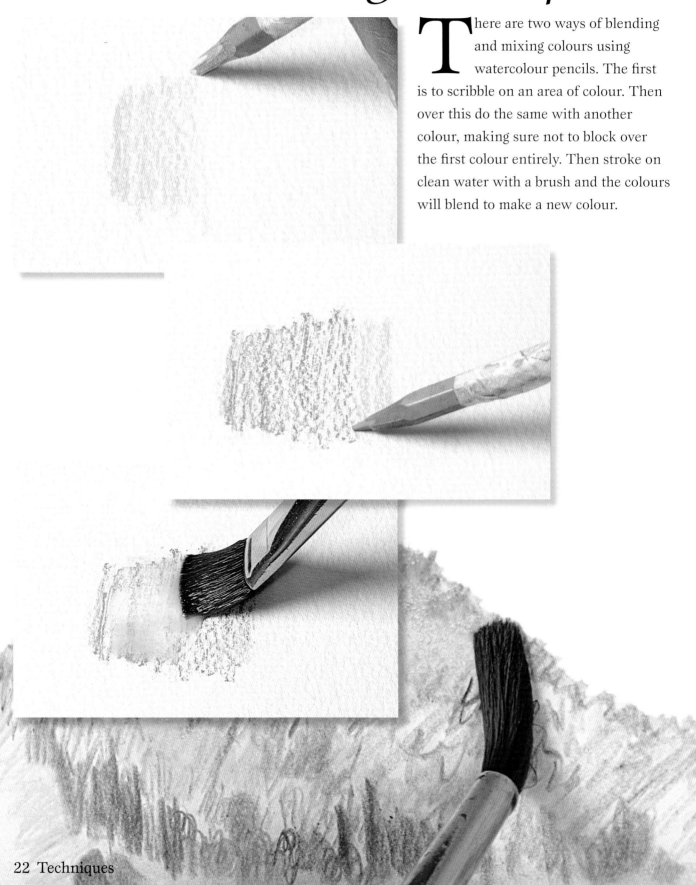

There are two ways of blending and mixing colours using watercolour pencils. The first is to scribble on an area of colour. Then over this do the same with another colour, making sure not to block over the first colour entirely. Then stroke on clean water with a brush and the colours will blend to make a new colour.

Technique:
Blending on a Brush

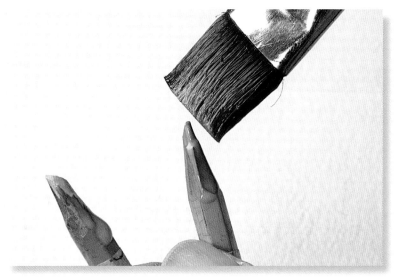

The other way to mix colours is by taking both of them off the pencil with the brush. Start with one colour and while this is wet, go straight to the other pencil and do the same. Stroke the brush on to the paper, and there's your mix. Both these mixing techniques can be varied by using more, or less, of each colour and more or less water, so experiment for yourself and see what you come up with.

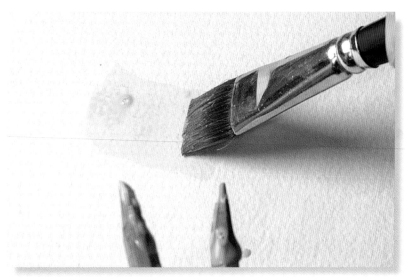

Technique:
Combining Wet and Dry

Here's how to combine the techniques I've shown you so far to make a tree with interesting foliage in a few minutes. Start by scribbling on Hooker's green, a very versatile colour; keep the marks loose and open, and allow some white paper to show through – the birds have to have somewhere to fly through the branches! Go sparingly over the green with a cadmium yellow pencil, letting some of the green and some white paper show through. Isn't it messy?

You'll want some shadow areas in the foliage, so use a blue-grey pencil to make a few scribbled marks, still keeping everything open and messy. But when you add clean water to this mash-mash of colours with the brush, everything merges, softens and blends together to give a great variety of colours and tones.

Use the brush to pull the merged colour to the edges of the foliage, and to make a trunk and a few branches. If you want to add some more distinct areas, let the tree dry, then go in with a pen – you can use a ballpoint or roller or, my favourite, a fine fibre-tip. Make a few rounded, scribbly lines and marks here and there, and that's it.

Sketching Tips

• When sketching outdoors, don't pay attention to people who wander over and look; they'll soon lose interest and move away.

• Always wrap up warm in anything but the hottest weather, and wear walking shoes if you're planning to go any distance. A hat and sunblock are essential in the sun.

• Folding chairs are attractive, with the bits for magazine racks, glasses of gin and tonic, and a reclining seat, but a simple shooting stick is far more portable and just as comfortable. Remember, you're not planning to sit around for hours: a quick 15–20 minutes per sketch, and off to the next location – find your scene, pick your spot, and off you go!

• Even when you're working with watercolour pencils, with their great range of rich colours, you don't have to use all of them all of the time. Just one colour, stroking the side of the pencil on to the paper, and a pen produced this effective little study.

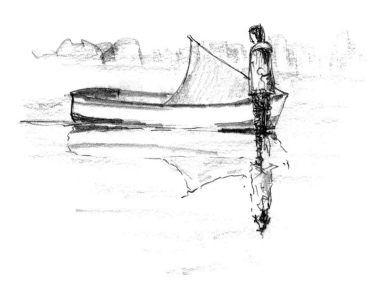

• Holidays are a great time for making sketches – and if you're near the sea, you have a ready-made source of water! People snoozing are a great subject, but you still need to try to work quickly, as this is good practice for other occasions …

• … such as this, when your subjects don't hold a pose for more than a few seconds. Here, just a few pencil lines reinforced with pen squiggles can do the trick.

• Take a look below: this is the full range of pencils I carry with me for a finished drawing – and I never use even half of them on any one sketch! So travel light and use what you have.

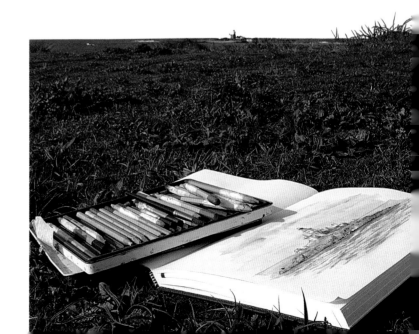

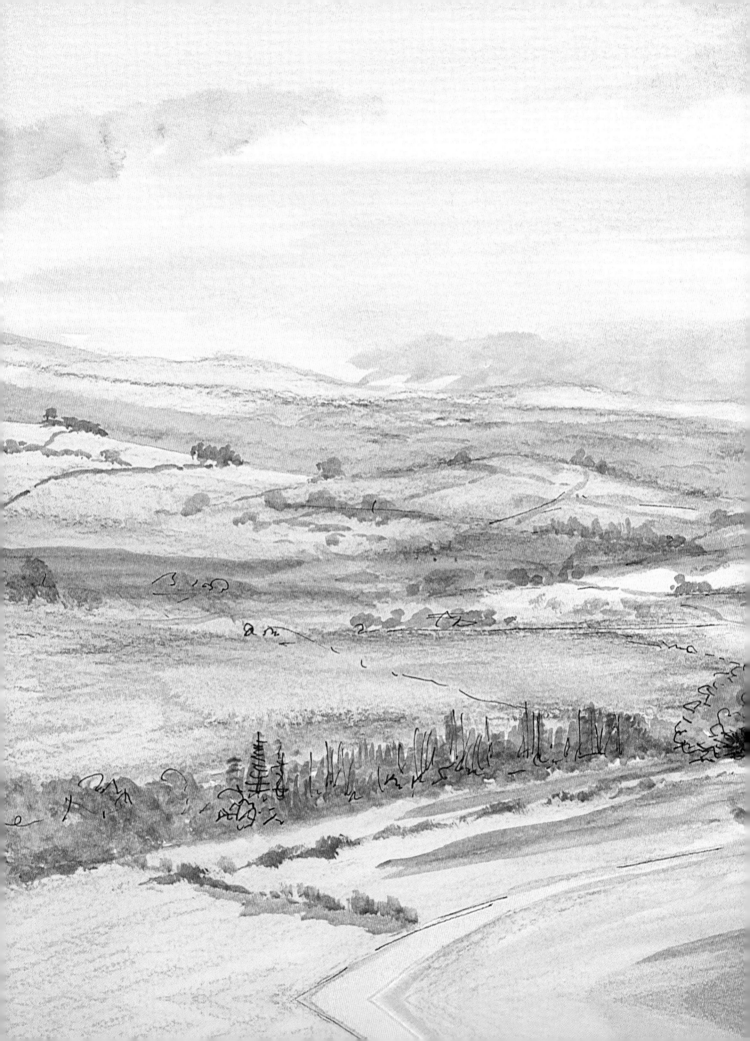

Exercises & Projects

The exercises and projects in this book are broken up into four chapters – Landscapes, Water & Sky, Buildings, and People & Animals – to get you painting the subjects you want to paint with ease. That's not to say that there aren't crossovers though so, for example, in the People & Animals chapter you'll find a landscape with people, and one with cows and sheep, and in the Landscapes chapter there is a lake scene. Each chapter starts with a sketchbook to inspire and encourage you to get sketching. Look out for the pencils or brush icon at the start of each exercise or project – this indicates whether it is a watercolour or watercolour pencil image that's being created. Work your way through or dip in and out, but above all have fun!

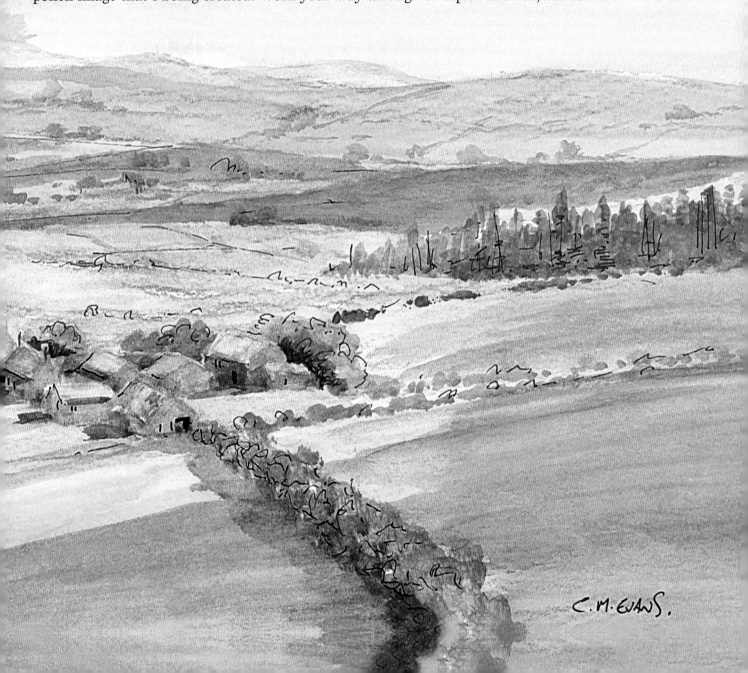

C·M·EVANS.

Landscapes

sketchbook

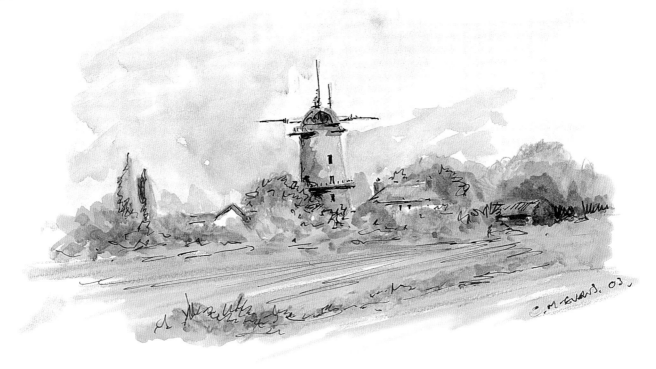

A large focal point, such as a windmill, is an obvious subject for a sketch ...

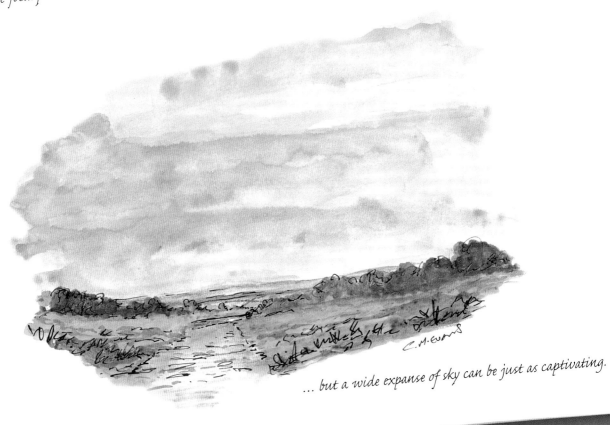

... but a wide expanse of sky can be just as captivating.

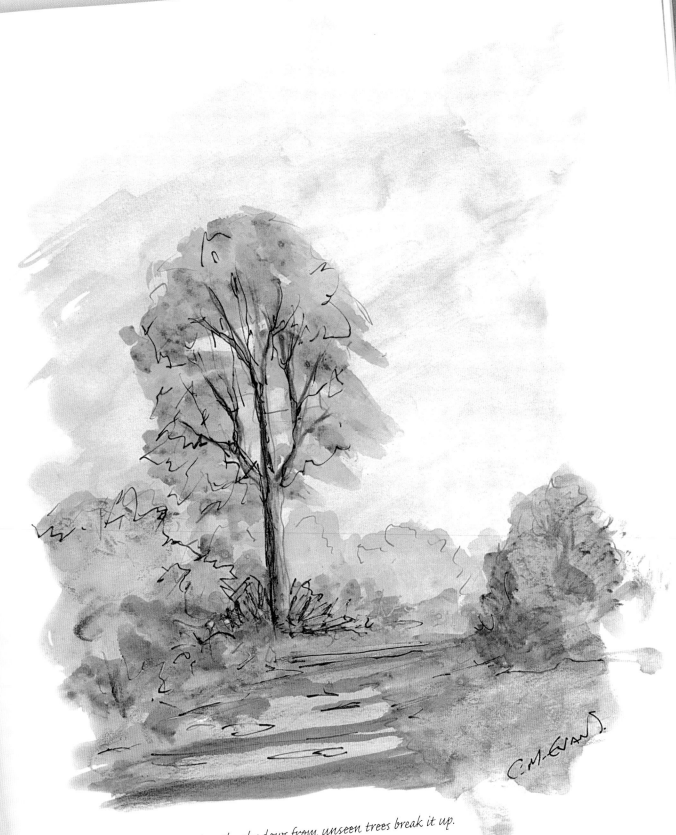

There's a path in this sketch too, but the shadows from unseen trees break it up.

Exercise:
Trees in Watercolour

It's almost traditional for trees to cause all sorts of problems, but the following pages show you how to get quick and clever results with watercolour paints.

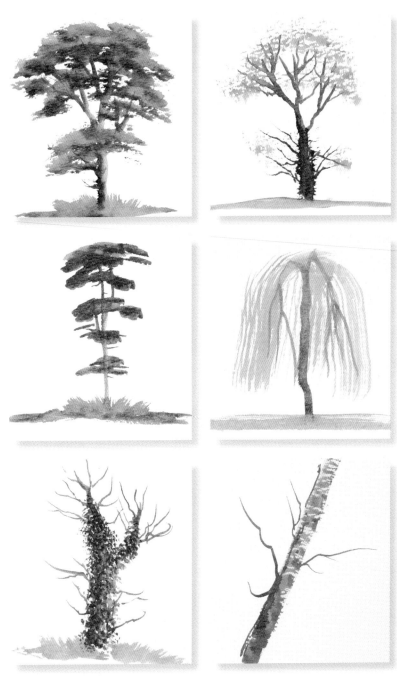

Tree in Detail

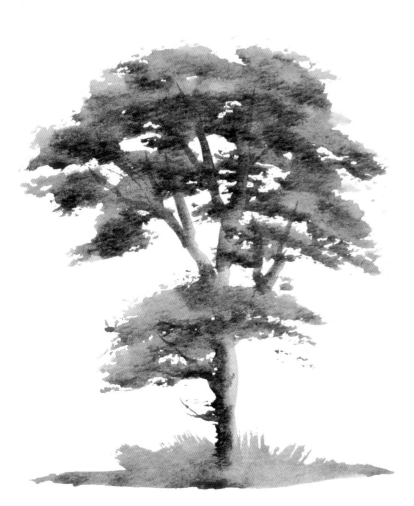

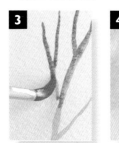

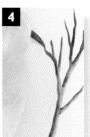

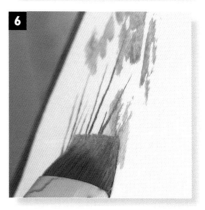

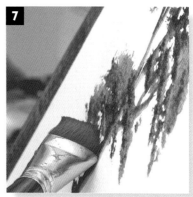

This tree may look quite complex, but it is not difficult. Remember to leave gaps through which you can see light and birds can fly.

1 Using a No. 8 round brush, make simple outlines of trunk and branches in yellow ochre.

2 While this is wet, with the same brush put raw umber on the shadow side, opposite to where the light is coming from.

3 The colours run into one another, so there are no hard edges where they meet. This gives a rounded effect.

4 Add a mix of burnt sienna and French ultramarine for a few twigs.

5 To create the impression of rough growth, flick out from the trunk with a No. 3 rigger brush and using the same mix, which adds detail.

6 Now for the canopy of foliage. Take up yellow ochre with a ¾in wash brush, and tap it on from the brush side, then do the same with a mix of Hooker's green and burnt sienna.

7 For the shadow areas, tap on a mix of burnt sienna and French ultramarine.

Winter Tree

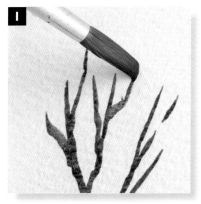

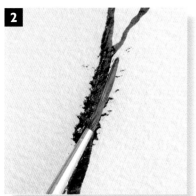

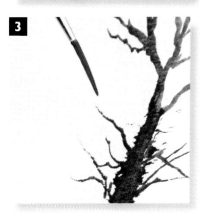

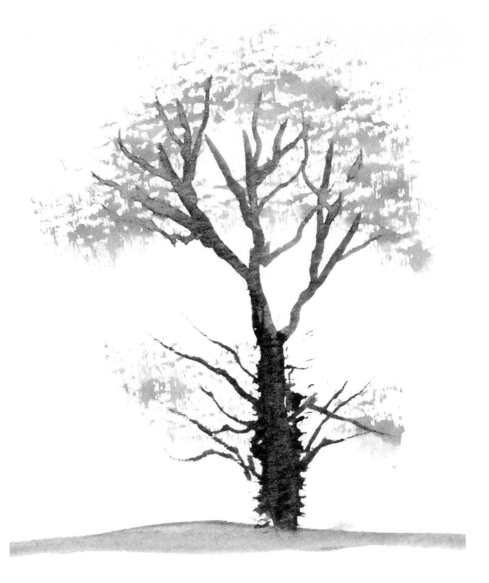

E ven though there is hardly any foliage here, the temptation is just the same as for trees with a canopy of leaves: to paint more than you actually need to.

1 Using the No. 8 round brush, make a simple outline of the main trunk and boughs with a mix of French ultramarine and burnt sienna.

2 Switching to a No. 3 rigger brush, add a bit of rough on the side by holding the full length of the brush head against the trunk and flicking out. The surface of the paper catches some of the paint and creates a drybrush effect.

3 This time using the tip of the rigger brush and the same wash, add a few twigs – don't go mad trying to add thousands of twigs, but keep it simple.

4 It's again much better to create an impression of a little winter foliage, so take the French ultramarine and burnt sienna mix on the ¾in wash brush and very lightly tap this. And there you are – a stark winter tree!

Scots Pine

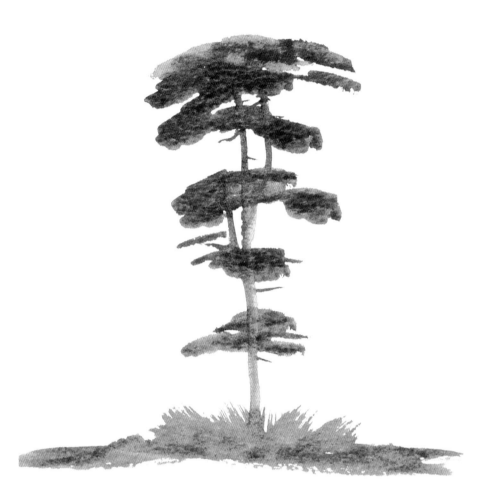

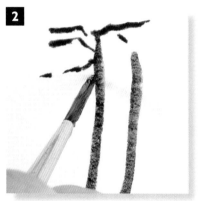

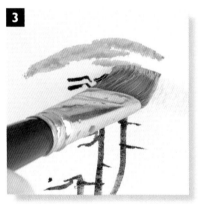

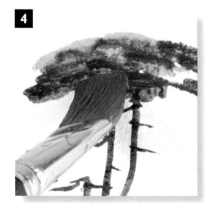

With its upright, strong outline, this is a powerful tree in any landscape. If you stick a few Scots pines in your landscapes, you are bound to add drama and shape; even better, they are simple to paint.

1 Take some yellow ochre with a No. 3 rigger brush and paint the trunk of a tall, slim tree – you can add as many boughs as you like, so long as the trunk shape isn't changed. While the first wash is wet, paint a mix of French ultramarine and burnt sienna down the side of the tree opposite the light.

2 Now for a technical term: use the second mix to add some squiggly bits on top, then move down the tree.

3 Next switch to a ¾in wash brush and load this with yellow ochre. Add dabs with the flat bristles for the foliage.

4 While this wash is still wet, make a mix of Hooker's green, burnt sienna and French ultramarine, and add a dollop of this among the yellow ochre. Continue steps for the foliage further down the tree, and finish by putting in a few dabs and upstrokes of the green mix for the grass at the trunk base.

Weeping Willow

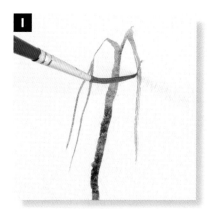

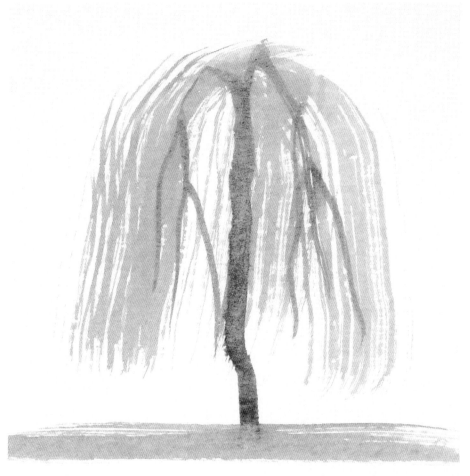

Weeping willows are lovely, atmospheric trees that really enhance a landscape. They have the reputation of being difficult to paint effectively, but here's how to achieve good results quickly.

1 Starting with a wash of raw umber, pull a No. 3 rigger brush up the paper for the main trunk, and then at the top turn the brush upside down and bring it back again for the 'weeping' branches. Repeat this routine, each time slightly thickening the trunk and adding another drooping branch.

2 Good quality brushes are strong and will take any amount of abuse. So, once you've made a mix of Hooker's green and yellow ochre, split a ¾in wash brush by bashing its head into the palette.

3 Push the split bristles into the paint.

4 Starting from the top of the tree, drag the brush down in sweeping curves. Add a little ground at the base, and there is a weeping willow.

Ivy-Clad Tree

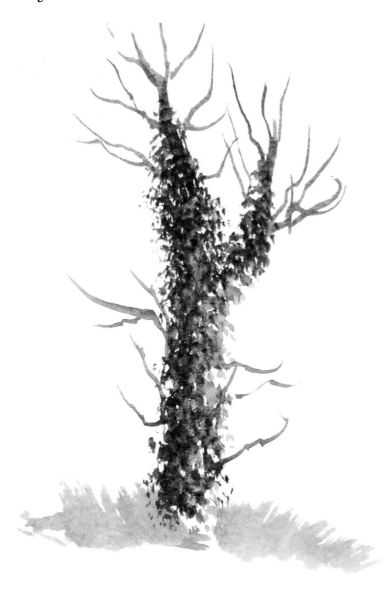

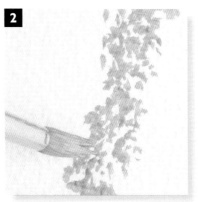

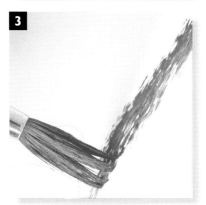

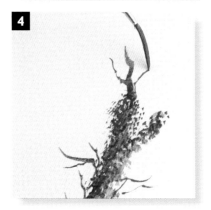

Overgrown and dead trees can be tricky, as you have to suggest the underlying shape of the trunk and branches without showing them. Try this method.

1 As for the willow on the previous page, start by splitting a No. 8 round brush and then take yellow ochre from the palette.

2 Stipple on the colour in the rough shape of the trunk and main branches, making sure to leave white highlights of paper showing through.

3 Now make up a mix of Hooker's green and burnt sienna, and repeat the stippling, leaving some of the first colour to show the lighter side. Mix French ultramarine and burnt sienna, and repeat the stippling to darken it further.

4 For the twigs, use a No. 3 rigger brush, and make a mix of raw umber and burnt sienna for the branches at the top. A final splash of green anchors the tree to the ground.

Silver Birch

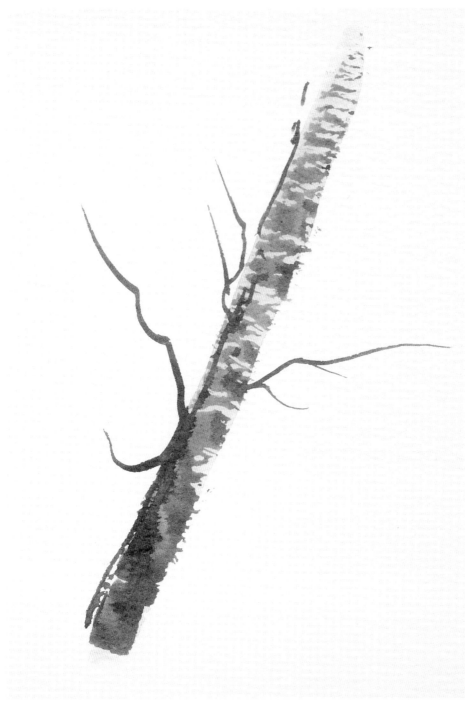

This particular species has a reputation of being notoriously difficult to paint. It's not the shape of the foliage that's tricky – it's the ridges and knobbly bits on the central trunk. But fear not; it can be done.

1 Using a No. 8 round brush, paint the trunk with a mix of yellow ochre and raw umber and let it dry; but you can use any colour you like, as it's just so as not to have white paper.

2 For the important strokes, make a mix of French ultramarine and burnt sienna, and apply it thus: hold the brush upright – not like a pencil – with the full length of the hairs resting on the paper, and drag it across the first wash, starting at the bottom and working up with less paint.

3 To finish add a few branches with a slightly darker version of the second mix.

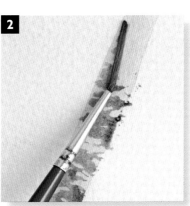

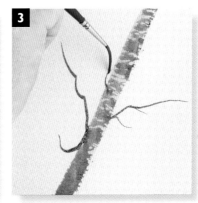

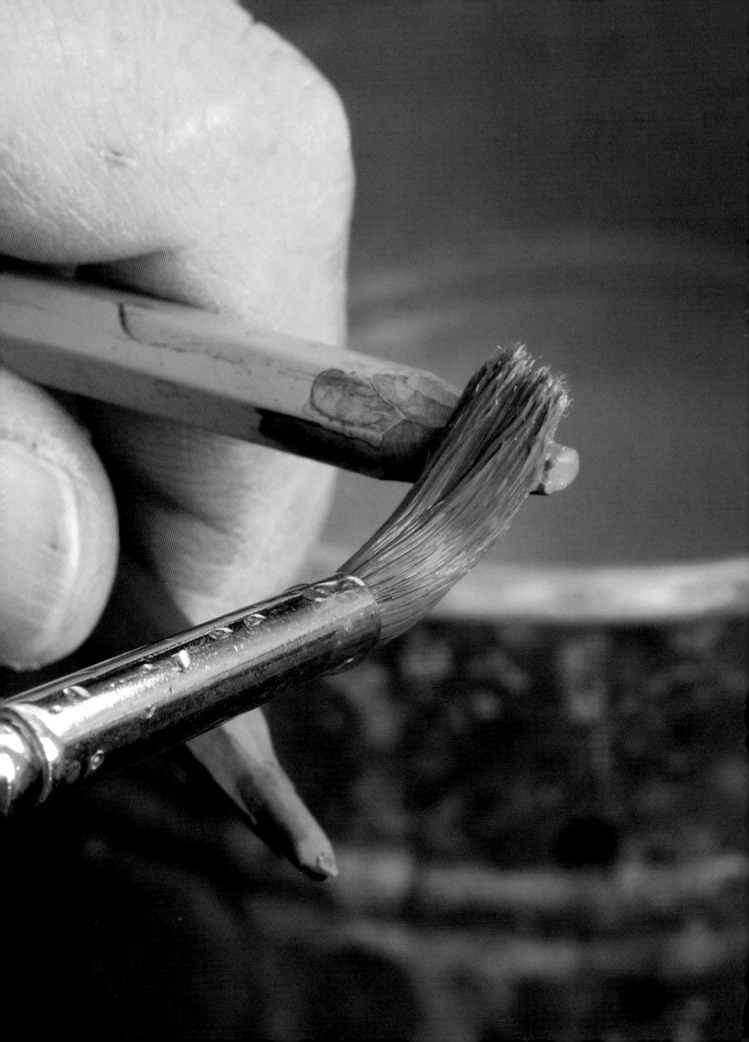

Exercise:
Trees in Watercolour Pencil

You can use watercolour pencils as a variation on paints; try out the trees in these exercises to give you a feel for using these versatile tools.

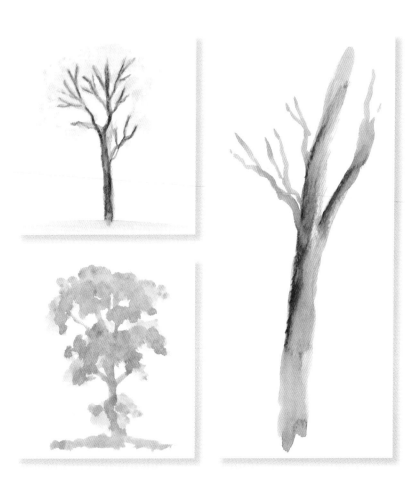

Winter Tree

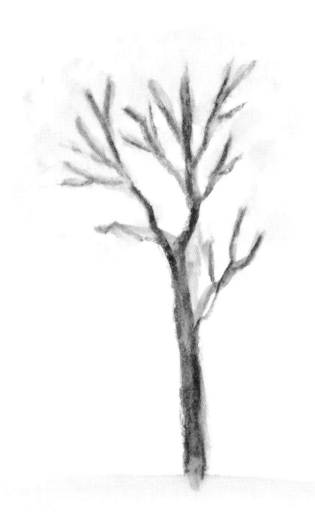

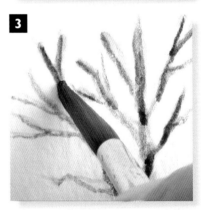

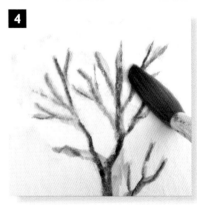

When painting bare winter trees, I always exaggerate their darkness to make the overall result more effective, especially on a lone tree as shown here.

1 Draw the basic shape of the trunk and main branches with a black watercolour pencil; don't try to make the colour too dark when drawing.

2 Next put yellow ochre pencil on one side of the tree and along most of the branches. Don't try to follow the exact line of the black, but give the impression of a canopy of twigs.

3 Taking clean water on a No. 8 round brush, go over the whole tree. This darkens the colours and gives a varied texture – you don't want to smooth everything out.

4 Rinsing the brush, take up just a little heavily watered black pencil to show the winter growth and ground – and there you have it!

Tree in Leaf

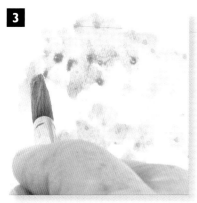

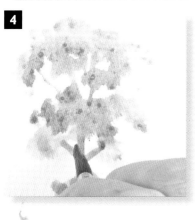

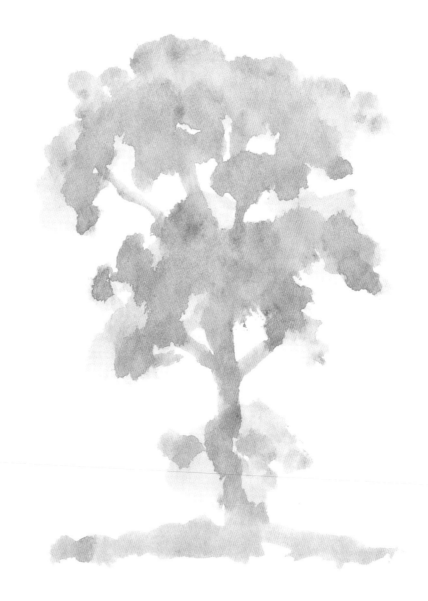

For a tree in full foliage, try mixing all the colours on the brush – just as you'd do for watercolour paints, only taking the pigment from the point of the pencil.

1 First dip a No. 8 round brush in clean water, make a mixture of dark green and brown ochre from the watercolour pencils.

2 Then dab the brush on the paper to make masses of leaves – keep everything light at this stage, and don't worry about little dots of accumulated pigment here and there, as it won't be visible when it dries.

3 While the paint is still wet, quickly add some blue-grey to the mix on the brush and again dab this on for the darker parts of the foliage, still leaving white paper for birds to fly through.

4 To finish, clean the brush, take straight blue-grey on to it from the pencil, and drag the pigment for the branches, trunk and ground at the base.

Blending Trees

This exercise uses both dry watercolour pencil work and brushwork to give a strong final effect. The main things here are to work quickly when adding the water to the pigment marks and not to spend time looking for a polished result – the roughness makes the character of this tree.

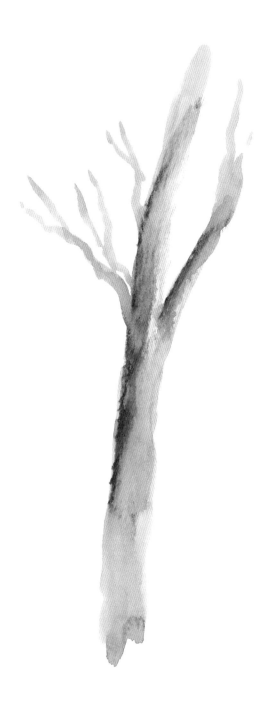

1 The first pencil colour is brown ochre, which you can use for the lightest tones on the tree.

2 Follow this on one side with brown pencil – don't try to cover all the paper with the pencil marks, as the water will do that later.

3 Next add some black pencil for the darkest, shadowed side.

4 At the moment everything looks like a vertically striped, odd-coloured stick of rock with a growth on the side …

5 … but dip a No. 8 round brush in clean water and stroke the tip on to the pencil marks …

6 … blending the colours as you go. It's important to make the strokes just along the length of the trunk – if you mess about too much and go back over what you've done with the brush, the effect will be muddy.

7 Drag some of the merged colour from the trunk to make a few branches and twigs.

8 After rinsing the brush go gently along the main branch, again being careful not to over blend or merge the colours.

9 Let everything dry, and hey presto – you have a lovely rounded tree trunk with knots and all.

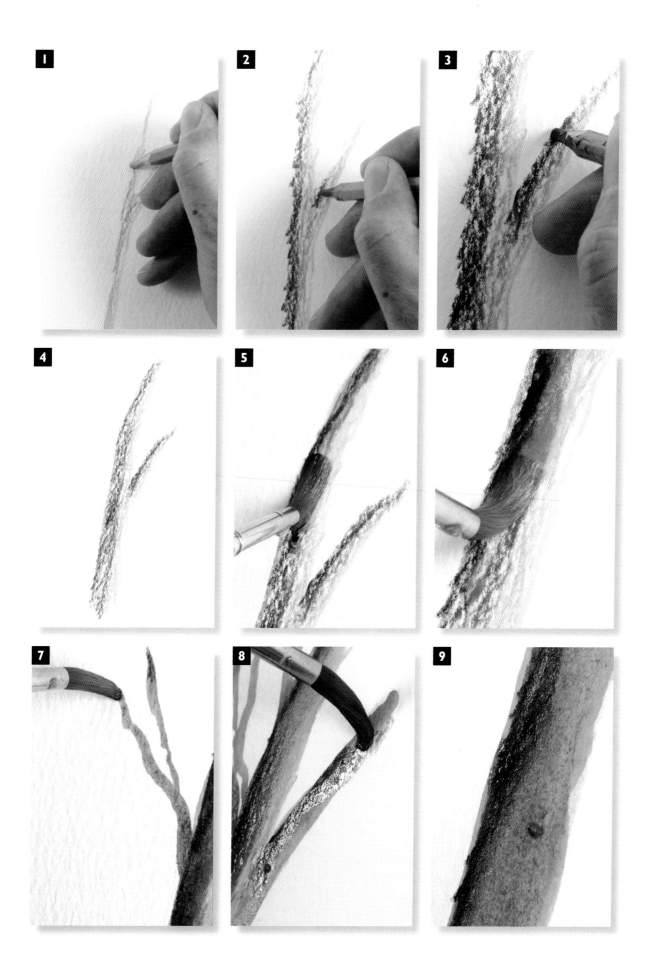

1 2 3 4 5 6 7 8 9

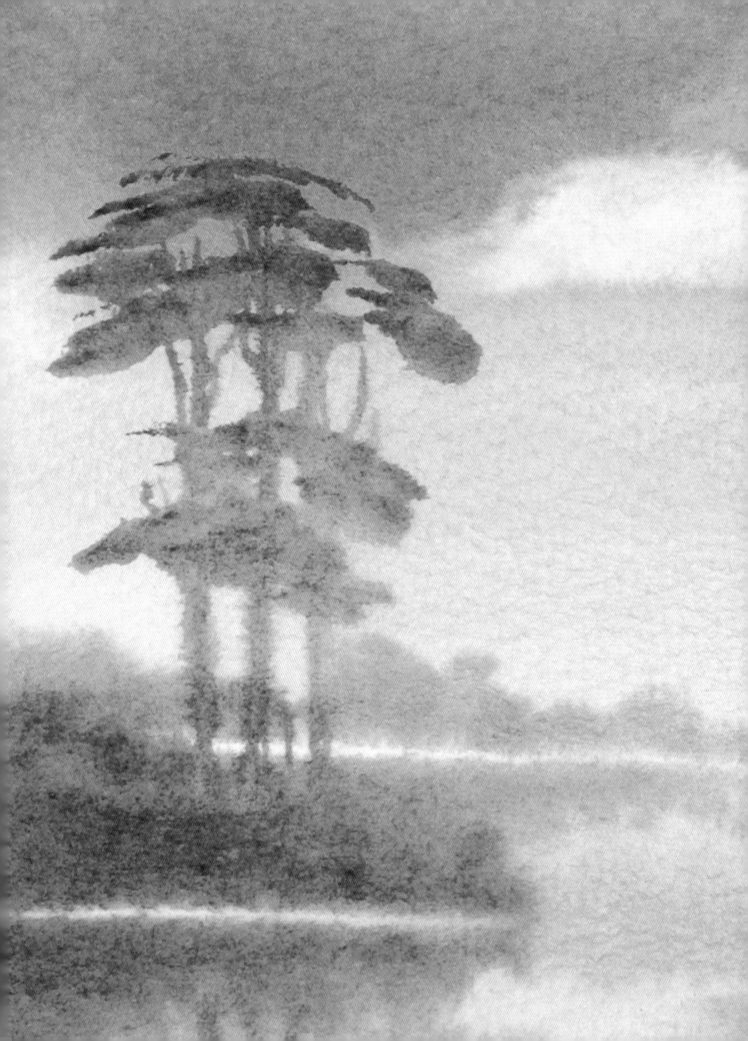

Project: *Trees and Lake*

This first project introduces my key ideas on painting: keep paints and brushes to a minimum, work fast and concentrate on the big picture.

Ideally, this little study should only take a few minutes to do. I used a limited number of colours, and I used the same mix for several parts of the painting. Most importantly, you should think about the overall picture all the time – don't get worried about whether anything is absolutely accurate or right, but work quickly and confidently.

1 To begin, I use a large flat wash brush to wet the whole of the paper, then squeeze out the brush and add a line of yellow ochre across the middle.

2 I add burnt sienna above and below the ochre, and above and below that, a mix of French ultramarine with a tiny touch of burnt sienna. I mop up the bottom of the picture, squeeze the brush out and merge the colours.

3 After rinsing and squeezing out the brush, I draw out the pigment in the sky for clouds, and repeat this in the water for a reflection.

4 Using a really wet mix of French ultramarine and burnt sienna and a No. 8 round brush, I wipe the brush straight across the picture so that it spreads – bleeding of pigment is normally my worst enemy, but I can take advantage of it now. I repeat this in the water for the reflection of the trees in the distance. To make a difference between the water and the sky, I use the ¾in wash brush and clean water to suck out pigment in a line across the picture.

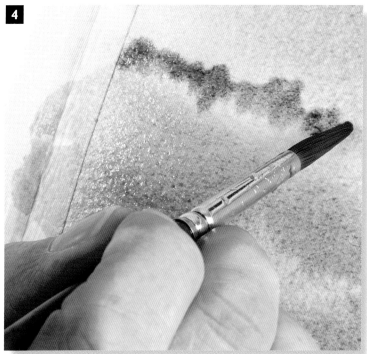

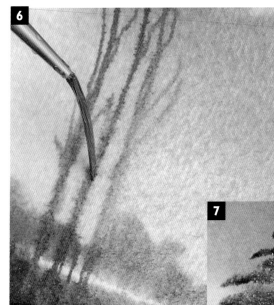

5 For the bushes, I make a watery mix of Hooker's green and burnt sienna, drop this on to the paper so that it spreads, and repeat below the dividing line. I then drop a mix of French ultramarine and burnt sienna into the green of the bushes to make shadows, and again repeat this, pulling out the colour in the reflections with the wash brush.

6 I now switch to a No. 3 rigger brush and use raw umber to make a couple of trees with their branches, repeating this for the reflections.

7 Returning to the round brush and the Hooker's green and burnt sienna mix, I dab on sharp-edged marks to make the foliage of the Scots pines. And that's it – the work only took me a couple of minutes to do, but it looks great.

Project: *Woodland and Fields*

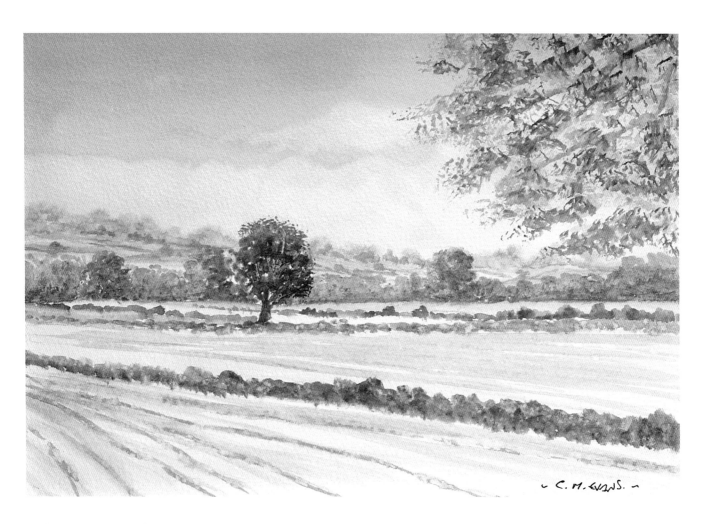

This particular landscape is right outside my back door – you don't always have to travel far to draw or paint. I removed a telegraph pole that interfered with the composition and made a feature of the single tree.

top tip

I used cool grey pencil for the initial drawing on watercolour paper. The trees were just rough shapes, without any details, and I didn't draw the poplar on the right at all.

1 To start, I take manganese blue off the pencil with a ¾ in flat wash brush, and then work it quickly across the sky area. While this is wet I go into it with a slightly darker version. (The bubbles you can see will disappear as the washes dry.)

2 I rinse the brush in clean water and squeeze it nearly dry, then suck some of the damp pigment off the paper to form clouds. Hey presto! This gives you sky with a minimum of detail.

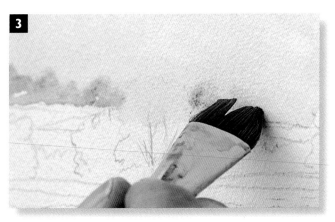

3 Working quickly while the sky is still damp, I take some blue-grey off the pencil and use the edge of the brush to put in the furthest trees. As it blends into the sky washes, this gives a soft, hazy, distant effect.

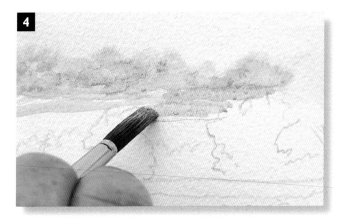

4 While this wash is damp, I switch to a No. 8 round brush to tap on some Hooker's green and viridian for the slightly closer trees; I keep these washes weak. After drawing down some strokes of green, I add yellow ochre to give a patchwork effect for the fields.

5 I add some blue-grey blobs for bushes, just tapping on the colour with the brush, and stroke on olive green, again taking the colour off the pencil, in the middle distance in front of the field. I've created a view with true distant softness, all with a few blibs and blobs.

6 For the trees in the middle ground I wet the tip of a yellow ochre pencil with clean water and draw on some short lines; these more permanent marks have a slightly stronger colour than those in the distance, adding to the impression of recession in the picture.

Project: *Woodland and Fields* 51

7 Going into the yellow ochre, I scribble on viridian and then blue-grey for the base of the trees. The secret here is not to go in too hard; if this section is too dark, what can I do for the foreground? Now take a look at the result – what a mess it seems to be!

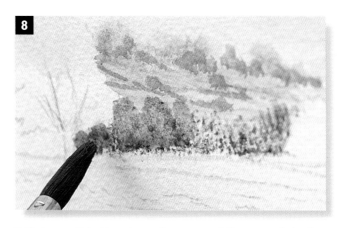

8 But now it is time to make sense of the mess: I stroke clean water on to the pencil marks with the No. 8 round brush, and suddenly there is the green foliage of a distant woodland. I leave a few touches of the underwash showing, big enough for a squirrel to appear through the foliage.

9 Taking the colour off the pencil with a clean brush, I stipple small marks of yellow ochre onto the more pronounced mid-distance trees; I use a little water and 'split' the brush hairs on the paper to give a leafy effect.

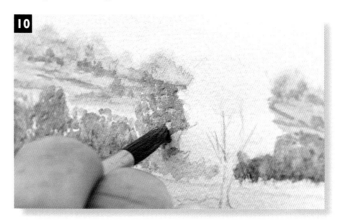

10 I follow this with sap green, again 'splitting' the brush; to show the direction of light, I work on the right, leaving the left-hand side of the tree more ochre.

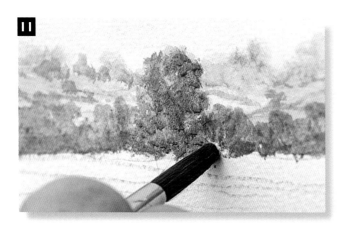

11 The next colour for the trees is a stronger, darker Hooker's green, and I then add warm permanent magenta to give the shadow colour under the more prominent trees.

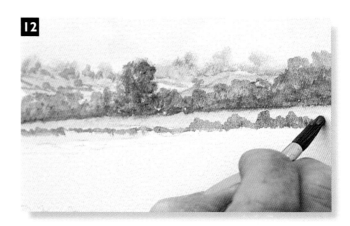

12 Moving to the field in front of these trees, I stroke on a pale wash of sap green, then put in a touch of cadmium yellow for the next bright field of rape. I separate these with a stippled-on hedge, a mix of viridian and permanent magenta, made on the brush.

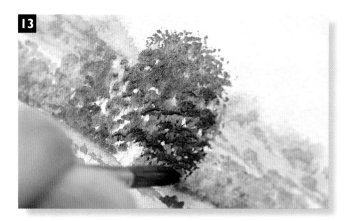

13 For the main tree I put on a bright wash of cadmium yellow to make it stand out, then tap on a stronger mix of viridian and magenta, 'splitting' the hairs of the brush for the effect of leaves. I apply Mars black to the bottom of the foliage, and drag it down the trunk and base.

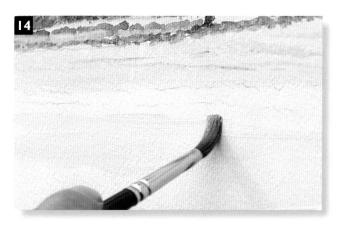

14 I begin the foreground field of oilseed rape with a strong wash of cadmium yellow, painting long lines from side to side and leaving the front hedgerow area untouched.

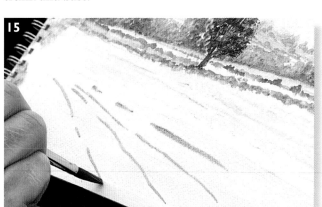

15 Across this wash I drop in diagonal lines of viridian for tractor tracks and lines of weeds; this gives a flow to the field. Returning to the viridian and magenta mix, I put in the middle hedgerows, which get slightly darker towards the right side of the picture.

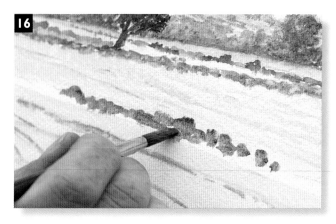

16 After going over the foreground field with an even stronger cadmium yellow wash, I use the viridian and magenta mix for the large hedgerow. This time I drop in a touch of blue-grey at the base in a scrappy line that gives the impression of crops growing in it.

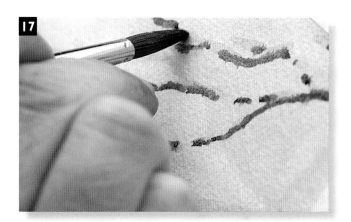

17 The last stage is to put in the poplar tree on the right side. I begin by stippling in lines of yellow ochre, followed by Mars black on the underside while the yellow ochre is damp. I make sure the lines have a broken, dotty feel.

18 'Splitting' the flat wash brush, I stipple on a dryish wash of yellow ochre for the foliage. I then add Hooker's green, twizzling the brush to add the twigs amongst the foliage. I finish by doing the same with a mix of blue-grey and Mars black – and there we are!

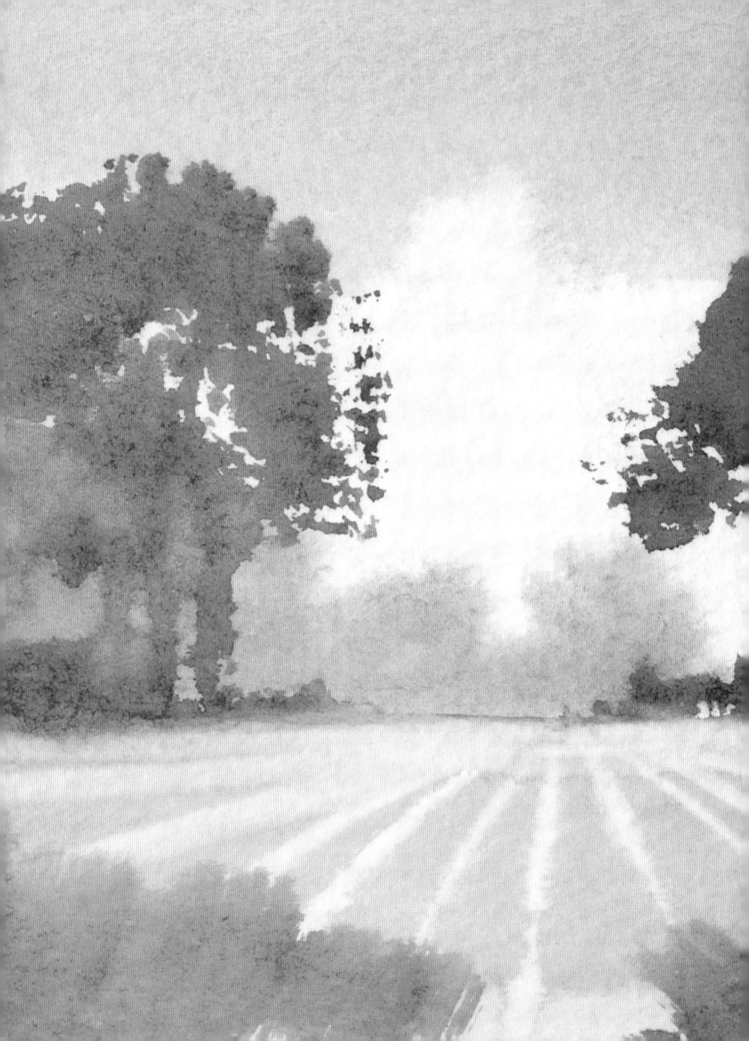

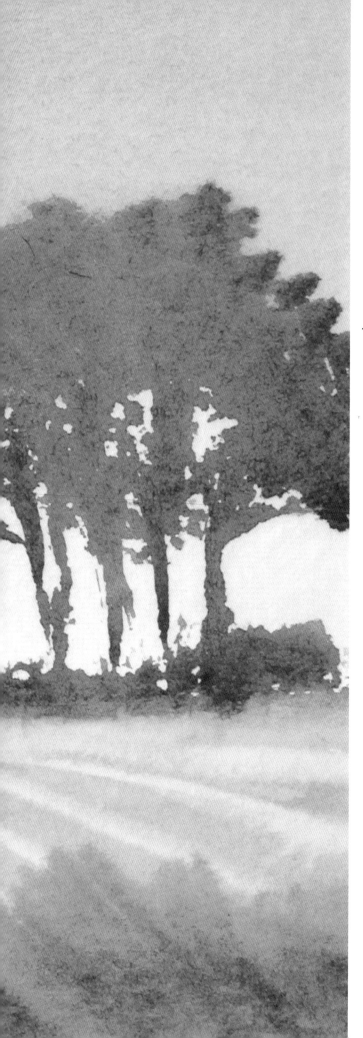

Project:
Cornfield

This golden view sums up summer in the countryside – you can almost feel the heat. The project uses just one brush, to keep things as simple as possible.

In addition to using one brush only, I decided not to do any preliminary drawing for this project. The combination fine-tunes your brushstroke skills and you get to find out what your single brush can do. Try to limit yourself to about 10 minutes here, because you have to work quickly to finish.

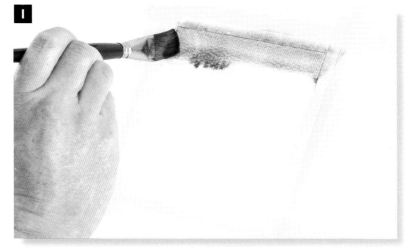

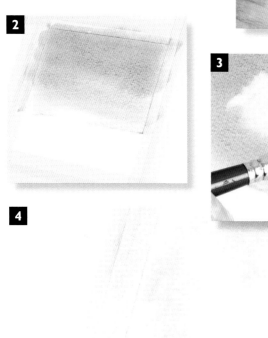

1 Using a ¾in flat wash brush, I start by wetting the sky area – about two-thirds of the picture – with clean water. I then apply a first wash of watery French ultramarine across the top.

2 I then continue down the paper, using more water and less paint each time. This is known as a graduated wash – but I call it slapping it on quick!

3 After rinsing and squeezing out the brush, I use it to draw out the wet pigment to make cloud shapes.

4 Using clean water, I mop along the bottom edge.

5 While the sky is still very wet, I add a touch of burnt sienna to French ultramarine to make a darker blue, which I then dab into the horizon.

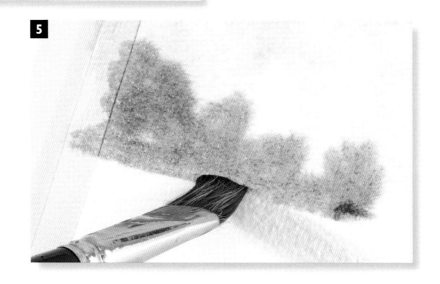

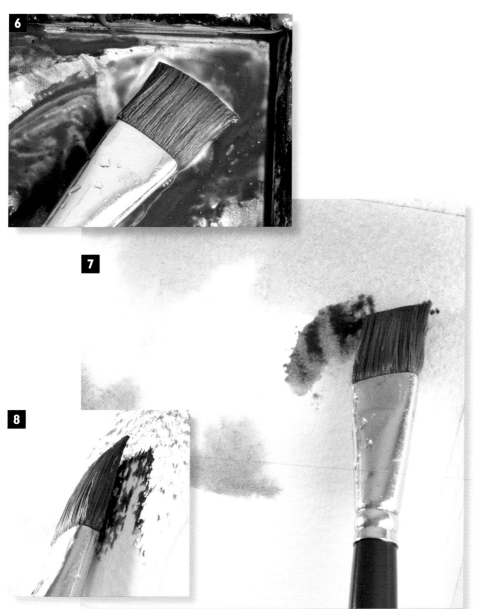

6 For the foliage, I make up a mixture of Hooker's green and burnt sienna, which I keep strong but watery. I dab the brush into the mix, thus loading the hair with lots of paint.

7 To start the foliage for the foreground trees I tap the hair of the brush on to the paper, where it picks up on the rough-textured surface.

8 I make sure the metal of the brush also taps on to the paper – this guarantees that the whole length of the hair is slapping on the paper.

9 The result is a mass of green leaves, but not a solid one, that still has some of the sky colour showing through. As the paint dries, it will show darker and lighter clumps of foliage.

top tip

When it comes to painting trees, unless you are a botanical artist, it's best to concentrate on painting full foliage as a mass, not on the individual leaves.

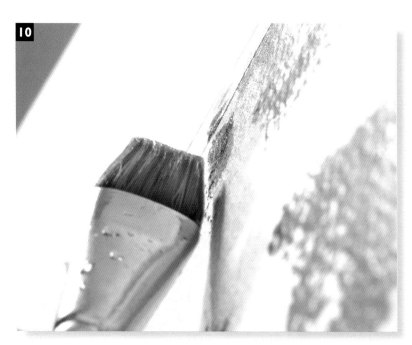

10 To add liveliness to the foliage, I also use the side of the brush to flick upwards into the greater mass of leaves.

11 I then use the end of the brush hair to create the trunks and large branches. I call this bit 'joining up the dots'.

12 With the brush thoroughly cleaned, I load yellow ochre on to it and make one broad stroke across the paper below the trees, and clean and squeeze out the brush to remove a band at the very bottom – I don't take out too much pigment here, however.

13 This time I squeeze out most of the water and use the end to draw out pigment to make the spaces between the rows of corn.

top tip

I use double layers of ordinary masking tape to stick the paper to the board – you can also use wider tape rather than two runs. However, I never use the brown 'lick and stick' tape: for a start it doesn't ever peel off properly, and it tastes awful!

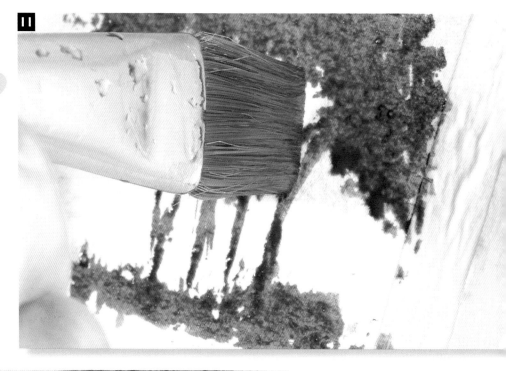

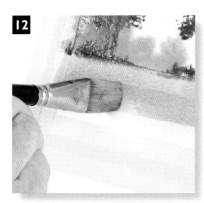

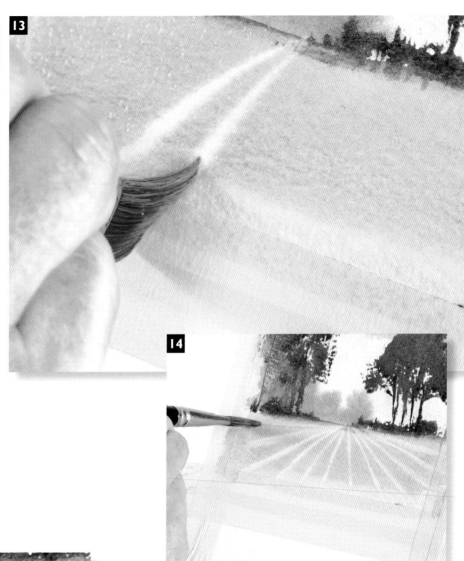

14 As I add the lighter rows, I squeeze out the brush every few strokes to make sure I remove the pigment, not just move the paint about.

15 Now I make up a light green from Hooker's green and burnt sienna, and add a few flicks of this into the very foreground.

16 When I push the brush upwards the hairs split apart to give me some blades of grass. I peel off the tape, and there's my picture – not bad!

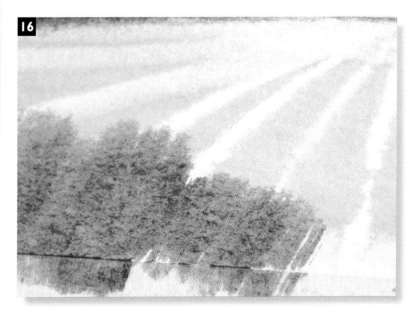

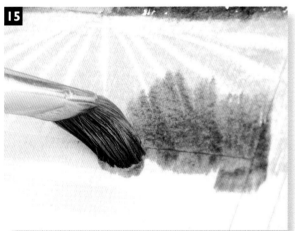

Project: *Moors and Hills*

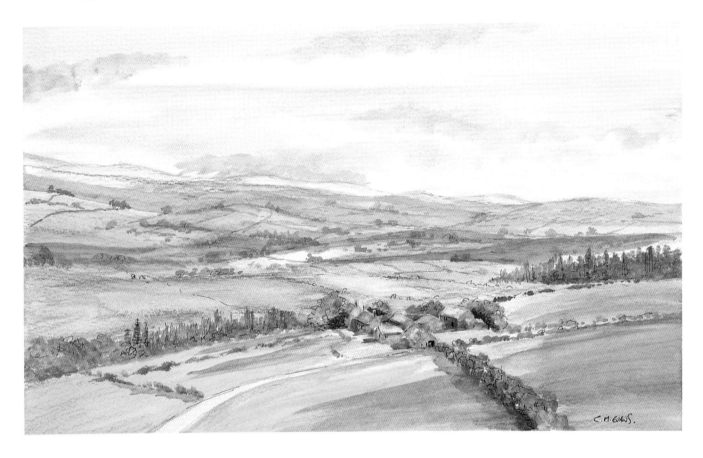

*When you come to a big vista – like this view of Alnwick Moor –
you can't put everything in, so pick a portion and focus on it the
way you would any other landscape.*

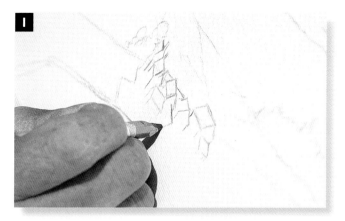

1 Working on Langton Rough watercolour paper, I make the initial drawing in cool grey: the pine forest is zigzag scribbly lines, and I draw in the outline of the splash of light on the far fields. Because I'm looking down on the farm, the roofs of the buildings slope diagonally upwards slightly to give the feeling of recession.

2 With the outline drawing done, it's time to start adding the colour; in the far distance I put on a little Prussian blue and I scribble the pencil over the paper, like in a child's colouring book.

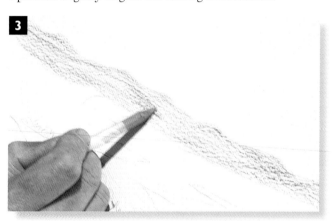

3 I follow the blue with some blue-grey on the furthest hills, then add some burnt sienna and raw umber for the darker, bracken-covered parts. In addition to putting the colours on to the white paper, I push them into the other colours, to merge when I add water later.

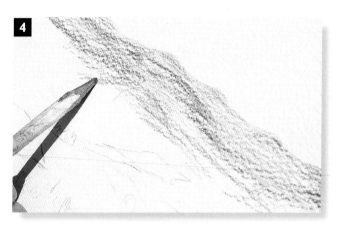

4 As I come forwards into the middle ground I switch to Hooker's green, scribbling it in and stroking it on to fill up the paper – the rough nature of the paper ensures that the white will show through a little below the textured bumps on the surface.

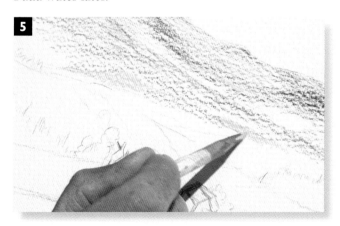

5 There are some fields of bright oilseed rape among the green areas, and I use cadmium yellow for these. Then I go over some of the green pencil marks, not trying to cover them but giving opportunities for blending later.

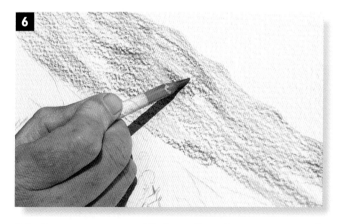

6 In the same way as with the yellow, I go over some of the Hooker's green with blue-grey, to darken and tone down the furthest fields and introduce a cool colour.

Project: *Moors and Hills* 61

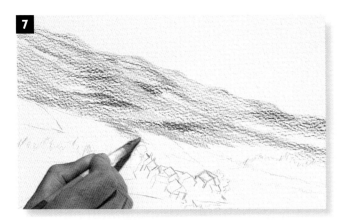

7 Coming further forwards again, I use yellow ochre for the fields leading to the farm; so far I haven't drawn a single tree, apart from some patches of woodland, as going into such detail would bog me down – a few blobs here and there will do for now.

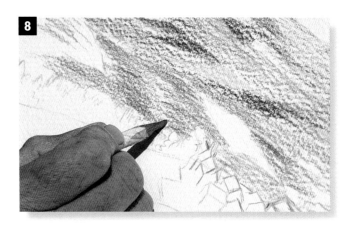

8 For the field immediately above the farm, I start with sap green, then warm this with yellow ochre and darken it with Hooker's green, working the colours into and over each other as a basis for applying water. I then fill in the bare patch with cadmium yellow.

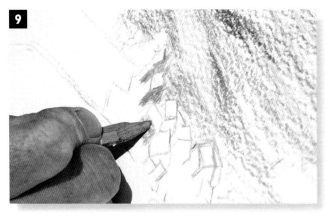

9 Now for the farm buildings: I start by filling in the sides facing the light strongly with yellow ochre …

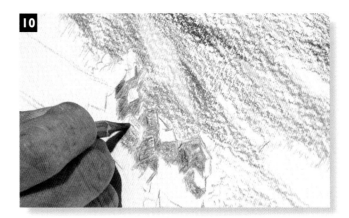

10 … and then use raw umber for the darker sides. I use cool grey for the nearest building and burnt sienna and blue-grey for the roofs. The farmyard is a mix of yellow ochre and blue-grey.

11 I've nearly finished the drawing part: the fields on this side of the farm are the same blending of cadmium yellow followed by Hooker's green, over and beside the yellow. I haven't filled in the plantation forests yet, but now it's time to go into the sky.

This is a big piece of paper, so I use a ¾in flat wash brush to wet the sky area with clean water, then use the same brush to take yellow ochre off the pencil and paint it into the bottom part of the sky; the water helps this wash spread and flow.

12 Next I put Prussian blue into the top of the sky in the same way – working quickly, just as with a watercolour painting. As the colours bleed together I add some blue-grey for the darker blues in the sky; any bubbles in the paint will go as the colour dries.

13 While the sky is damp I stroke clean water into the Prussian blue at the top of the distant hills, so they soften into the base of the sky. Let there be light! I leave everything to dry for a while.

14 Now it's time to reap the rewards of all that drawing – I merge the colours of the distant hills with clean water, producing lovely bracken colours as the ochre and blue-grey blend together.

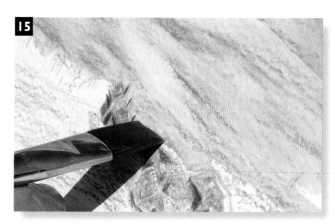

15 As I carry on into the green areas, I bring the brushstrokes down to follow the lines and contours of the fields, and even leave some parts dry so the texture of the paper shows through. I stop at the top of the farm buildings for now.

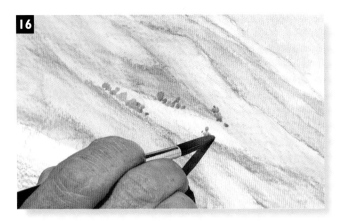

16 Moving back into the middle distance, I use mixes of blue-grey, Hooker's green, permanent magenta and Prussian blue, taken off the pencils, to put in some lumps and contours. I then drop in blobs and dots for trees, using a No. 8 round brush and mixed blue-grey and Prussian blue.

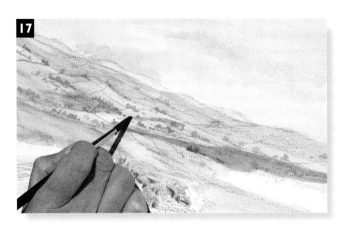

17 The basic washes on the fields are now dry, so I use permanent magenta to put in great swathes of shadows cast by clouds across the landscape.

18 Next I wet the farm buildings, working very carefully and remembering to keep the lighter parts as I drew them …

19 … and then I go into the farmyard and merge the pencil marks there, before letting the whole area dry.

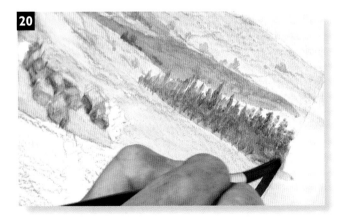

20 For the plantation on the right I make a good strong mix of Hooker's green and blue-grey, taking the colours off the pencils with not a lot of water on the brush. I tap in the tops with the brush point and use the side further down.

21 I use a slightly lighter version of the mix for the tress on the left, and add some cadmium yellow to the green mix for the trees nearest the farm, to add contrast and depth.

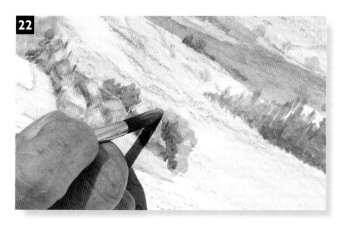

22 For the deciduous trees that border the farm I start with Hooker's green, then add permanent magenta at the base, particularly where the trees meet the buildings. While the green is wet I dab some cadmium yellow into the top parts.

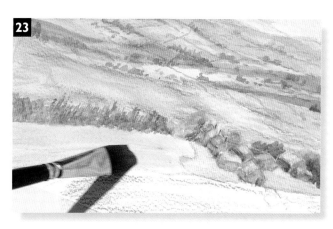

23 Switching back to the flat wash brush, I fill in the foreground fields with big broad strokes of clean water. I take these washes up to the plantation trees, leaving the hedges as white paper.

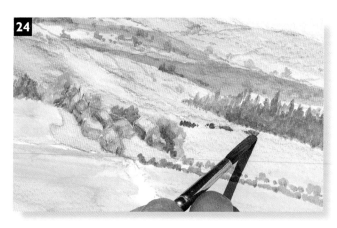

24 I use the No. 8 round brush for the hedgerows, using mixes of Hooker's green, sap green and blue-grey and making sure that the colours are stronger in the foreground than further away. Even as I fill these bits, I leave tiny bits of paper uncoloured to catch the light.

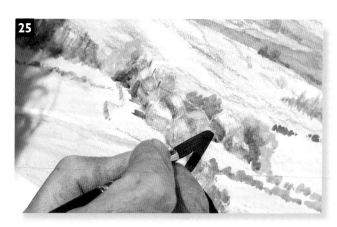

25 I use permanent magenta for the shadows among the buildings, cast by the hedges and, using the wash brush, a great sweep across the foreground – the more shadows, the more light. After filling in the track with blue-grey, I let everything dry.

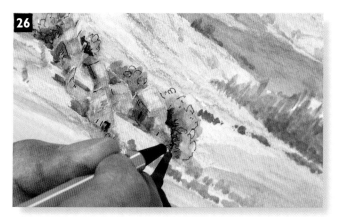

26 By now I'd put a lot of work into this picture and didn't want to 'overcook' it, so I kept the final touches to a minimum: using a fine black fibre-tip pen, I put a few squiggly bits on some trees and tightened up lines on the buildings. What a great result!

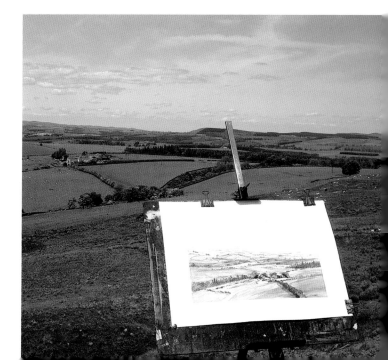

Water & Sky

sketchbook

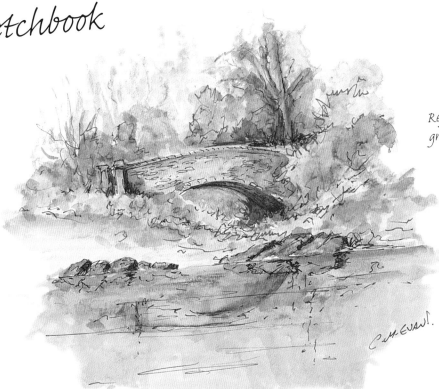

Reflections in still water make great sketchbook subjects.

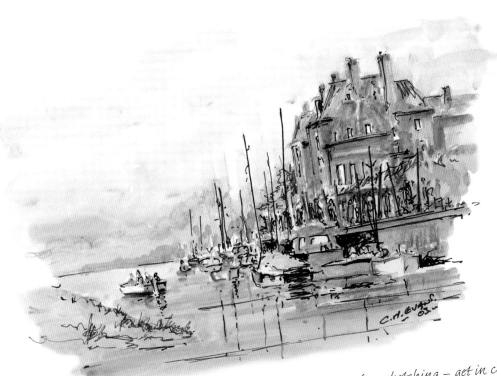

Don't just stick to one position when sketching – get in close or pull back to include more of the surroundings.

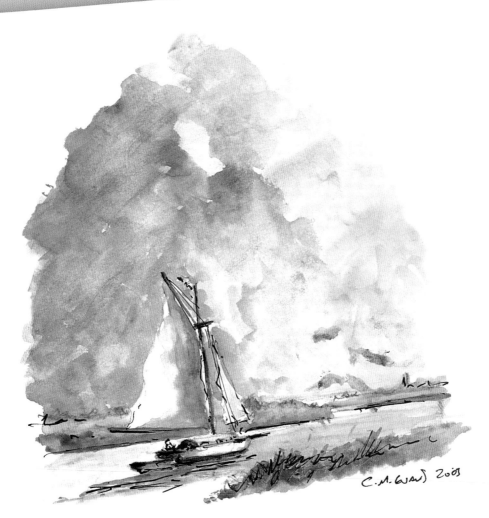

C. M. (WAS) 2003

The sun on the sail makes the
sky behind very dramatic.

Working in monochrome allows me to make more detailed sketches.

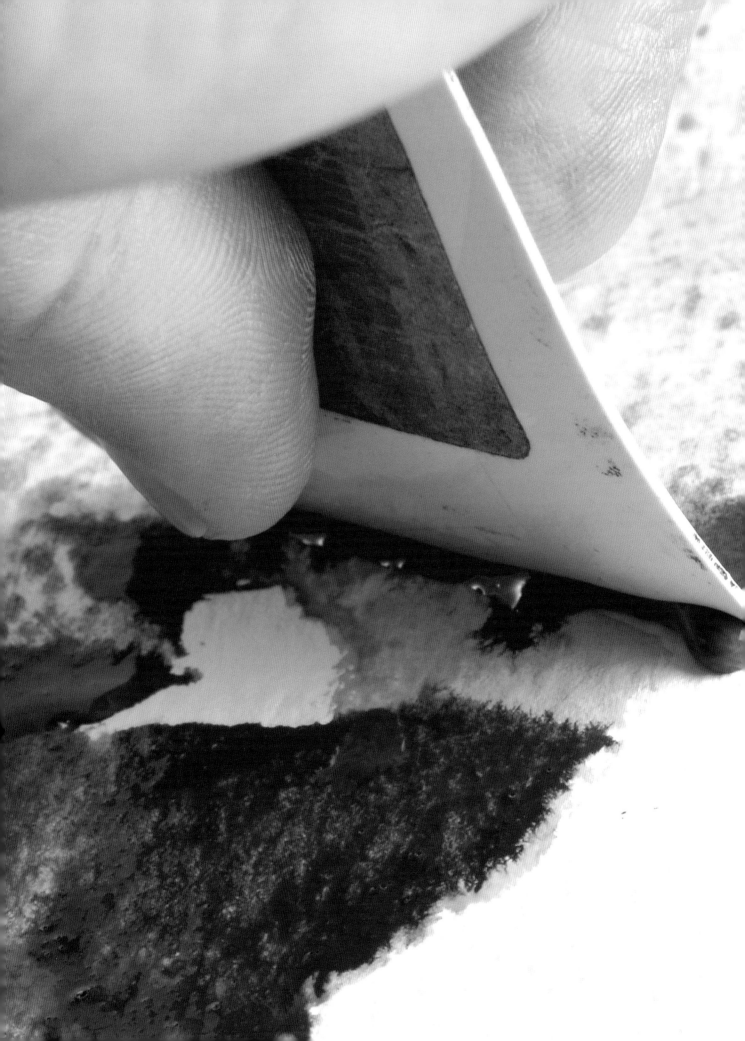

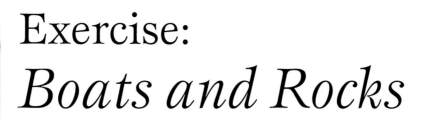

Exercise:
Boats and Rocks

Although you can sometimes get away with a straight view of the sea, with no other features, there will undoubtedly be times when a bit more interest is needed. Here's how.

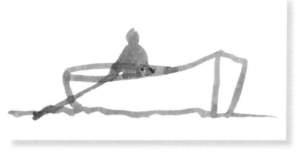

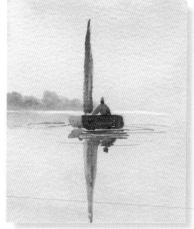

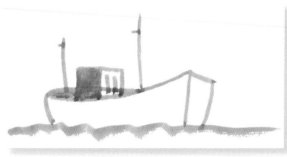

Rowing Boat

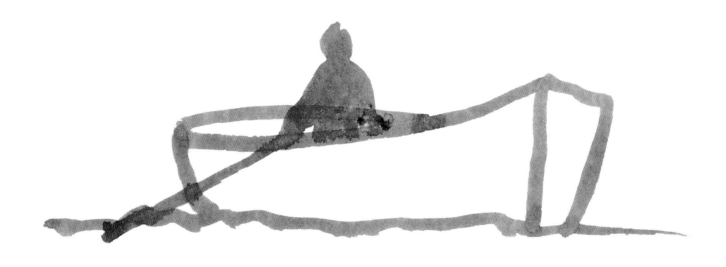

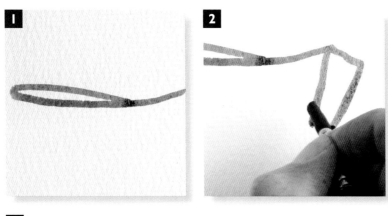

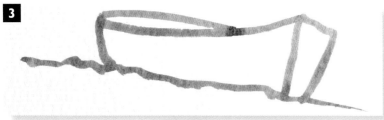

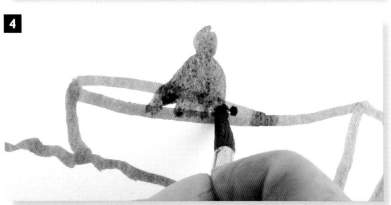

What worries many people is painting the front end – the pointed shape – so they tend to put the boat sideways on. If you use a 'fish shape', it becomes really easy to make a basic boat.

1 Paint most of the shape of a thin fish, but don't finish the lower tail line.

2 At the end, make an irregular rectangle without the bottom line that closes the box.

3 A light, squiggly line to make the sea, and you have an effective simple boat.

4 One round blob for the head, an elongated one for the body and another one for the arm and even an oar, and there's your rowing boat.

Trawler

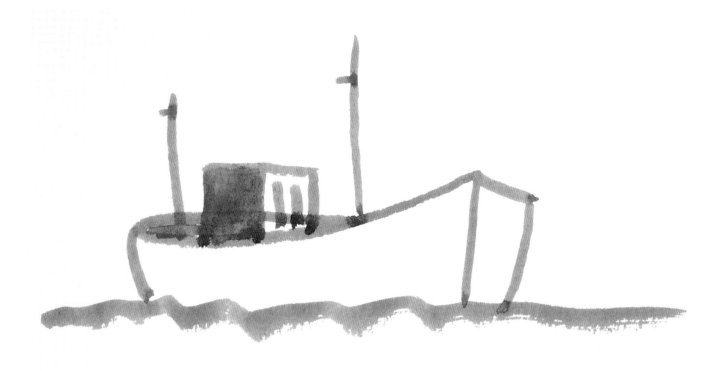

O nce you get used to working with the fish shape to start your boats, you can then expand your repertoire with just a few simple strokes of the brush. Here's a fishing trawler to give you an idea.

1 With one flowing brushstroke, paint the fish shape, this time bringing the 'tail' up and then down at the end corner.

2 Stick a box on top, making sure that the box corners are correct for the angle at which the boat is to your view. Add a couple of simple strokes for windows, block in the box side, then put in a couple of masts and a lapping sea line, and that's the trawler done.

1

2

Boat on a Lake

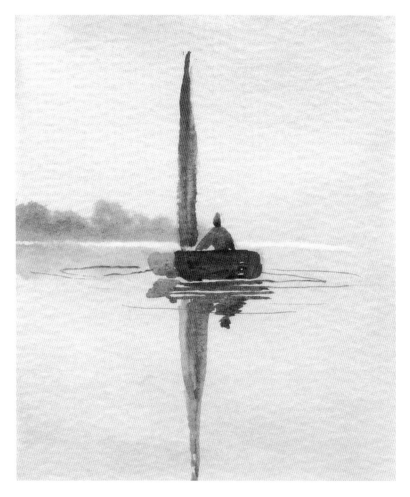

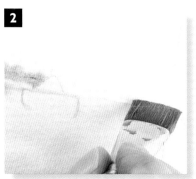

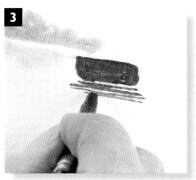

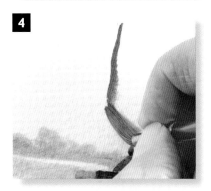

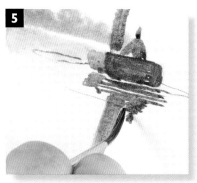

In this exercise, I make the sky and water all in one. There is a bit of drawing to give you some clues: a horizon line (sky and water) with a couple of rounded bits for the boat and a triangle on top for the figure.

1 Wet all the paper, and wash light red across the middle, and a mix of French ultramarine and light red at top and bottom. Draw out the clouds and leave to dry a bit.

2 Drop in a darker version of the mix, stopping at the boat, then draw out a separation line in the middle of the picture and leave to dry fully.

3 Use a fairly strong mix of raw umber and burnt sienna to make burnt umber for the side of the boat, and a lighter version for the sides and reflection, which is in strands, not solid.

4 For the sail, use light red, and repeat underneath lighter for the reflection.

5 Add the shadow side of the sail in a mix of French ultramarine and burnt sienna, darker than the trees, and use the same mix for the reflection and the figure in the boat. Finish with a few ripples.

Rocks

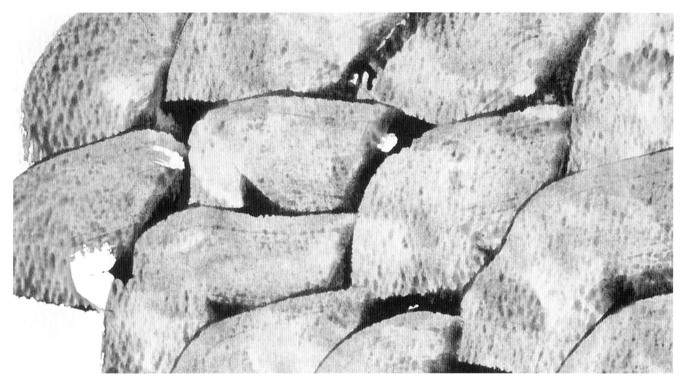

Y̲ou can go into detail when painting rocks, but this takes up a lot of time. My way uses few colours and a credit card – if you want smaller rocks, cut up the card, which will save you money as well!

1 Use a flat wash brush to dab on light marks of yellow ochre.

2 Wash the brush and, while the ochre is wet, add mid-tone colours using raw umber.

3 Make a black from French ultramarine and burnt sienna and add this, leaving some patches of white on the paper.

4 Scrape the credit card over the wet paint to create a clump of individual rocks; don't be loose with the card, but dig it in. And there are your rocks!

Exercise: *Skies*

Whether it's a flat, open prairie or a crowded town scene with high buildings, any landscape needs to have an effective, convincing sky. These exercises show you some quick and clever ways to paint skies.

Fluffy Sky

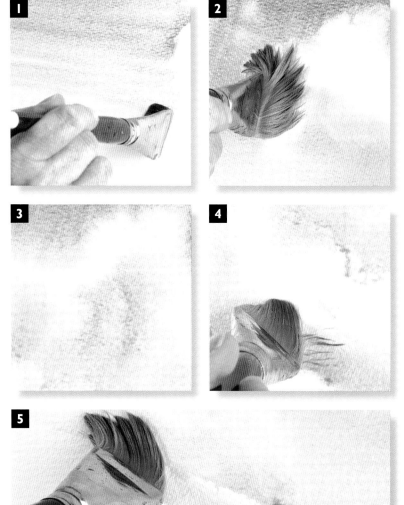

It's important to get this exercise done in less than five minutes – two or three is ideal, as beyond that the paper will start to dry, and taking pigment out of drying paper results in sharp edges.

1 Wet a rectangle of paper with a large flat wash brush, then stroke a watery wash of French ultramarine over the whole piece of paper.

2 Rinse out with water, then squeeze the brush until it's slightly damp, then use it to draw the pigment off the paper to make cloud shapes.

3 For the cloud shadows, drop a very watery mix of French ultramarine and light red into the bases of the clouds.

4 Draw out the pigment as before to soften the edges.

5 Wet the brush with a little clean water and squeeze most of it before mopping out the bottom line. There you go.

Angry Sky

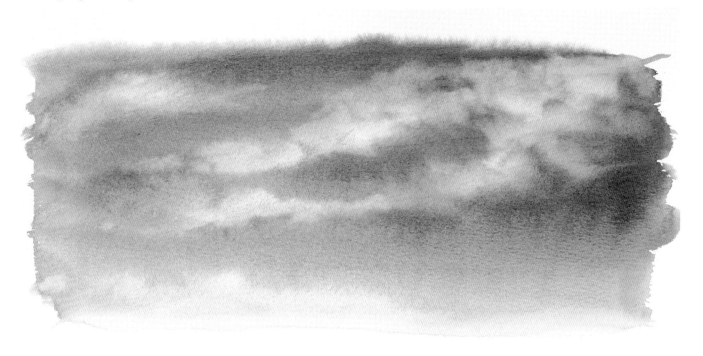

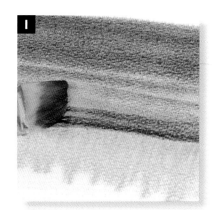

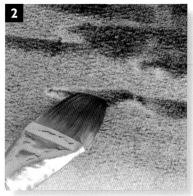

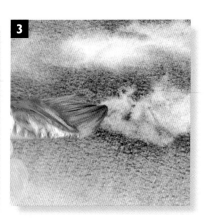

You should run if you see a sky like this!
I use a brush to draw out pigment for two reasons: first, it gives a softer edge than can be got from a piece of kitchen roll or sponge, and second, it means I don't have to carry any extra gear around. Using the brush also leaves some of the underlying colour in place.

1 Using a flat wash brush, wet the entire area and stroke yellow ochre across the bottom third of the paper. Follow this with burnt sienna on the middle third and a mix of French ultramarine and burnt sienna from the top, all the way through the other colours, so as to avoid sharp joining lines – the other colours will still shine through. Remember that the colour when dry will be 50 per cent lighter than when it is applied, so don't worry about going in too dark.

2 Make up another mix of French ultramarine and burnt sienna, with more sienna. Paint this into the sky while the other washes are still wet.

3 Wash and squeeze out the brush, and draw or suck clouds from the wet washes.

Neutral Sky

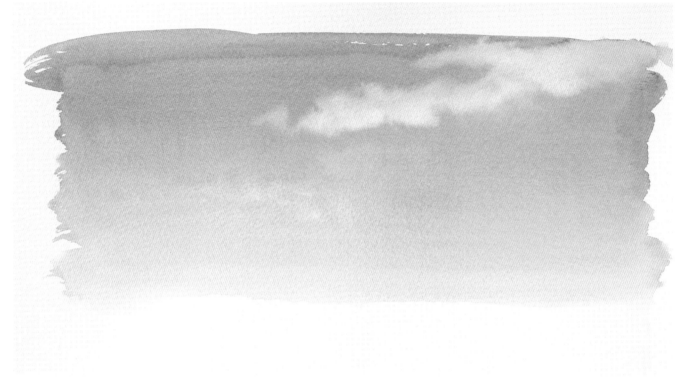

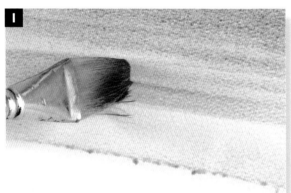

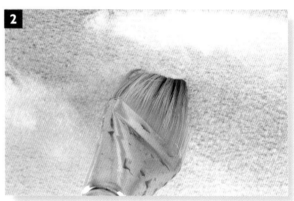

In a way, a neutral sky is almost more of a challenge than the other types seen in these exercises – nothing is happening here, so you need to get what is there down well on the paper.

1 Using a large flat wash brush, wet the paper with clean water and then put a mix of yellow ochre and alizarin crimson across the bottom of the sky. Next, stroke a mix of French ultramarine and light red from the top of the sky all the way down through the first wash; don't stop when the colours meet, but work over so you can see the reddish wash underneath the second one.

2 As for the other exercises, wash and squeeze out the brush and draw out the pigment at the top, to give an impression of a quiet sky with few clouds.

Sunset Sky

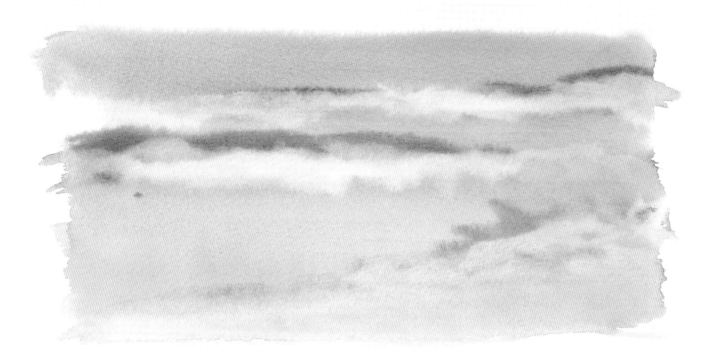

Here's a tip: in a sunset sky the sun has already gone over the horizon, so you should take the pigment out from underneath the clouds.

1 After wetting the paper, put a stroke of yellow ochre across the bottom and another in the middle. Add some light red – this is a powerful colour, so be careful when you use it.

2 Start painting a mix of French ultramarine and burnt sienna from the top, but leave little bits of underlying colour showing to provide the sunset glow.

3 Add more burnt sienna to the mix to darken it, and put in a few sharp bits of darker cloud.

4 Use a cleaned brush to draw out the cloud shapes.

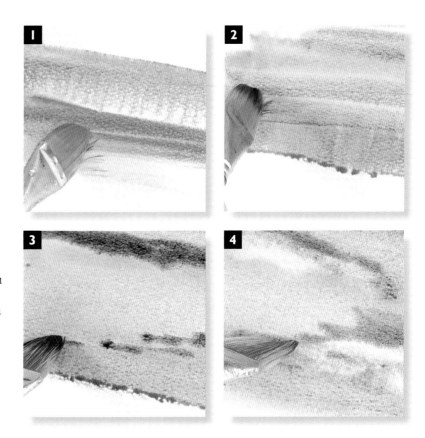

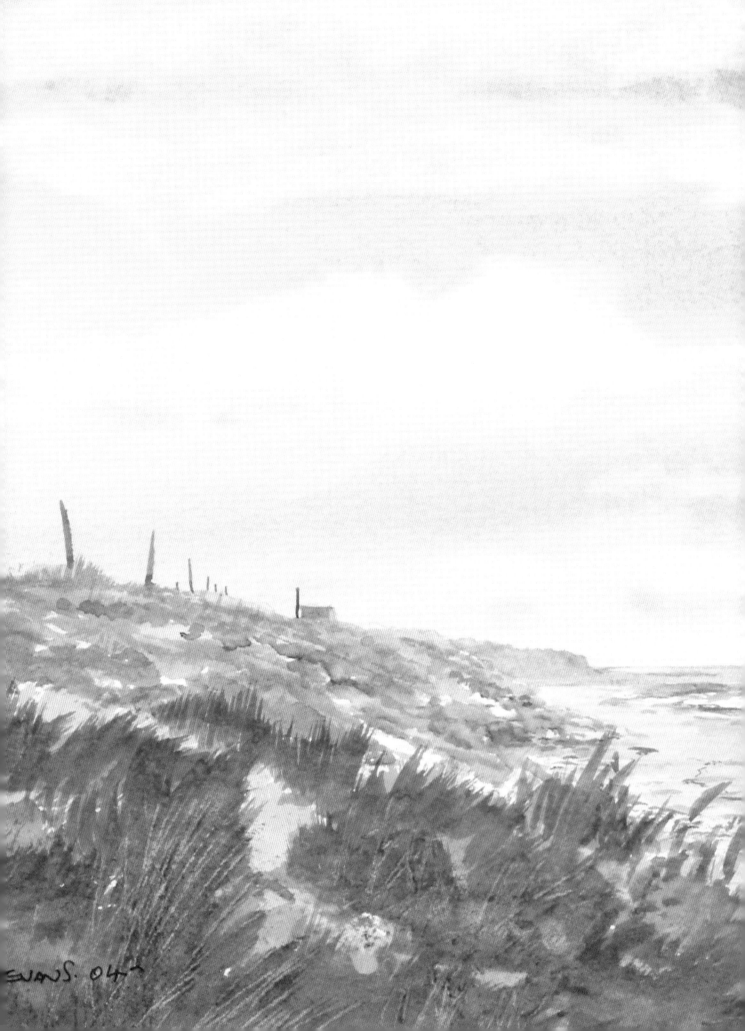

Project:
Seascape

The combination of open sea and big sky is an irresistible one. You don't need to work on details here, but can concentrate on getting the mood.

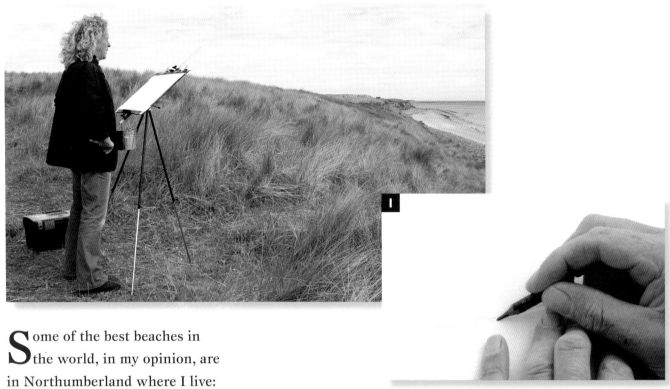

S ome of the best beaches in the world, in my opinion, are in Northumberland where I live: beautiful and uncluttered. Even if it's a bit cold and windy, a day where the light is not too bright is perfect for painting, as you can see what you're doing – on a glorious sunny day, you can't see anything for the brilliant white paper.

1 The most important line is the sea line: this doesn't have to be perfectly straight, but it mustn't be wobbly. To get a straight line, I draw against another piece of paper – no problem!

2 I use seawater to wet the sky area with a 1½ in wash brush, and then apply a wash of alizarin crimson and yellow ochre at the base, then French ultramarine above, blending the paint together.

3 After washing out the brush and squeezing out the water, I use it to suck out the paint along the bottom line and take off the paint for the clouds. The idea here is to work fast before the paint dries, and to sum up the feel of the sky, not chase the clouds – they'll always win.

4 In the sky I drop in some French ultramarine mixed with a little light red for more clouds, then rinse and squeeze the brush again and use it to take out the excess at the bottom. I now let the painting dry; any flies that get stuck to it can become birds in the picture later!

5 When everything is completely dry, I start on the sand dunes on the distant headland, putting on a mix of French ultramarine and light red loosely with a No. 8 round brush.

6 While this wash is still wet, I add a tiny bit of yellow ochre below it.

7 I clean the brush in water, squeeze it until it's just a bit damp and quickly merge the two washes together to create a nice soft edge.

8 I put in a weakish wash of yellow ochre for the next hill on the left.

9 While this wash is still wet, I drop in a mix of Hooker's green and yellow ochre so that the colours merge, leaving no hard edges. I then add slightly weaker mixes further into the distance.

10 I use French ultramarine with a tiny bit of light red for the distant building – which is an old coastal defence bunker – putting more water into the mix for the side edge and making it darker in the shadows. I then let everything dry completely.

Project: *Seascape* 83

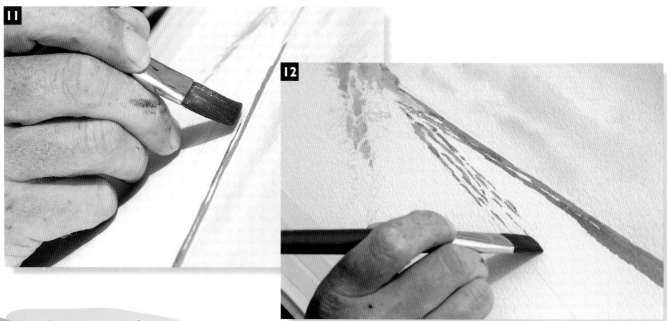

top tip

Whenever you need to
let washes dry before
continuing, use the time to
change the seawater in your
bucket – the walk will do you
good, and you can come back
to look at the painting again
with a fresh eye.

11 Now it's time to start the sea, using my Charles Evans British sea colour (see page 11) – this can be used as a base colour for mixes, but today I'm using it as it comes. Switching back to the ¾in wash brush, I start with the horizon line.

12 As I get nearer to the headland and beach, I just tap the brush on to the paper, then add a few squiggly lines the closer I get to shore. At this stage I leave a lot of white paper between the brush marks for highlights.

13 As before, I wash and squeeze out the brush to pull out paint for the ripples in the waves, and let the painting dry again.

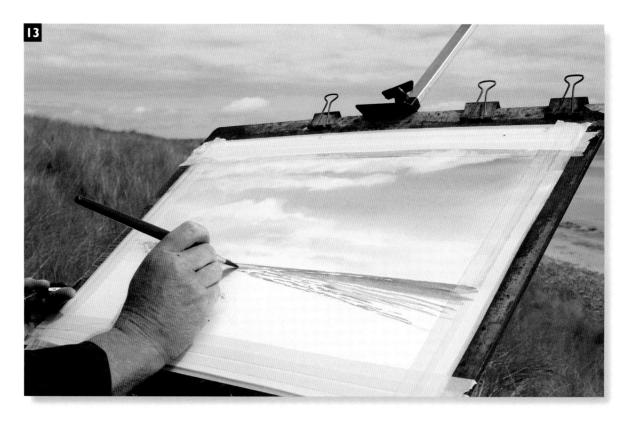

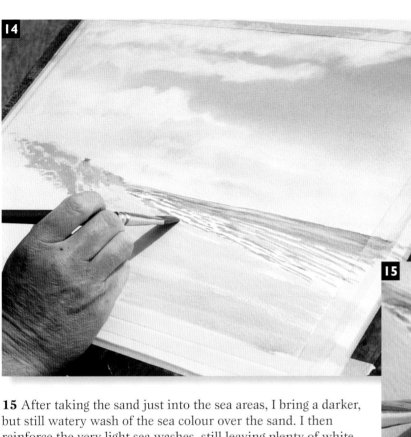

14 With everything dry, I make up a mix of the Charles Evans sand colour – this is also a useful colour for lightening mixes, while not being opaque like white paint. This time I use it as a base colour, adding a little French ultramarine and a lot of water, then make wide strokes to block in the basic colour of the sand. (On warmer beaches, I might use tiny amounts of yellow ochre or burnt sienna.)

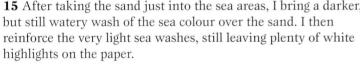

15 After taking the sand just into the sea areas, I bring a darker, but still watery wash of the sea colour over the sand. I then reinforce the very light sea washes, still leaving plenty of white highlights on the paper.

16 Switching to the No. 8 round brush, I mix the sand colour with some raw umber for the stones in the middle distance – I'm not trying to paint every single one, but to give an impression of the lines and shapes of the stones.

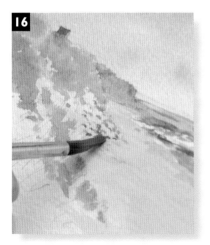
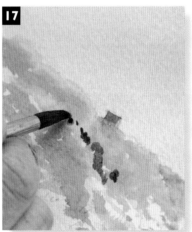

17 I use a mix of French ultramarine with a little light red and plenty of water to paint some dips and gullies in the sand dunes among the grasses. As in any painting, these darker touches make the most of the lighter areas around them.

18 For the smaller touches on the beach – the darker patches of sand, strands of seaweed, stones and pebbles – I use a darkish mix of French ultramarine and burnt sienna.

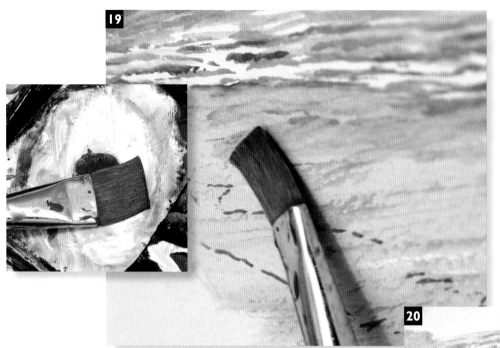

19 Using the same mix as for step 18, only this time going back to the ¾ in flat wash brush, I lightly brush over the surface of the paper to create a sparkling texture on the sand.

20 Switching back to the No. 8 round brush, I then add some more dark areas in the sea and along the shore line.

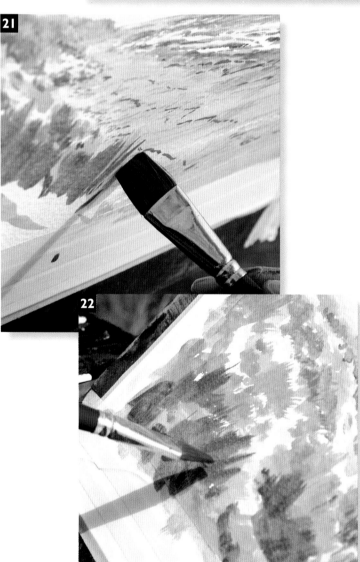

21 I now make up a warmish mix of the Charles Evans sea colour and yellow ochre, and paint this into the nearest sand dunes with the ¾ in flat brush. I flick the brush up to go into the darkest areas here, and then use a mix of Hooker's green and yellow ochre in the same area – again, I flick up into the yellow for tall, windswept grasses, being careful to leave white highlights.

22 In the foreground I paint on a mix of Hooker's green and burnt sienna – because the colours will dry up to 50 per cent lighter than when applied, I use quite a strong mix.

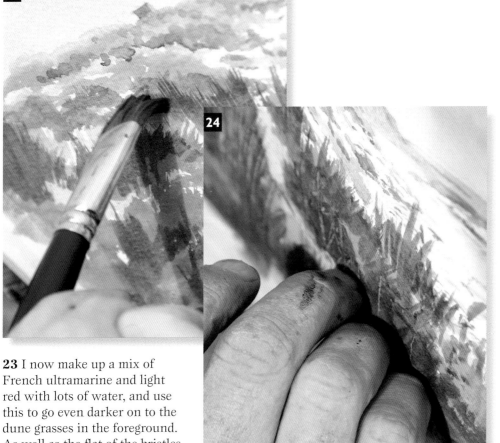

23 I now make up a mix of French ultramarine and light red with lots of water, and use this to go even darker on to the dune grasses in the foreground. As well as the flat of the bristles, I use the side of the brush to get the effects I want – it's worth experimenting with all angles and all parts of the brush to see what you can do.

24 While the wash is still wet. I scratch into the paint with my fingernails to give the impression of light and stalks without trying to get in every single one.

25 Using the mixture from step 23, I switch to a No. 3 rigger brush to put a few seagulls in the sky and a few vertical marks in the far distance, making sure that these are smaller the further away they are. I finish by taking off the tape – and there's the painting!

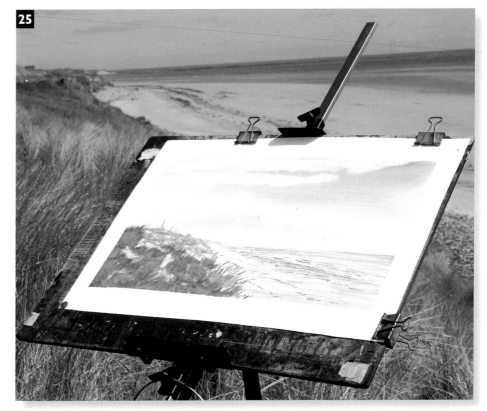

Project: *Lake*

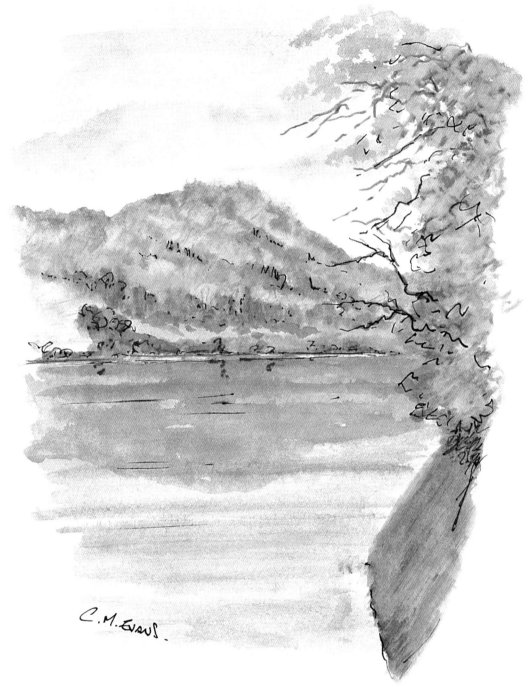

C. M. EVANS.

Although this is a landscape, I decided to do it in a portrait format because it's a lake scene and I want to see a lot of lake! To frame the lake I put a bit of land in the foreground and added some bushy bits above it.

1 I start by filling in part of the hillside with Hooker's green; I don't want too much of a block of colour, so don't press too hard with the pencil. Detail isn't needed at this stage, so I don't put in tree shapes.

2 To add variety to the hillside I follow the green with more strokes in cadmium yellow, then orange and then yellow ochre. It's beginning to look rather messy …

3 … and looks more so when I put in a few touches of olive green to give some variation to the darker Hooker's green. But even with all these colours I make sure not to shade in everywhere, as this bit is in the distance.

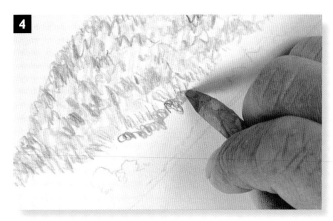

4 To give more of the cool feeling of distance, I drop in some Prussian blue towards the hilltop and then some blue-grey behind the more distinct trees at the bottom. I block in these trees with long strokes and rounded short ones, pressing harder with the Hooker's green.

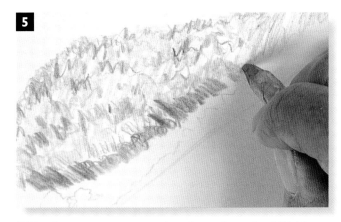

5 For the grassy areas coming down from the hillside to the lake I use a brighter green, viridian. Now it looks even messier, though admittedly quite pretty.

top tip

As in this project, don't be hidebound by the format of the paper – if you want to do a landscape view in portrait format, just do it!

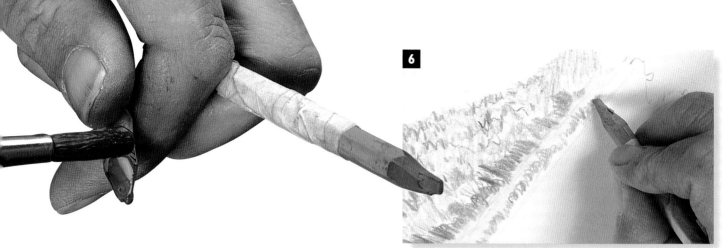

6 A few touches of yellow ochre represent some sharper, bushy bits on the lake side of the hillside, and I reinforce these with viridian. This is usually the stage where I don't want anyone to look at the picture – but I know what is going to happen next …

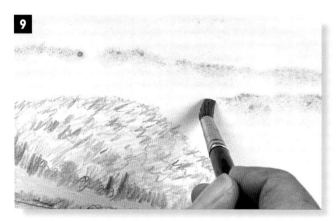

7 … and that is, that I touch in Mars black as lightly as I can along the very base of the hillside.

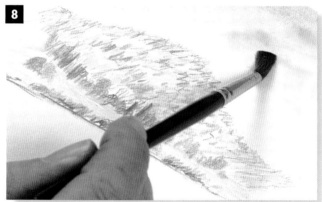

8 Now it's time to concentrate on the sky. I don't want to make it too bright at first, so I stroke some Prussian blue off a pencil with a No. 8 round brush and plenty of clean water (see top left), and spread it quickly on to the paper.

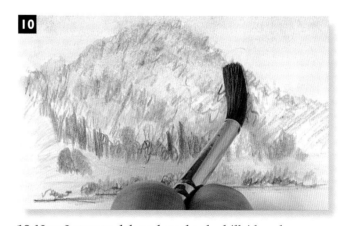

9 While this wash is wet, I put in more detail in the same way, using the same technique to put in rounded, shorter marks of blue-grey with the brush.

10 Now I start to dab and stroke the hillside colours with clean water, gradually merging them together and making the drawing into a painting in one go. The idea is not to make anything in the hillside too sharp or overpowering.

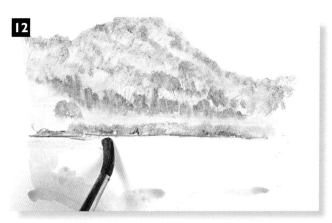

11 Again while the hill is wet, I tap a few bits of blue-grey from the brush on to the hillside to shape it and indicate its contours and the direction of the slopes. The colours soften on the wet wash and add a feeling of distance.

12 I don't want to repeat every single shape and colour of the hill in the reflection in the water, so I keep to the main colours and shapes. I start by brushing Hooker's green off the pencil for the main hill shape …

13 … and tap in some yellow ochre while the green is wet. This leads to a lovely merging of the colours. The all-important blue-grey gives the shapes of the contours and tree lines. This is not the colour of the water, but the reflection in it.

14 While the reflection wash is drying I touch in a few scribbles to represent leafier parts over the dry sky area; I just tap some viridian off the end of the pencil …

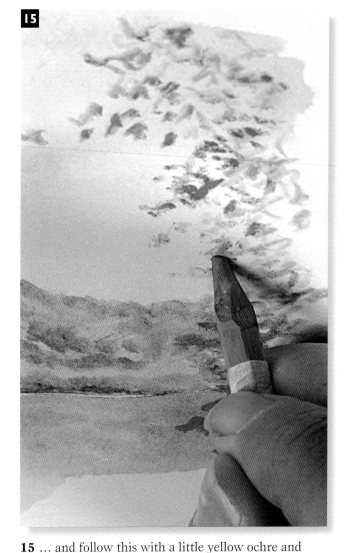

15 … and follow this with a little yellow ochre and cadmium yellow to give no more than an impression of foliage: the leaves and bushy parts are something to look through into the distance, not a solid mass, so I apply them sparingly.

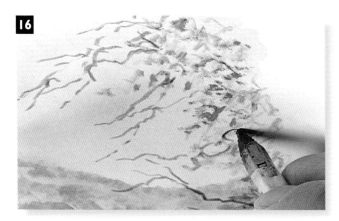

16 Next I put on a few lines of Mars black – I intend these not to be wetted with a brush, as they are to represent the harder lines of twigs and branches in among the bushy bits.

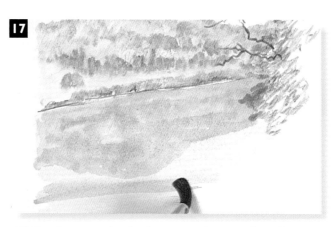

17 For the water in the foreground, I start by taking Prussian blue off the pencil with the brush and washing it all over the dry reflections – this doesn't disturb them, but makes everything blend together as one stretch of water. And there we have a lake!

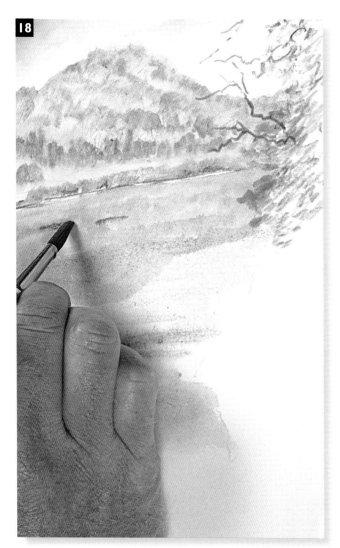

18 While the Prussian blue wash is wet, I put a few touches of blue-grey here and there in the reflections to give some darker shapes that add interest …

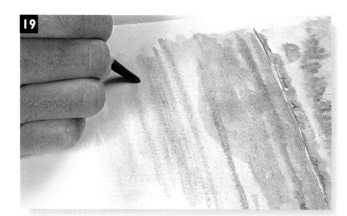

19 … and then carry on into the foreground area of the water, using different strengths of the blue-grey shade in long, horizontal strokes as I go.

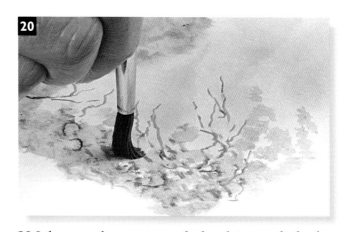

20 I then use clean water on the brush to wet the bushy parts, tapping with the brush tip – not everywhere, as I leave the black twigs and some of the pencil marks as hand drawing to contrast with the merged areas.

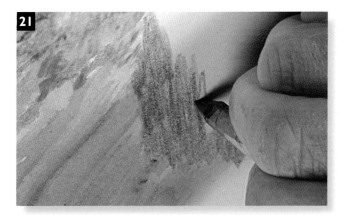

21 I tackle the bank in the right foreground next: I use Hooker's green and sap green for the most part and make the marks work by drawing the bank in the direction of the shape I want. A bit of yellow ochre comes next in an attempt to capture the light …

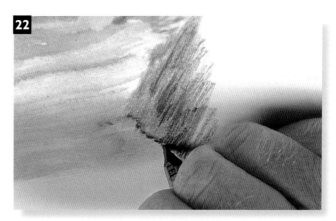

22 … and I finish this part of the drawing with Prussian blue, using it to make the margin with the water's edge, and also, stroking it on more lightly, to darken the bank.

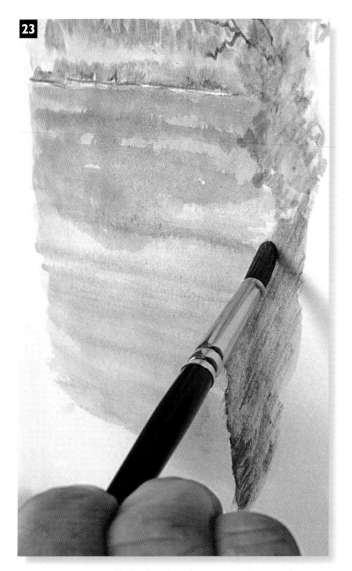

23 I next merge all the bank colours together with a clean wet brush, using the wet-into-wet technique as I go over the pencil marks. I work in the direction of the pencil strokes to keep the feeling of direction and shape.

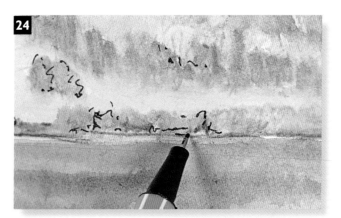

24 Switching to a fine fibre-tip pen, I put in a few squiggly marks to denote some tree and bush lines in the hillside and the bushy bits on the right side, plus a few lines on the lake. The pen is merely a backup to help highlight a few areas, and I make sure that it doesn't take over the picture.

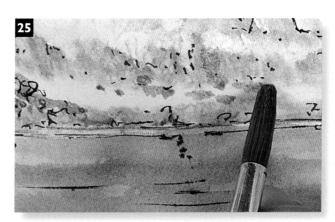

25 The final stage is to take some permanent magenta off the pencil with the brush and drop in some of this shadow colour among the bushes and trees. Now, you have to admit it – aren't lakes simple to paint?

Project:
Water Scene

This peaceful little scene is very quick and easy to do: all you need is a box of watercolour pencils, a brush, some water and a pen to finish off.

I have owned my tin of 24 Derwent watercolour pencils for over six years now, and I am still using all the original pencils – so this is a pretty economical way to work! (It also helps that I use a sharp knife for sharpening, not a pencil sharpener, which eats any pencil quickly.) For this project I start with gunmetal grey for the very simple outline; unlike a standard pencil, with watercolour pencil the lines disappear when water is applied, so all I am doing at this point is providing a few guiding lines.

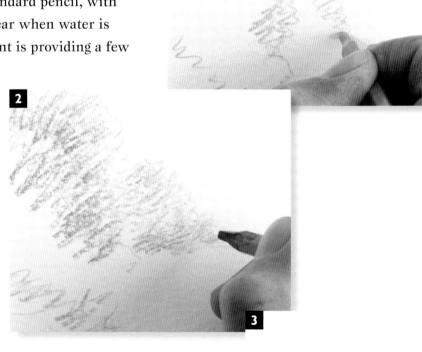

1 Inside the tree outlines, I add a little bit of brown ochre, just colouring in like a child's drawing and capturing light here and there by leaving patches of white paper.

2 Now I continue this colouring in with dark green, going over the ochre in places.

3 With watercolour pencils, the harder they are pressed, the stronger the colour they provide, so I get a feeling of recession by lightening the pressure as I go.

4 Moving on to the distant bank, I put in a tiny touch of purple, using nice light strokes above a very sparse line of brown ochre. I'm making no attempt to keep the lines straight, but looking for bumps.

5 Going back to the first area, I put blue-grey marks across the other colours.

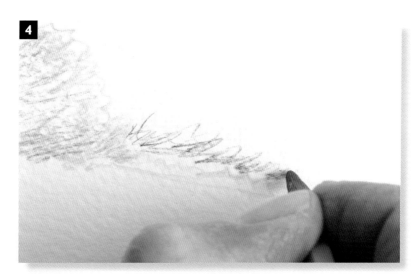

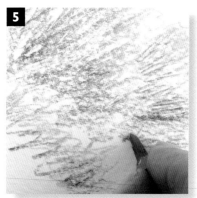

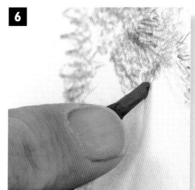

6 With watercolour paints, I use Hooker's green; with watercolour pencils, I put the colours on top of each other – first the blue …

7 … and then the yellow. It may not be green yet, but just hang on.

8 Right – that's the main bit of drawing done. Now it's time for the magic!

9 For a large area of one colour, scratching and then wetting pencil lines doesn't give a very smooth result, so with a No. 8 round brush and clean water, I stroke Prussian blue off the pencil and start to make washes for the sky. Some people call this a graduated wash – I say whack it on!

10 Now I rinse the brush and stroke some blue-grey off the pencil to add clouds; and there's a quick and clever way to make a watercolour pencil sky.

11 For the rest of the painting where there are pencil marks, I simply go over the marks with a clean brush and merge the colours together.

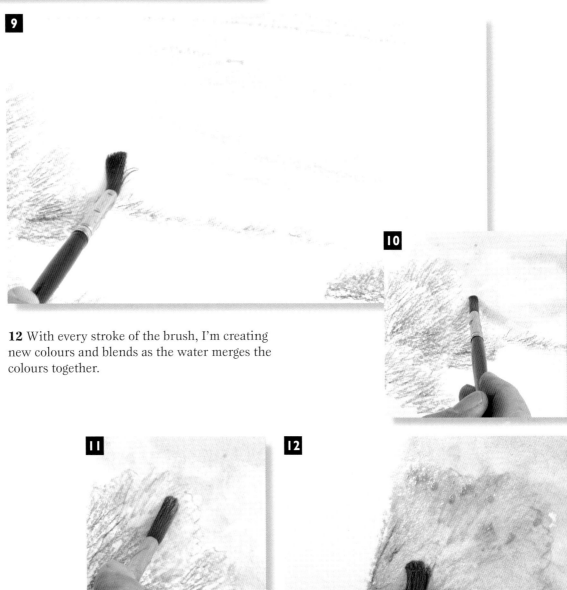

12 With every stroke of the brush, I'm creating new colours and blends as the water merges the colours together.

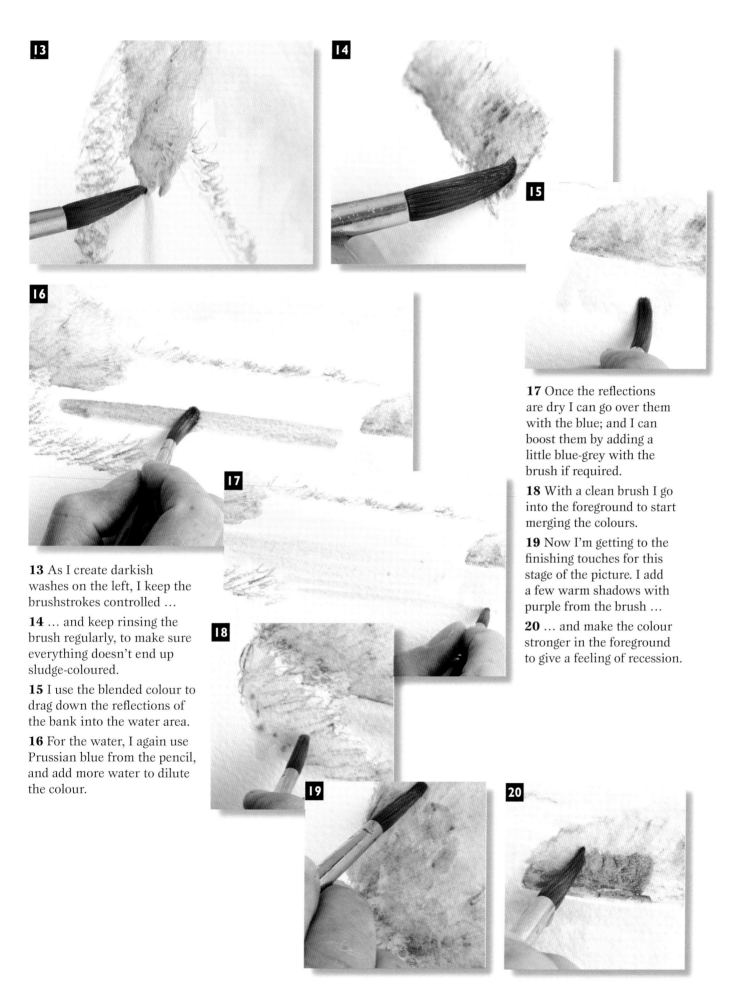

13 As I create darkish washes on the left, I keep the brushstrokes controlled …

14 … and keep rinsing the brush regularly, to make sure everything doesn't end up sludge-coloured.

15 I use the blended colour to drag down the reflections of the bank into the water area.

16 For the water, I again use Prussian blue from the pencil, and add more water to dilute the colour.

17 Once the reflections are dry I can go over them with the blue; and I can boost them by adding a little blue-grey with the brush if required.

18 With a clean brush I go into the foreground to start merging the colours.

19 Now I'm getting to the finishing touches for this stage of the picture. I add a few warm shadows with purple from the brush …

20 … and make the colour stronger in the foreground to give a feeling of recession.

Project: *Water Scene* 99

21 I take a short break at this point, to let everything dry completely and to look at the overall picture. Working with the pencils again, next I add some squiggly lines for the foreground grass, using dark green.

22 I then repeat the strokes with blue-grey, both creating lines in new areas and going over some of the green ones.

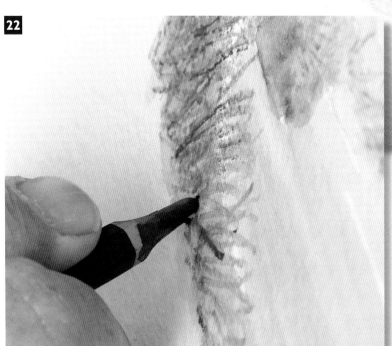

23 To repeat some of the shapes of the land in the water, I take first dark green and then blue-grey off the pencils with the brush and use this to create the darkish reflections.

24 I use the same colours on the other side of the picture, being careful to echo only the darkest shadows on the bank.

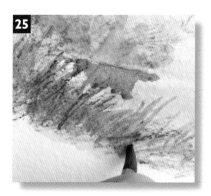

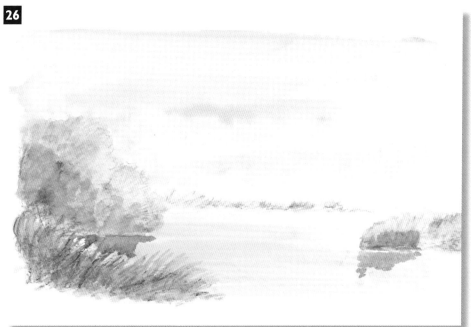

25 To match the reflections, I add a few more dark green grasses with the pencil.

26 And there we have a very simple watercolour pencil and wash painting – but I feel it needs a little more definition here and there.

27 When everything is completely dry, I use a thin-nibbed green gel pen to add just a few squiggly lines to pull out the areas I want to stand out.

28 What I'm not doing here is line-and-wash work – this is purely to add a tiny, but important, amount of emphasis.

29 Moving to the right-hand bank I add a few more lines, then switch to black pen for the foreground grasses – and that's the finished painting.

Project: *Boats in Harbour*

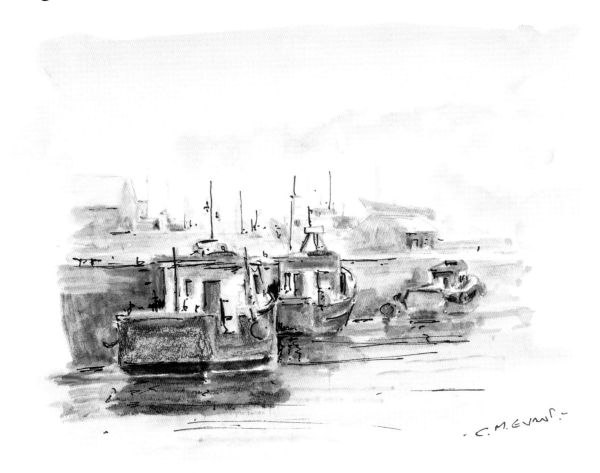

Harbours can look rather complex, but try to concentrate on the boats
and not get pulled into all the other things in the scene. In the distance,
the boatyard can be an impression of blocks with verticals for masts.

top tip

Use a hardback
sketchbook for this project,
as it will stand any amount
of hammering on location
and in transit, and because
it is properly string-bound,
you won't lose your valuable
sketches and artworks.

1 I start by filling in the nearest boat with cadmium red, just like in a child's drawing. As with any pencil work, the harder you press, the darker it gets – with watercolour pencils, the more pigment that is pushed into the paper, the stronger the tone will be.

2 For the boat on the right I use a light blue pencil; throughout this drawing part of the project I'm leaving the white of the paper to stand for the white parts of the picture.

3 A touch of light red is useful for the waterline of the blue boat. Next I switch to Vandyke brown for the doorways of the boats.

4 I then apply a touch of blue-grey for the windows.

5 The initial drawing was done in a light gunmetal grey, and I return to this colour to put in the various bits of fishing gear on the boats. Don't be tempted to overdo this because too much detail will spoil the picture.

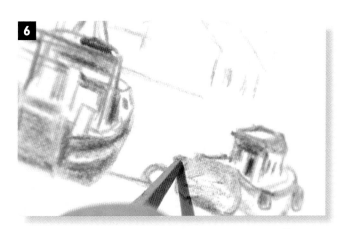

6 For the buffers at the tops of the boats I use yellow ochre, and then apply orange for the buoys, going over this with cadmium red. At no point do I go into too much detail with the pencils – I'm just looking to achieve an impression of the colours and the shapes.

7 I keep to this lack of detail when I add a few buildings in the background, otherwise they might come too far forwards in the picture. For this I use raw umber, and I make very light strokes for the harbour wall using the same colour.

8 I go over the harbour wall again, this time with an equally light application of blue-grey; however, I press down hard at the base of the wall to make a stronger tone and indicate the shadows cast there by the boats.

9 Don't forget that water has reflections of what's on it. Here I'm not going into any details of the boats, just repeating the colours in blocks for now.

10 For the base of the main boat I use strong strokes of Mars black, and then go on to add this colour to all the boats and the reflections on the water.

11 Now it's time for a sky wash. I use a No. 8 round brush and clean water to lift the pigment off a Prussian blue pencil and paint on the sky swiftly.

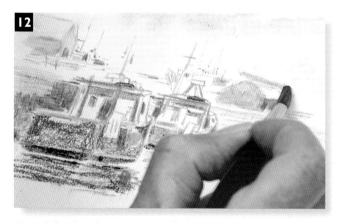

12 While the sky wash is still damp I clean the brush and take it over the distant buildings and make them merge into the general mêlée of the background.

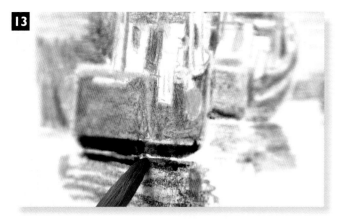

13 Once more wetting the brush with clean water, I start to stroke it on to the colour of the boats – and suddenly the drawing becomes a painting! I make sure to take the colours down into the reflections as well, wetting each section in this way.

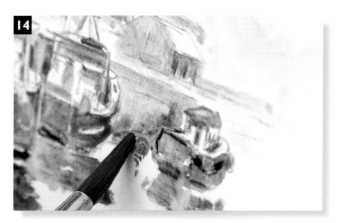

14 Now I move on to the all-important shadow cast by the boats on the harbour wall, making this strong and dark, while leaving little bits of white paper showing, to capture the light between the boats and the wall.

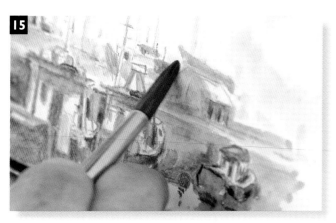

15 Recharging the brush with clean water, I go over the marks for the bits of 'gubbins' (a technical term used by all seafarers!) on the tops of the boats.

16 For the sea, I take the pigment off the blue-grey pencil and stroke the wash over the reflections of the boats, glazing the colours together to give a watery impression. I strengthen the colour here and there to indicate ripples.

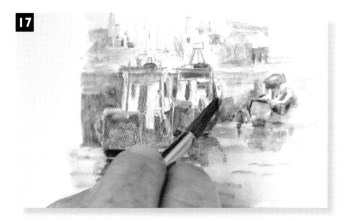

17 I use the same technique for the shadows on the harbour wall, and add a few areas of shadow here and there on parts of the masts and buoys. With the washes finished, I then let it all dry completely. While it's drying I take the time to look at the picture to see where I feel it needs the addition of a few finishing touches.

18 To finish, I apply a few fibre-tip pen lines to sharpen up the harder lines and pull things together, but without including too much detail or too many extraneous features – any pen will do, as long as it doesn't make blots. And there it is: the harbour with a traditional Northumbrian cobble (pronounced 'coh-ble') fishing boat in the foreground.

Buildings

sketchbook

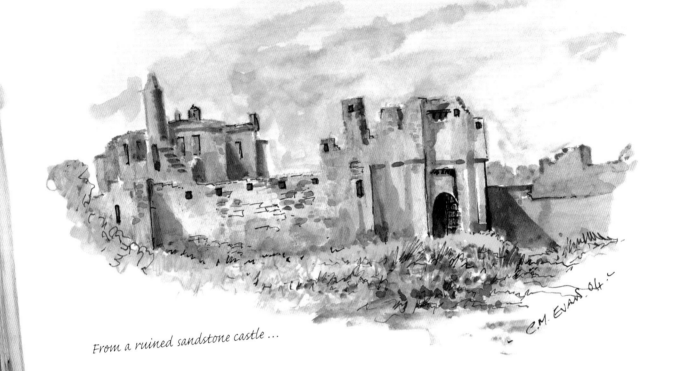

From a ruined sandstone castle ...

... to a detailed doorway in shadow ...

... and from somewhere really quite well-known

... to somewhere quite secluded, there is always something to sketch.

Exercise: *Buildings*

Buildings can give a sense of scale to landscapes and are a great focal point in any watercolour painting. The quick exercises here show you how to slap on paint for a good result.

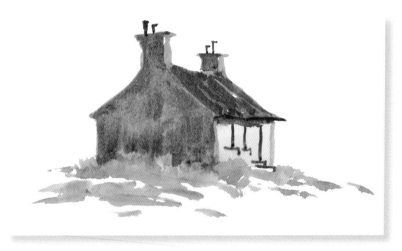

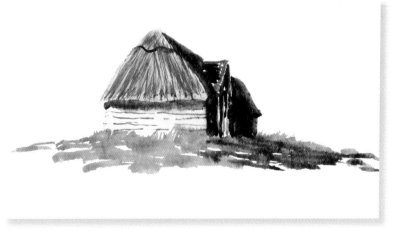

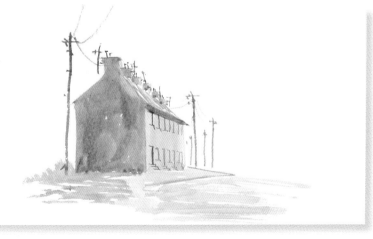

Cottage

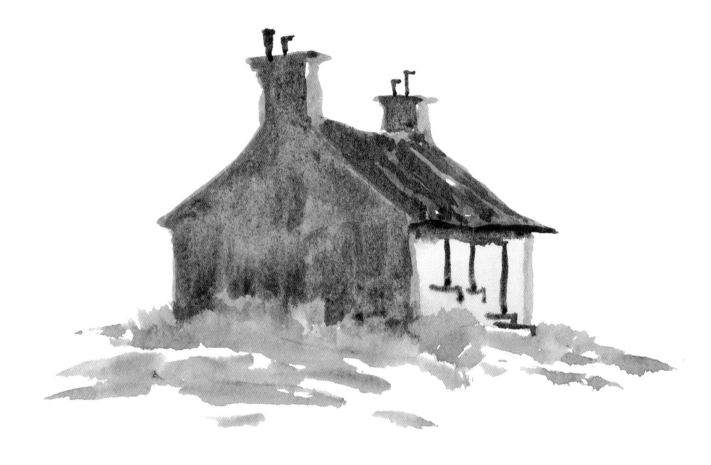

A very simple building to make a start with is a single small cottage on moorland. The whole building can be done with just one brush.

1 Using a No. 8 round brush, paint the closest end of the building, far chimney and one sloping roof line in raw umber.

2 Make a light mix of French ultramarine and burnt sienna, and use this to make the two horizontal roof lines – and there's the building shape.

3 With a slightly darker blue mix, block in the roof, leaving a few white gaps.

4 While this is drying, fill in the nearest wall with a strong wash of raw umber.

5 The other visible wall is lighter than the near one, and for this use a very watery raw umber wash.

6 Now the roof is dry, make up a third, darker mix of French ultramarine and burnt sienna, and go over parts of the roof, following the slope.

7 When the light wall is dry, use a very dark mix of French ultramarine and burnt sienna and make a tick mark for the window, plus one for the ledge.

8 Finish all the windows and do the door in the same way, then use more ticks for the chimneys. A little Hooker's green and raw umber applied with a flat brush for the grass, and there's the cottage.

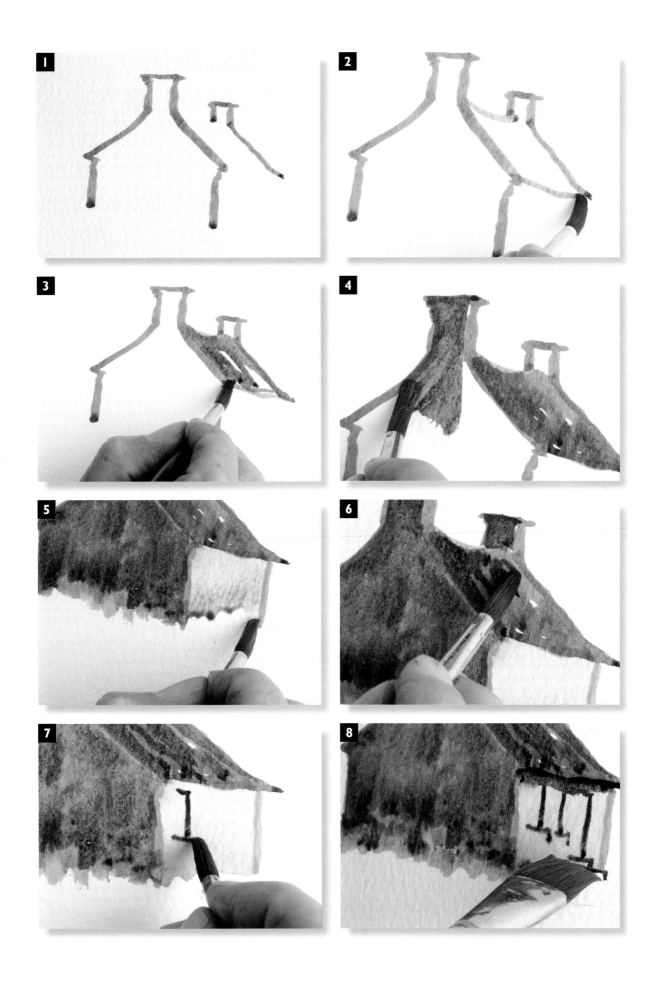

Thatched Barn

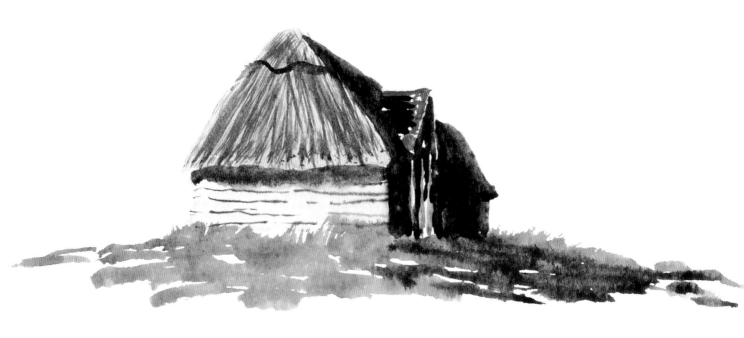

Thatched buildings don't have sharp edges and straight lines – the character is in the unevenness, and you only need to give an impression of the thatch itself.

1 Using a gunmetal grey watercolour pencil draw a simple outline – the 'point' of the roof is actually round.

2 Use a No. 8 round brush and yellow ochre to block in the near side of the thatch, then use burnt sienna to drop in the highlighted parts of the front. Then use a black mix of French ultramarine and burnt sienna to paint the shadowed front roof.

3 With the same mix fill in the shadowed parts of the front, including the windows.

4 Now smash the brush into a watered-down mix of raw umber, splitting the hairs, and stroke it on to the dry ochre, and follow it with a watery mix of the black.

5 For the side of the barn, add more French ultramarine to the black mix with a lot of water.

6 Use the full-strength mix and a No. 3 rigger brush to paint the thatch tie across the roof, which shouldn't be a straight line.

7 For a few lines to suggest the planks at the side, use the same mix and brush.

8 To finish, go back to the round brush and a light black mix for the roof shadow. A last bit of green with the shadow of the barn, and that's it done.

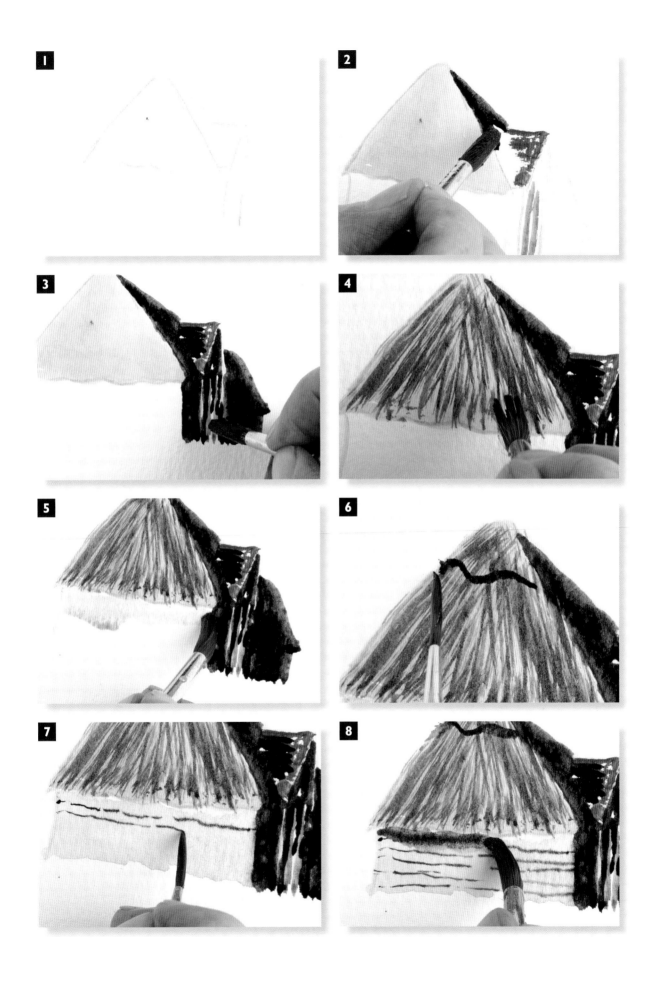

Row of Houses

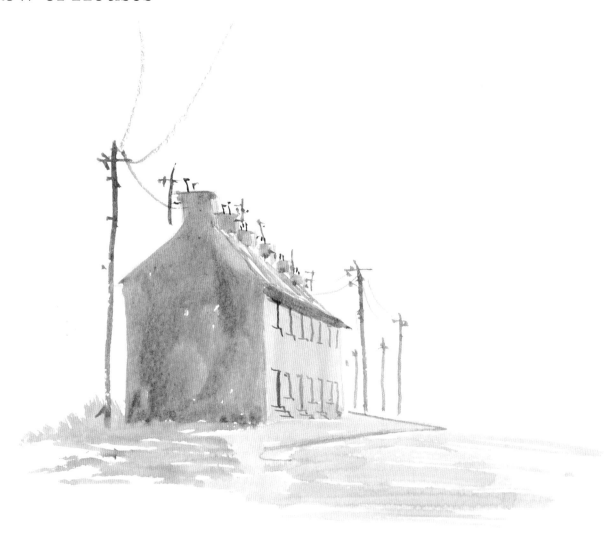

For a row or terrace of houses, the rules are the same as for the single cottage on pages 110–111, but you have to make sure the chimneys, windows and doors match up.

1 Start by drawing the end of the nearest house with a gunmetal grey pencil.

2 After extending the bottom of the roof line and adding the far wall end, draw in the chimneys, making each one smaller as it goes away. Then block in the end wall with raw umber and a No. 8 round brush.

3 Next touch in the near side of the chimney sides with the same mix.

4 Use a watered-down version of the umber for the front of the buildings, then use a light mix of French ultramarine and burnt sienna for the roof slope, leaving white gaps.

5 Switching to a No. 3 rigger brush, use a black mix of French ultramarine and burnt sienna for the chimney pots, painting them with ticks.

6 As for the single cottage, use ticks to paint in the windows.

7 Then add more windows and doors, this time adding steps to the doors with a further series of ticks.

8 For the final touches, put in the television aerials and telegraph poles and wires with a light version of the roof blue, and use the same mix for the roof shadow. A bit of grass by the side, and some watered umber and blue mix in front of the houses, and you're there.

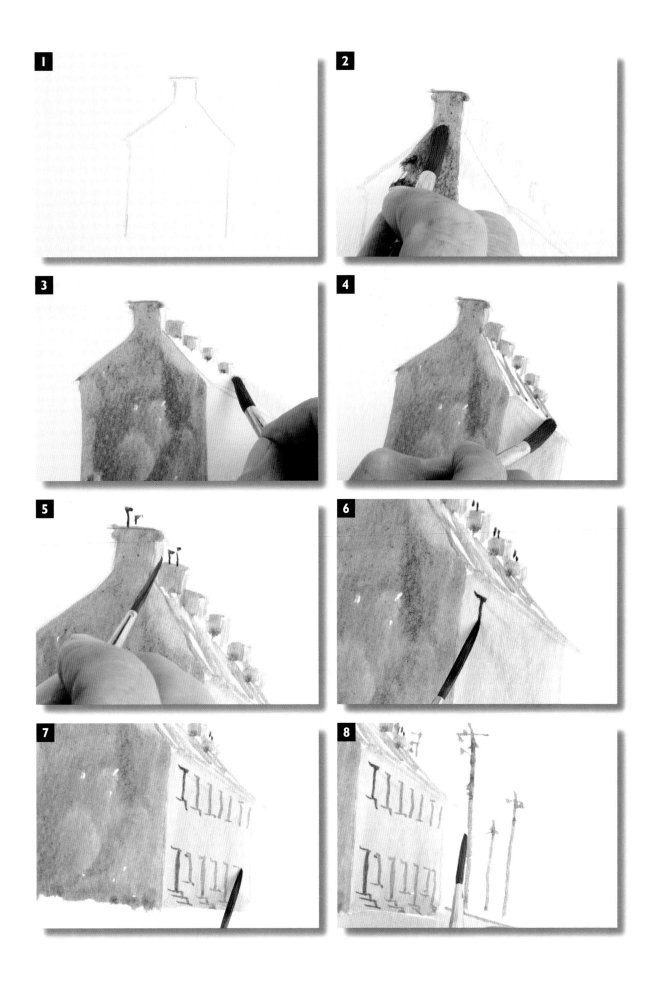

Project: *Houses and Lane*

Buildings don't have to be the focal point in a picture. Here, a few houses half-hidden down a country lane are all you need.

All I have here to start with is a very simple basic outline drawing. I never use crosshatching or shading in preliminary pencil drawings because any texture or detail work should be done in the painting by the paint.

1 With a large wash I wet the sky area, then work from the top down with a watery wash of French ultramarine. I go through the tops of the trees, so that any gaps will be sky colour, not white paper.

2 I rinse and squeeze out the brush, then draw out the pigment for the clouds and let the sky dry, but not completely.

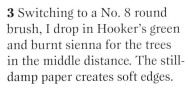

3 Switching to a No. 8 round brush, I drop in Hooker's green and burnt sienna for the trees in the middle distance. The still-damp paper creates soft edges.

4 While this is still wet, I add a watery wash of French ultramarine, mainly along the bottom, which gives a feeling of 'what's around the corner'.

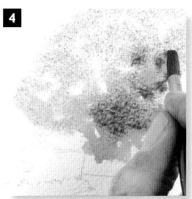

5 With a touch of raw umber I very loosely drop in the basic colour for the furthest building; at this stage I'm just blocking in, with no detail. I add a little texture to the slightly wet paper with a tiny bit of light red, and while this is drying I fill in the windows with a mix of French ultramarine and a very little burnt sienna.

6 On the nearest building I block in the shadow side of the white walls with the same mix as for the windows.

7 Working within the window frames, I use the mix for the glass panes, leaving white highlights.

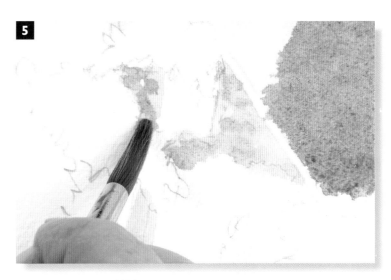

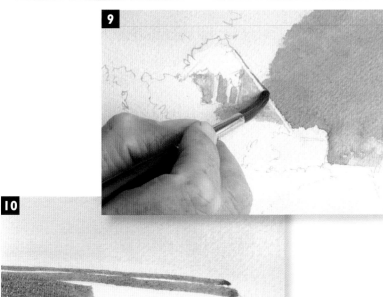

8 For the roof of the white building I use burnt sienna with a tiny touch of raw umber. Again, I don't go into detail and leave a few smidgens of white. I then paint the shadow side the same colour as the side of the building.

9 While this is drying, I move back to the furthest building – which means that I get on with the painting more quickly than if I were to use a hairdryer to dry one part. I use the roof mix from step 8 to add the roof line.

10 For the roof of the barn on the left I use a slightly darker version of the burnt sienna and raw umber mix of the other roofs. As always, I make sure to leave some white – if I need white, there's no finer white than the paper.

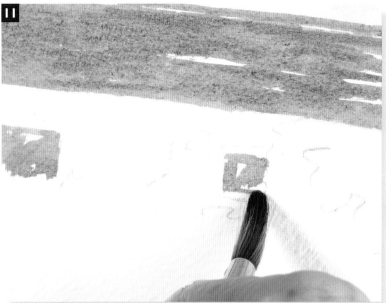

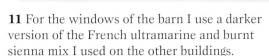

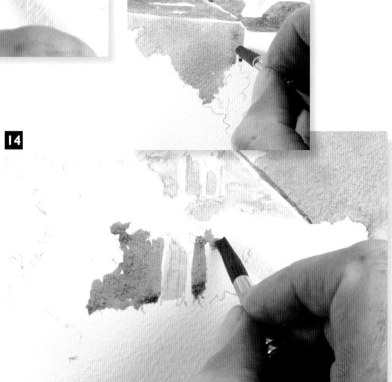

11 For the windows of the barn I use a darker version of the French ultramarine and burnt sienna mix I used on the other buildings.

12 I make up a very watered wash of raw umber for the barn walls, painting this into the tree shapes.

13 Where the main barn wall goes into shadow, I add a touch of French ultramarine to the raw umber to darken it slightly.

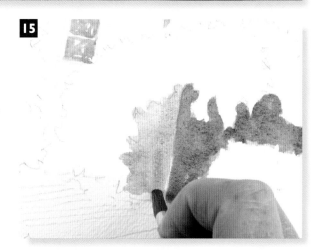

14 While the paint on the barn wall dries, I move back to the furthest building and colour in the shadow side of the garden wall with the raw umber and French ultramarine mix, making sure it gets weaker the further into the distance it goes.

15 I bring this colour all the way along the wall, and then dilute the mix to go round the corner to the front-facing part of the wall in front of the white building.

16 Adding some burnt sienna into the wall mix, I put some stones into the barn wall – just a few strokes, as I'm painting the wall, not building it.

17 To get a slightly darker tone, I add a touch of French ultramarine into the mix.

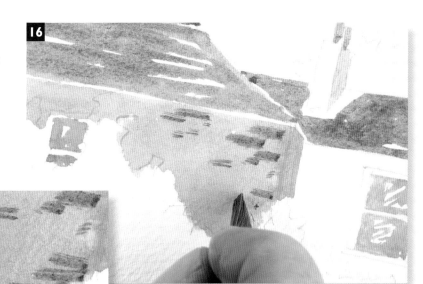

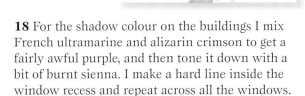

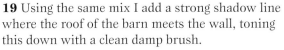

18 For the shadow colour on the buildings I mix French ultramarine and alizarin crimson to get a fairly awful purple, and then tone it down with a bit of burnt sienna. I make a hard line inside the window recess and repeat across all the windows.

19 Using the same mix I add a strong shadow line where the roof of the barn meets the wall, toning this down with a clean damp brush.

20 I then put in a few touches of the shadow mix along the barn roof – for a big, solid roof such as this, I need to make quite wide marks.

21 After adding quite a bit of water to the shadow mix I apply it lightly to show the shadows of the foliage on the front of the white building.

22 I then add some shadows to fill in the gaps on the furthest building, down the gate and on the chimneys, using the same watery mix.

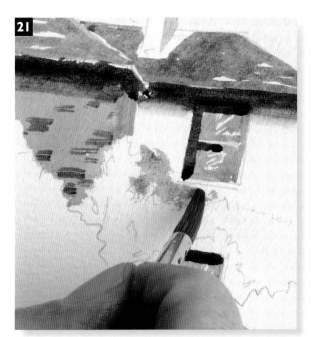

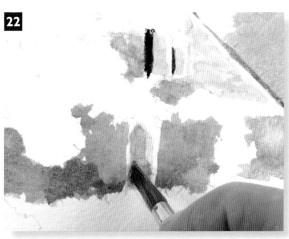

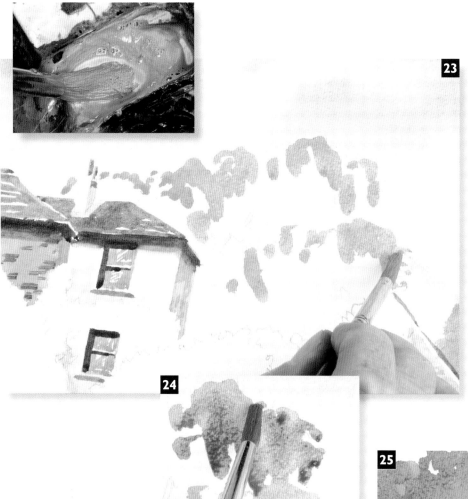

23 Once again while everything is drying, I move on to another part of the painting. For the big trees behind the buildings, I start with a well-watered wash of yellow ochre for the top part.

24 I make a light mix of Hooker's green and burnt sienna and go over most of the first wash, remembering to leave a few gaps of the sky colour through the foliage.

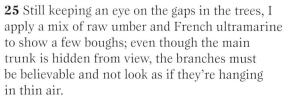

25 Still keeping an eye on the gaps in the trees, I apply a mix of raw umber and French ultramarine to show a few boughs; even though the main trunk is hidden from view, the branches must be believable and not look as if they're hanging in thin air.

26 Where the foliage comes down to meet the buildings I add some French ultramarine to the green mix – this makes the buildings zing out of the background. I merge the colours together with the side of the brush while they are still damp.

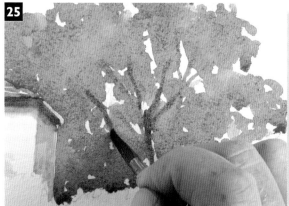

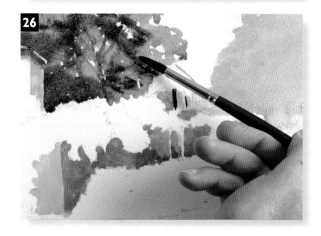

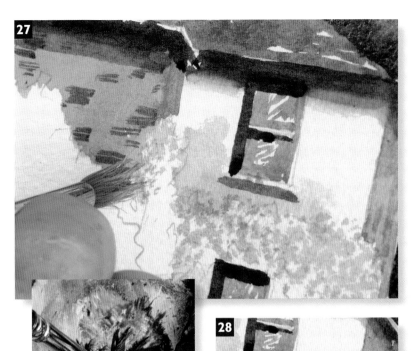

27 For the ivy growing up the buildings I split the hairs of the round brush and dab yellow ochre on to the paper, not attempting to paint each and every leaf.

28 Over this I put a nice strong mix of Hooker's green and burnt sienna, again splitting the hairs and dabbing the colour on.

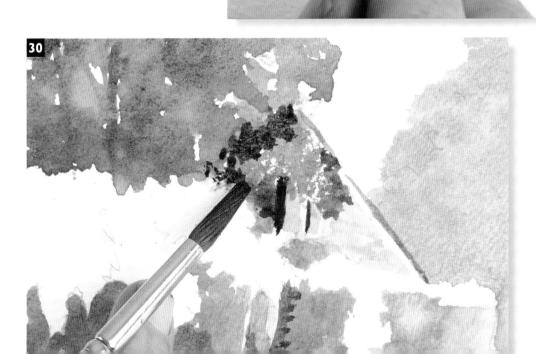

29 Even ivy is going to cast a shadow, so I go back to the basic shadow mix of French ultramarine, alizarin crimson and burnt sienna and stipple it over the other washes with split hairs.

30 I repeat steps 27, 28 and 29 for the ivy on the furthest building, using the same technique and weaker versions of each of the mixes to give the impression of greater distance. The technical term for this is 'tonal recession'.

31 With the shadow mix I cast a little shadow from the chimney on to the roof of the white building.

32 I then use a much stronger version to darken the bases of some of the trees.

33 As this dries, I return to yellow ochre to dab a first wash on to the foreground bushes.

34 Still leaving some white gaps, I stipple a mix of Hooker's green and light red over the first ochre wash.

35 Once again I go in with the shadow colour on the wet washes, keeping this colour darkest in the gateway to the building in the distance.

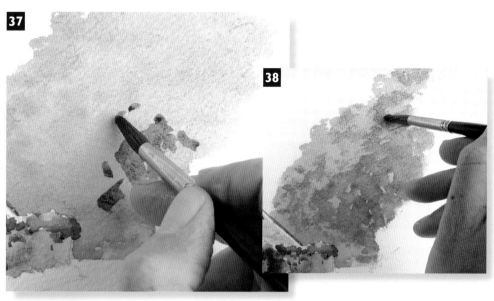

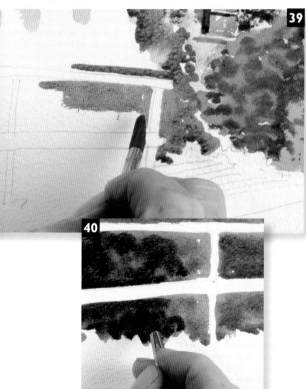

36 I add a few strokes of a raw umber, French ultramarine and burnt sienna mix for the stones in the garden wall, not trying to add detail but a bit of texture.

37 While this is drying, I go back to the trees in the distance and apply a mix of Hooker's green and French ultramarine to bring in some texture and contours.

38 I then strengthen the mix and add a few shadows among the mass of foliage.

39 I use the same mix as in step 37 to block in the bush in front of the barn, still leaving some gaps and cutting in front of the ivy on the buildings. Again I strengthen the mix to add variety and texture.

40 Where the bush is darkest I add some of the shadow mix, being careful to cut in around the white fence as a negative shape, rather than using masking fluid.

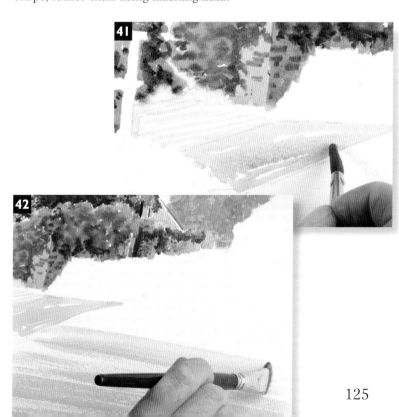

41 I fill in the gaps in the near gateway with a little light red on the steps and inner path, and then mix this with raw umber and plenty of water for the main path.

42 Changing to a ¾in flat wash brush, I use the same watery mix to pick up the surface of the paper for the main track of the lane, keeping the colour lighter further away. I then let everything dry completely.

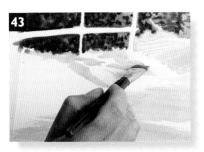 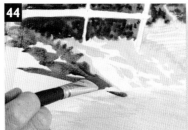 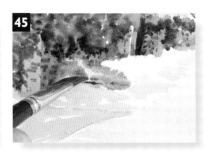

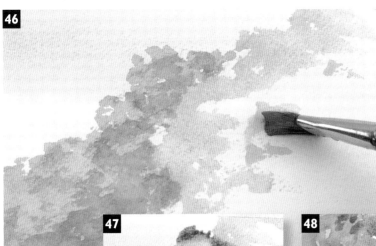

43 To start the grass verges, I apply yellow ochre with the flat wash brush.

44 While this is wet, I dab on a mix of Hooker's green, burnt sienna and a touch of French ultramarine.

45 I tap with the corner of the brush in the furthest bits of the verges, leaving some white.

46 While this is drying, I move to the right-hand trees, using the side of the wash brush to tap on some yellow ochre.

 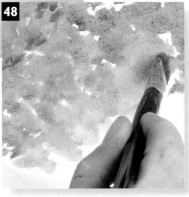 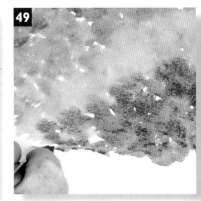

47 I use the side of the brush again to tap on a mix of Hooker's green and burnt sienna – now the distant trees look even further away.

48 At the front of the trees I use yellow ochre with a bit of alizarin crimson.

49 While this is wet I stipple on a mix of Hooker's green, French ultramarine and burnt sienna, splitting the brush hairs and allowing some background to show through. I then add some French ultramarine to darken the trees.

50 I leave the trees and start the right foreground verge with yellow ochre.

 top tip

If you don't leave gaps in trees and bushes, the birds can't fly into or through them!

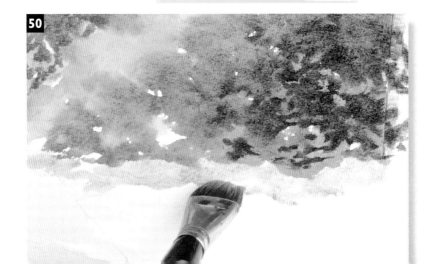

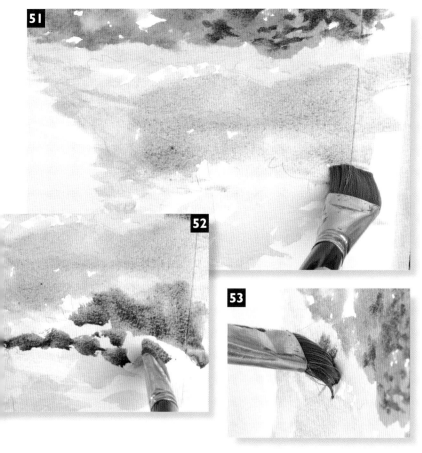

51 I splash a daub of a raw umber and light red mix from the track into the right-hand edge.

52 For a rich, dark green I apply a mix of Hooker's green, burnt sienna and French ultramarine over the wet washes.

53 I flick and dab the green mix to show the rough patches of grass, allowing some of the original ochre wash to show through.

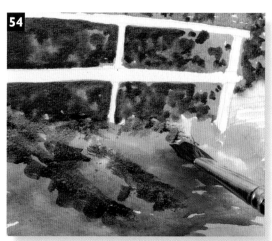

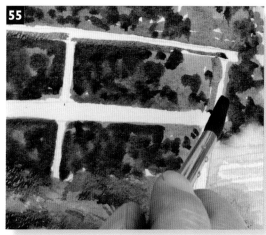

54 While this dries, I return to the left-hand verge with the shadow mix, using the side of the wash brush to bring the shadows down the verges to the lane.

55 I switch to the No. 8 round brush to put the shadow mix along the white fenceposts and a very diluted version along the rails. I then add the shadows to the right-hand verge.

56 To tie the painting together, I apply a very diluted dark wash of the shadow mix across the lane from the verge.

57 I block in these shadows, add shadow lines to the steps with a light mix of shadow colours, and allow everything to dry. I then remove the tape for a crisply framed finished painting.

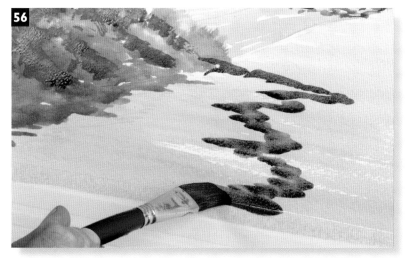

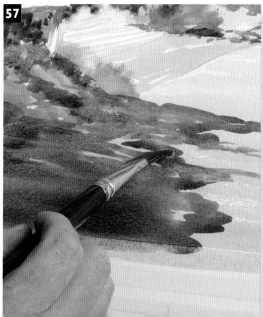

Project: *Into the Village*

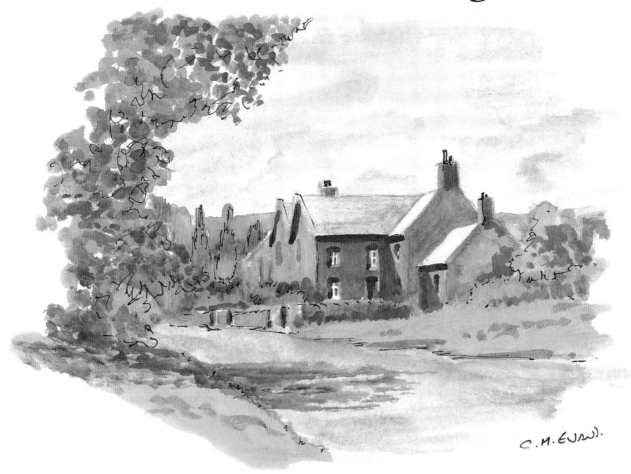

C.M.EVANS.

This painting was done on the roadside going into a village; just past the old house in the foreground you can make out the rough shape of another house, which happens to be my own. You don't have to go far to find subjects to draw and paint – just sketch what's around you.

top tip

I used light grey pencil for the initial drawing in my sketchbook; this kind of location work will always have a few mistakes and extra lines in it, but once some water is applied, these disappear.

1 In this particular village, all the buildings are a lovely sandstone colour, so for the main building I use raw umber for the walls in shadow and yellow ochre for those in sunlight – just scribbling on with the pencils.

2 For the roof I use blue-grey, putting on the colour with side-to-side strokes of the pencil. This is one of those pictures where I find myself drawing for a long time before the water finally pulls everything together.

3 For the distant trees and bushes I start with sap green, scribbling on a few marks here and there. To show different types of foliage, such as conifers and shrubs, I vary the green and switch to Hooker's green and viridian.

4 After putting some touches of cadmium yellow among the greens for front gardens, I use the same colour for the foreground grassy verges, then go lightly over the top of this with viridian, ready for mixing with water later on.

5 I draw the walls with the same colours I used for the buildings, then use some Prussian blue among the far trees – this might seem a strange choice of colour, but when wetted, it'll bring in a wonderful sense of coolness and recession.

6 There are some very bright bushes in this scene, so I use cadmium orange to dot them in. To finish the drawing part, I go back to the Prussian blue to put in the window panes (though not the frames); I work these in quite strongly, as I probably won't wet them.

Project: *Into the Village* 129

7 Now for the sky. I apply this by taking the colour off the Prussian blue pencil with a No. 8 round brush and clean water, and simply brushing it on. There's a lot going on below, so I don't want to make the sky vie for prominence – a few quick sweeps of colour do the trick.

8 While the sky is wet, I mix Prussian blue and blue-grey by taking the colour off one pencil and mixing the two on the other pencil. I then use this for the distant hills, which are quite a long way off. Here I'm just filling in my outline from my initial drawing.

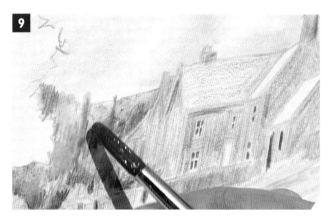

9 While the distant hills are wet, I clean the brush and apply water to the furthest trees and shrubs – look how the water starts to pull the scribbled marks together.

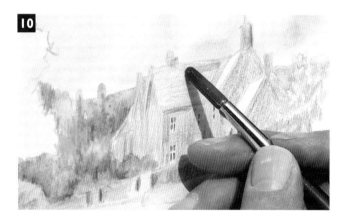

10 The sky's almost dry now, so I rinse the brush and block in the roof with clean water. This side is in shade; I leave the side catching the light as the colour of the paper.

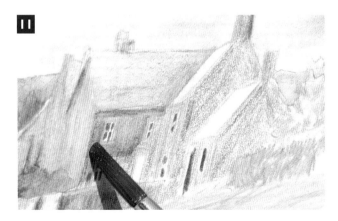

11 When I start work on the building, I know I need to keep the colours moving – old buildings have variations in colour and the roof lines may sag, so I don't use a straight edge and actively aim to have varied tones on the walls.

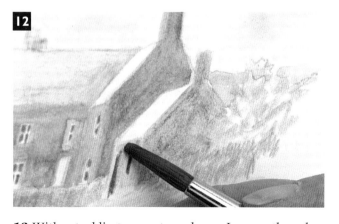

12 Without adding any extra colours, I sweep the ochre and umber of the walls across the bottom of the roof line in the nearest building, to give a good rich colour.

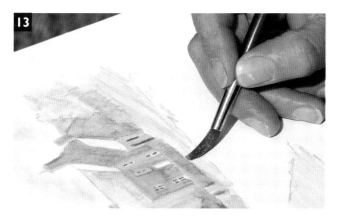

13 After cleaning the brush once more, I carry on to the bushy areas and hedgerows with one sweep, then rinse and merge the colours together on the foreground verges – what a difference this makes, and how different from the shrubbery this new colour is.

14 Taking my shadow colour of permanent magenta off the pencil, I now put in shadows on the roof lines, eaves, doorways and windows. Applying shadows to one side of the building warms it up, and I add shadows to the other walls and to the grass verge.

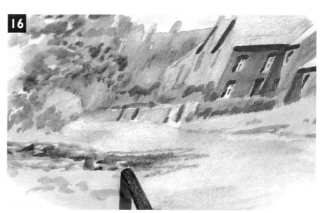

15 For the main tree on the left, I start by tapping on leaf shapes and clumps with Hooker's green, then use a dark blue-grey, also taken from the pencil, to give a feeling of depth.

16 The Tarmac road is blue-grey; I stroke the colour on with the brush, and then go back to permanent magenta to carry on the dappled shadows from the verge. A few marks with a fine black fibre-tip pen, and it's done – at least I don't have to go too far for a warming cup of coffee …

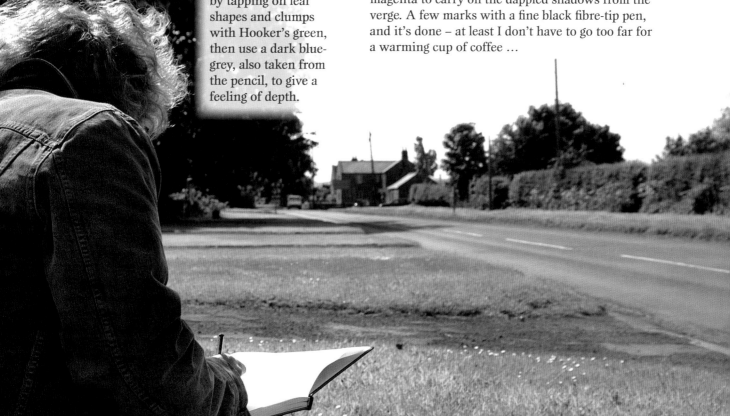

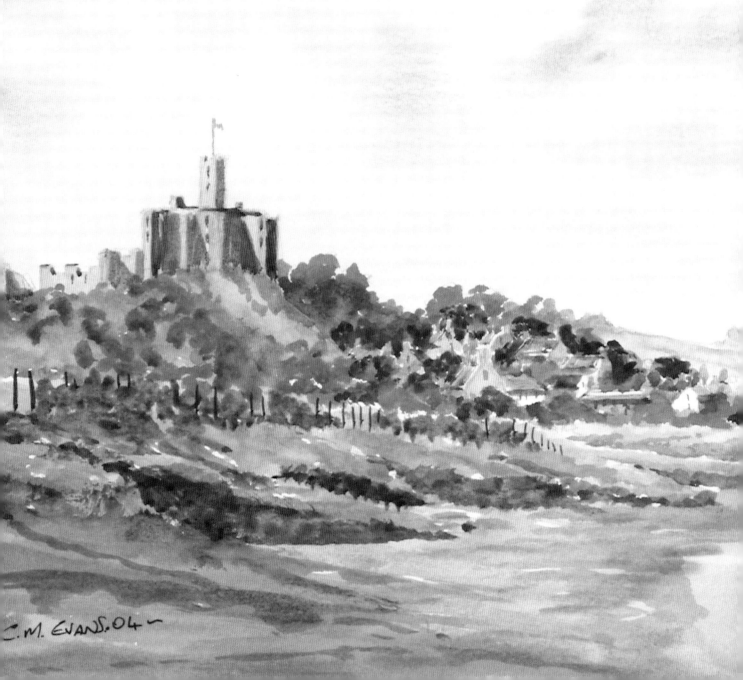

C.M. EVANS.04

Project: *Castle and Estuary*

After the quiet country lanes in the last projects, I decided to go for something grander: this is Warkworth Castle in Northumberland.

In this view, from the River Coquet, there's quite a lot of detail. I didn't try to draw it all, but focused on getting the castle fairly true to life; after that I just picked out some of the prominent and large buildings, and then stuck in a few rooftops and chimneys for a general impression. Working outdoors, the only race is to get the sky down on paper – after that you can relax, enjoy yourself, look at the view around you and soak up the atmosphere.

1 With a large flat wash brush I wet the entire sky area. I then use the brush to mix together a little yellow ochre and burnt sienna, and put it on to the bottom of the areas and bring it upwards. While this is still wet I add some touches of French ultramarine above it.

2 Still with the sky area wet, I mix French ultramarine and light red for the outer blue areas at each side. As always with skies, I work quickly into the wet paper and washes.

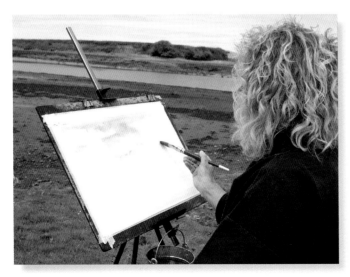

3 I rinse and squeeze the brush, then use it to draw out the pigment along the bottom edge of the sky area and into the sky to create clouds.

4 For the darker patches beneath the clouds, I use the French ultramarine and light red mix. So far, this has taken under five minutes.

5 As the sky dries, the first mix begins to come to the fore and creates a glow among the clouds; this will have an influence on the rest of the picture.

6 Now I move to the landscape in the far distance. Switching to a No. 8 round brush, I make up a weak mix of French ultramarine and light red and drop this in for the trees on the horizon, which look like a few lumpy bits.

7 Below these I put on a little bit of well-watered yellow ochre and stroke the pigment down – I don't make horizontal or vertical strokes for hills, but follow the actual contours.

8 For the trees and bushes here I use a mix of yellow ochre and a tiny hint of Hooker's green.

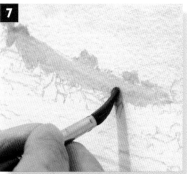

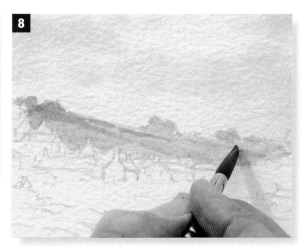

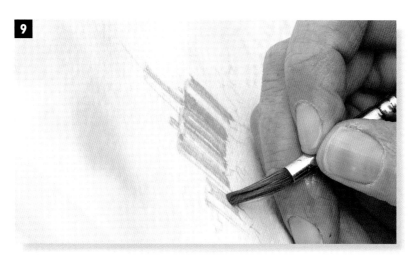

9 To start the castle I make up a mix of raw umber and yellow ochre. The light is coming from the left, so I use this mix for the darker parts on the right – these shadows create the true form.

10 I then put straight yellow ochre on to the sunlit parts while the shadowed sides are still wet.

11 For the church spire and tower in the town I use the raw umber and yellow ochre mix.

12 Next I add a little French ultramarine to the mix for the shadow side of the spire and the church roof.

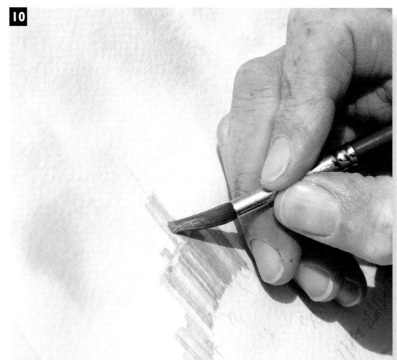

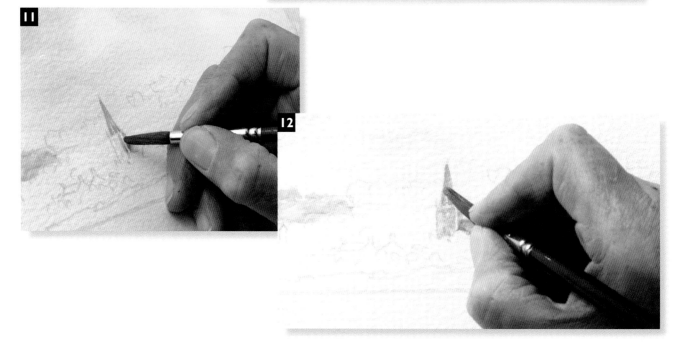

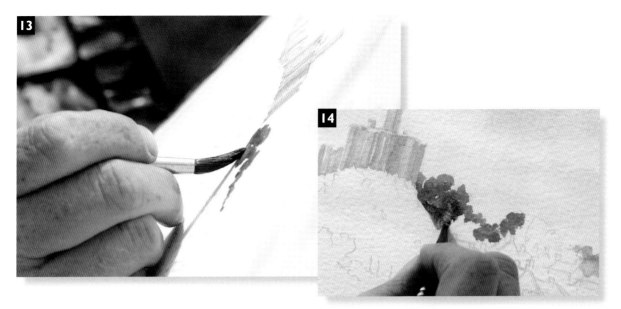

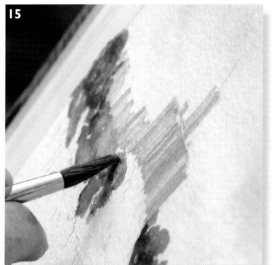

13 With a darkish but watery mix of Hooker's green and French ultramarine I drop in some of the distant trees by the castle.

14 While this wash is still wet, I add a mix of Hooker's green and burnt sienna and merge this in from below.

15 I then bring the mixes in from the right across the front of the castle, cutting into the building carefully. Here and there I add a few touches of yellow ochre to merge with the darker colours.

16 To soften the base of the general mêlée of trees here, I use a fairly weak wash of French ultramarine.

17 I apply a light wash of Hooker's green and yellow ochre for the hillside on which the castle is standing.

18 For the darker greens going into the houses and filling in the tree areas across the church and over to the right, I use a mix of Hooker's green and burnt sienna.

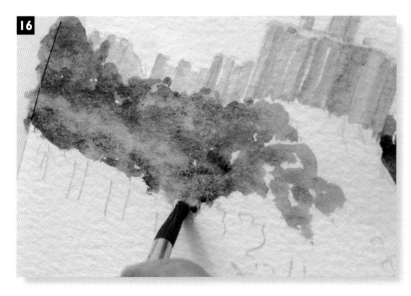

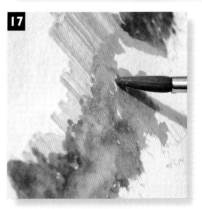

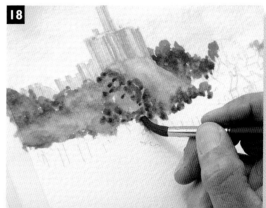

19 While the tree washes are drying I make up my shadow colour mix of French ultramarine, alizarin crimson and burnt sienna – you should know this recipe by heart now! – and put the very darkest shadow areas on the castle.

20 I have a look at which parts will cast shadows on to adjacent areas of the castle, especially the castellation to the left of the main building. I put in very light verticals for windows.

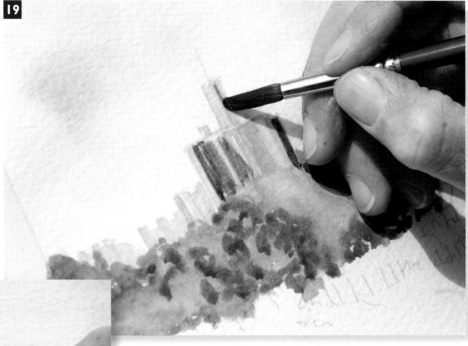

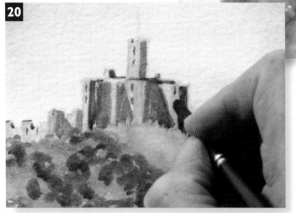

21 Before my hand gets too cold to hold the No. 3 rigger, I use this brush to add the smallest details without trying to be too exact at this distance. I use French ultramarine, burnt sienna and alizarin crimson for the flagpole, and a straight wash of alizarin crimson for the flag itself. You can see how windy it is in the photo below – and that the clouds have now covered the sky, which is why you need to get skies down quickly.

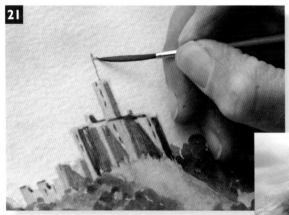

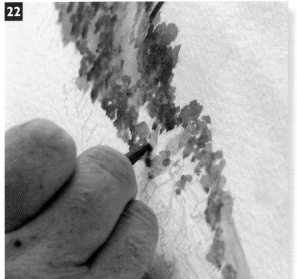

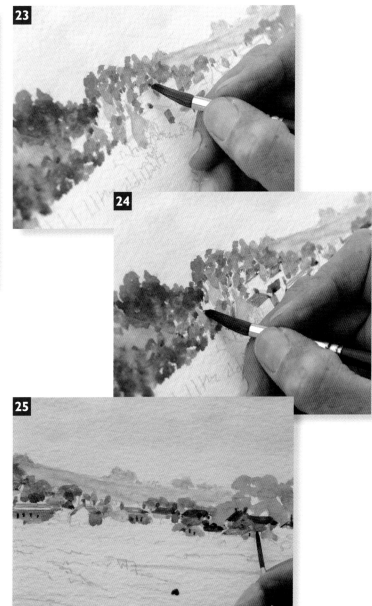

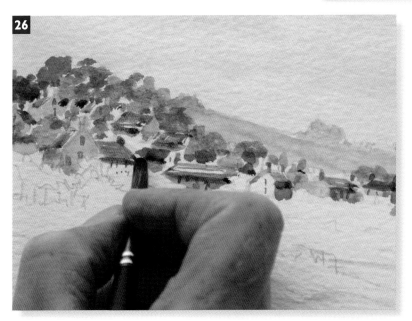

22 Switching back to the round brush, I use a light wash of raw umber to block in some of the buildings among the foliage.

23 I use a darker wash of raw umber for the shadow side of some of the buildings; this brightens up the light side.

24 For most of the rooftops across the whole picture I use a wash of burnt sienna, and then make a contrasting mix of French ultramarine and burnt sienna for the remaining roofs. I use this mix to fill in the shadows among the trees by the church.

25 Moving to the nearest buildings, I use a very watery wash of raw umber for the brighter side, and French ultramarine and burnt sienna for the sides that are in shadow.

26 With the rigger brush, I use my shadow colour to put in just the impression of a few windows in the houses, then switch back to the round brush for some bits of roof shadow.

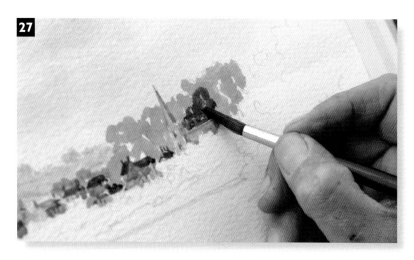

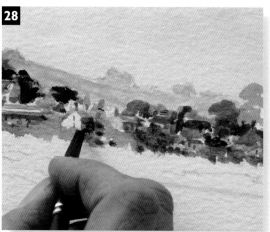

27 To put the darker trees over the lighter dry washes around the church and above the town I use a mix of Hooker's green, burnt sienna and French ultramarine.

28 I then put a diluted version of this mix along the bottom of the buildings.

29 For the light strand below the buildings I apply a wash of yellow ochre with a ¾ in flat wash brush.

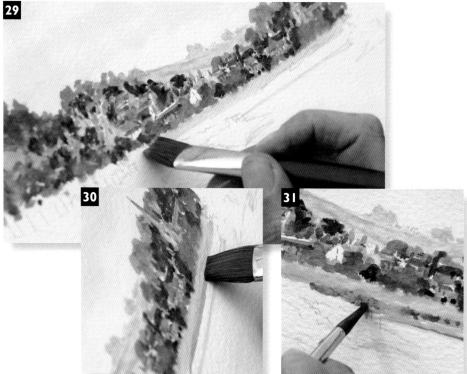

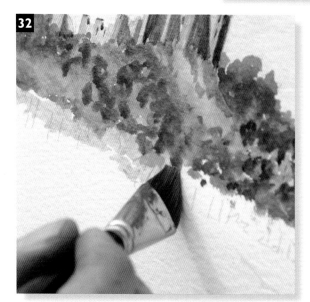

30 Using the same brush I then go below this line with a light mix of Hooker's green and burnt sienna to make an even thinner line …

31 … and below this I switch back to the round brush to apply the green mix with some French ultramarine in it.

32 Going back to the area below the castle, I start by cutting into the green with the flat brush and a wash of yellow ochre.

33 With the ¾ in flat wash brush I bring down the yellow ochre while it is still wet.

34 I then go into this with a mix of Hooker's green and burnt sienna, leaving some patches of white paper.

35 Back with the flat brush I continue to bring the green down, just making a few marks and not attempting to block in the colour.

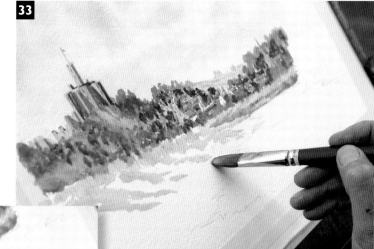

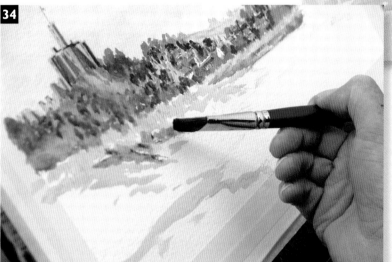

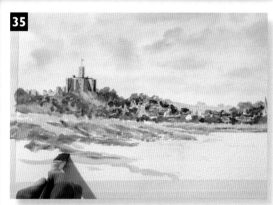

36 Even when I bring down the green to the foreground, I take care not to make the shade a solid one.

37 I switch back to the round brush and a stronger version of the green mix for the bushes.

38 For the smallest marks here I use the side of the brush as well as the tip.

39 Using the shadow mix of French ultramarine, alizarin crimson and burnt sienna, I add more darks among the bushes and create contours and shadow areas among the grasses, going down to the riverbank.

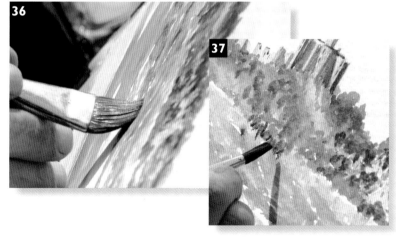

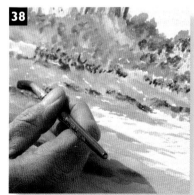

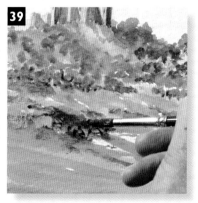

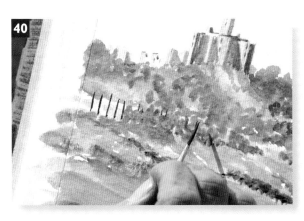

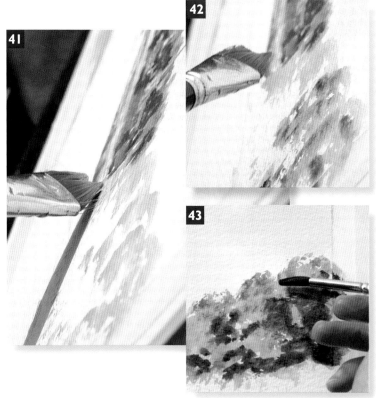

40 With an almost black mix of French ultramarine and burnt sienna and using the rigger brush, I add the fenceposts, getting smaller in the distance.

41 I start the trees on the right with the flat brush, tapping yellow ochre on to the paper.

42 While this is wet, I tap on a mix of Hooker's green and burnt sienna to give a ragged edge.

43 Back with the round brush I drop in a watery mix of French ultramarine and burnt sienna so that it merges with the first two washes.

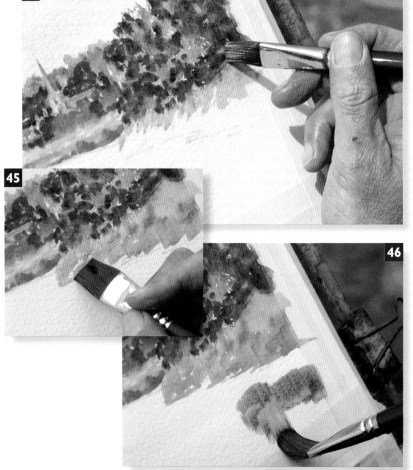

44 For the bank below the trees I use the flat brush to put in yellow ochre and then a mix of Hooker's green and burnt sienna below that.

45 I then add a mix of raw umber and French ultramarine for the muddy shore, merging this into the bank washes.

46 After wetting all the river area, I put in a wash of Hooker's green and burnt sienna for the reflections of the trees.

47 I then put in quite a strong mix of French ultramarine and burnt sienna for the ripples on the right by the bank.

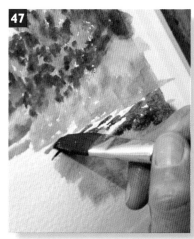

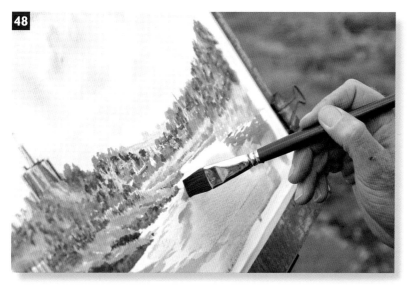

48 Just as with the sky, I aim to have the river area finished within no more than three or four minutes. I start by brushing on a watery mix of French ultramarine and a tiny bit of light red, merging this in softly with the other washes in the river.

49 I rinse and squeeze out the flat brush and draw out the paint in horizontal bands to show the highlights in the water and create some movement. It's important not to overdo this though.

50 Using my shadow mix and the round brush, I add a little shadow beneath the right-hand bank, and then do the same for the left-hand bank in the foreground.

51 Finally I go back to the flat wash brush and use a mix of raw umber and yellow ochre to give the impression of a muddy stretch going down to the water on the left. I stroke on the watery wash horizontally, taking care not to dull the highlights.

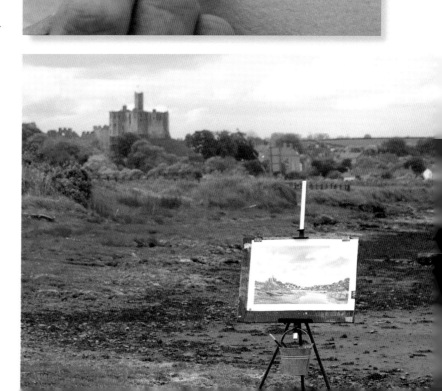

Project: *Dutch Barn*

The classic Dutch barn is a structure with some weird and imposing angles. The most difficult part is getting the angles correct, as my artist's eye is telling me they should be straight when actually they aren't! The fairly steep angle of the roof provides a feeling of recession.

top tip

I used cool grey pencil for the initial drawing on sketchbook paper and left in some small missed lines and angles; I don't need to rub them out before going further, as when I stroke over them with water they'll disappear anyway!

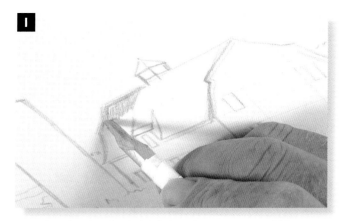

1 'Colouring in' the initial drawing may sound like a child's exercise – and to a great extent that's what it is – but you still have to work carefully. I start by using a little olive green pencil on the roof, making sure I go all the way up to the outline pencil lines.

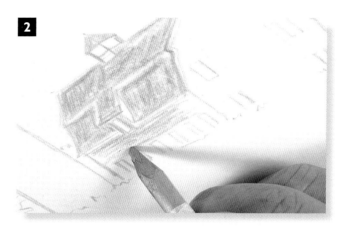

2 For the barn walls I use light red, a lovely salmon-pink colour, especially with a bit of titanium white pencil added. People ask whether I was taught colour mixing; I wasn't, but have learned it by experimenting and a lot of practice.

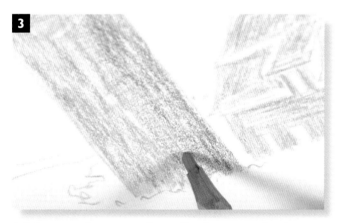

3 I then use the same colours for the tower. On the right of the tower I stroke in some blue-grey pencil, with the strokes heaviest on the side and getting weaker as they approach the centre – this produces a round feel on the tower. There's no detail of the brickwork at this stage.

4 To give the barn some form and dimension, there needs to be a dark side and a light one; a little blue-grey does the trick for the dark side, but I take care not to press this pencil too hard into the light red.

5 Don't paint sash windows with net curtains – and don't even paint the frames! All I do is put a couple of blue blobs of pencil marks inside the frame, using the white of the paper to make the frames themselves and the sashes.

6 With the buildings filled in, it's time for the sky, for which I use manganese blue, a particularly bright blue. I take the pigment from the pencil with a No. 8 round brush and go carefully round the building.

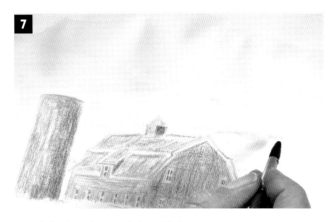

7 While the sky wash is still damp I use more manganese blue on the brush to paint in the distant hills, using a strong wash for those nearest. I then take some blue-grey on the brush and drop this on top of the blue, to tone down the brightness and bring the hills even closer.

8 From now on, I'm applying all the colour from the brush. After leaving the sky wash to dry for a couple of minutes more, so that it doesn't crinkle, I add some Prussian blue forwards of the middle distance, and then some cadmium yellow on top of this towards the foreground.

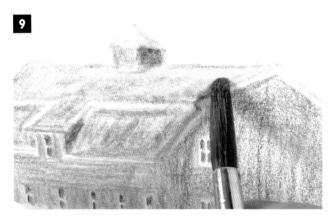

9 Now I'm going to wet the pigment marks on the building with clean water and the brush – this is where it all starts to come together – and as always, I plan to wet the light parts first, so I can carry the dark into the light. On the roof I make diagonal strokes in the direction of the slope …

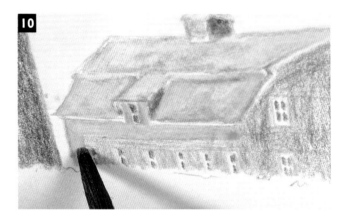

10 … and then wash the brush thoroughly before I start working on the red of the barn walls. I leave a tiny strip of white paper where the roof meets the walls, to show how the light catches these parts.

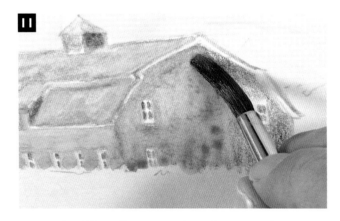

11 On the side wall, I merge the colours together to produce a darker tone. Remember that this is an old building, so it doesn't want to be all flat and perfect: in order to get a varied effect of texture, I pick up paint from a wet area and then put it on to the dried parts.

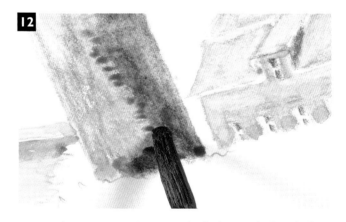

12 On the tower, again I wet the lighter side first before dealing with the darker areas; I then stroke the dark side gently into the light one and smooth the edges where the colours meet with clean water so as to give a rounded effect. I now leave all this to dry.

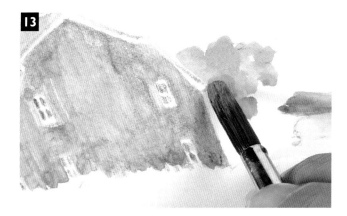

13 For the trees on either side of the structures, I take viridian pigment off the pencil with the brush and apply it in intentionally scrubby lines, taking these carefully up to the building's sides. The strong hues show just how powerful a medium watercolour pencils can be …

14 … but even so, I want to strengthen the trees. I mix manganese blue and blue-grey from the pencils on to the brush, and then apply this to the darkest point, where the bush meets the building, to give a strong framing edge.

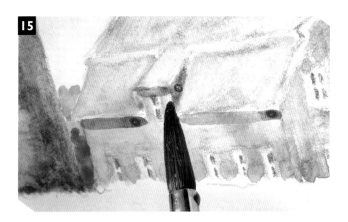

15 For the shadows on the barn I apply a warm permanent magenta below the roof to anchor it. A tiny touch of the same colour on the top and down the left of each window frame makes them appear recessed. I then use the magenta for a few lines along the walls to indicate that the barn is a wooden structure.

16 The tower casts a shadow on the barn: be brave, paint on the magenta liberally, and don't worry – the more you prevaricate and fear the action, the more you may spoil everything you've done so far. Don't forget the shadows from the top window and the top of the roof.

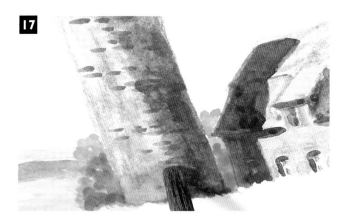

17 Now I reinforce the darkest shadow areas with blue-grey over the dry magenta. To give the impression of brickwork, I mix light red and raw umber off the brush and put in a few touches here and there – to be realistic, these should not be too many or too regular.

18 For the grass, I take viridian from the pencil and apply it quickly, just leaving a little of the white paper surface showing through. I then finish with a few bits of shadow using permanent magenta. And there we go – a proper old Dutch barn!

Project: *Church*

This beautiful little church is in the tiny market town
of Warkworth. A useful tip here is to leave open any gates
in your view, as this leads the eye into the picture.

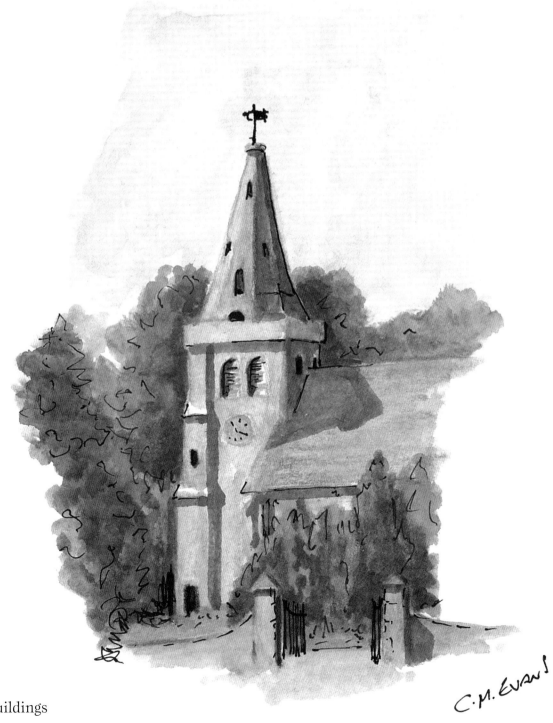

C.M.EVANS

1 I start with an initial outline drawing in blue-grey pencil, including some framing conifers and shrubs. To make sure the two windows in the tower look straight, I use a couple of guidelines to ensure the tops and bottoms of the windows align.

2 On the lighter, left side of the spire, I use yellow ochre pencil, and on the shaded side I use raw umber; however, this is an old church with weather-beaten stone and the lines aren't all dead straight – so I tone the umber into the ochre where the edges meet.

3 Next I bring the ochre and umber down the respective sides of the tower, working around the clock face and windows. For the roof I use side-to-side strokes of blue-grey, and go over them lightly with strokes of raw umber.

4 Because they were dark, I didn't leave the windows in the spire as blank paper; I put them in now with strong blue-grey. I then use Prussian blue for the clock face.

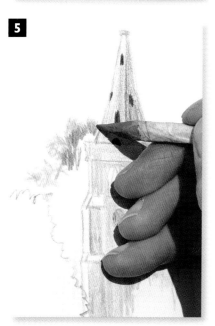

5 I start the trees behind the church with scribbles of yellow ochre. Into this I then add Hooker's green, being careful to go only up to the church building, not over it.

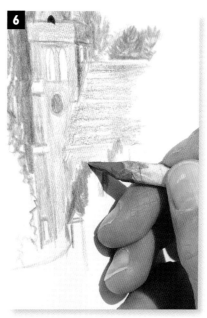

6 For the conifers in front of the church, I first scribble on some yellow ochre, followed by strong, hard Hooker's green, again going carefully round the gateposts.

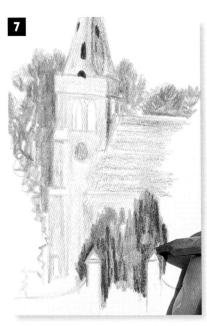

7 Over these colours I then go in quite hard with blue-grey. Already these trees look darker and further forwards in the picture than those behind the church, even with the ochre showing through.

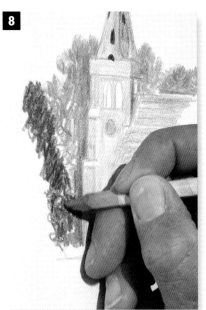

8 The tree on the left is a lovely copper beech, and for this I start with short, rounded brushstrokes in cadmium red; I then partially cover them with a little blue-grey, and then put some burnt sienna on top of the other two …

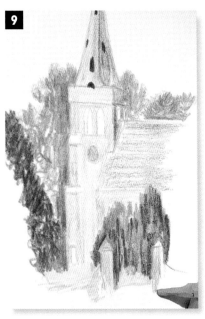

9 … followed by a touch of yellow ochre at the base and between the gateposts. For the posts themselves I use yellow ochre for the sunny side and raw umber for the side in shade, just as for the tower and spire.

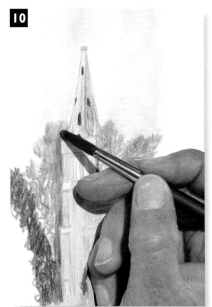

10 For the bright, cloudless sky I take Prussian blue off the pencil with a No. 8 round brush and paint it quickly on the paper; this is a vignette, so I don't try to cover everything. Loading the brush with clean water, I tap it on to the background trees so as to merge the colours, again working round the shape of the spire.

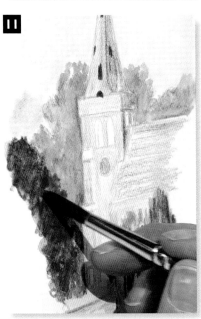

11 Making sure the water on the brush is clean, I then go into the three colours on the copper beech tree, tapping the brush on and moving the colours around to make a really vivid colour mix.

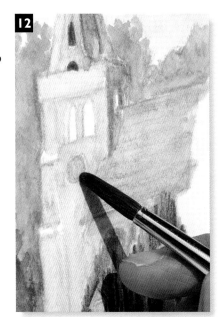

12 Again using clean water, I work down the church from the spire as I did for the drawing part, merging and blending the pencil colours. The colours on the roof mix and blend to make a lovely slate grey, and I solidify the colour on the clock face.

13 I now move on to the conifers and shrubs in front of the church, each time recharging the brush with clean water. When I paint the gateposts, I use the brushstrokes directionally, working vertically for the posts and horizontally for the walls.

14 The windows in the tower have green shutters: I use a Hooker's green pencil for this, then switch to Mars black to show the recesses strongly. I use the same black for the lower window and door in the tower.

15 For the darkest shadows where the conifers meet the church, I stroke permanent magenta off the pencil and then mix it with Mars black. I also put a little of this into the copper beech, but not too much.

16 I use a lighter version of this shadow mix for the shadows on the church, from the spire on to the roof and into the conifers around the gateposts. I then let everything dry before going in and putting in the final touches.

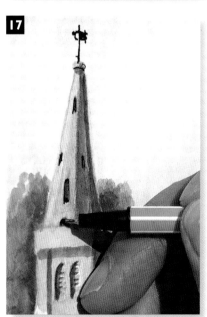

17 Using a fine black fibre-tip pen, I start by drawing in the weathervane on the spire. I then edge the windows, put hands and numbers on the clock face, add some fairly large iron gates, and finish with a few squiggles here and there on the trees and grasses. And there's a vignette.

People & Animals

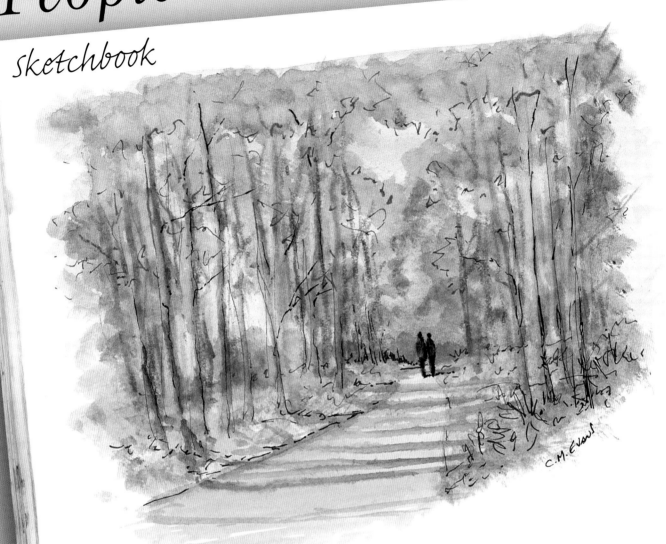

A tree-lined path leads the eye to the couple in this sketch.

I had to work quickly to get this duck on paper.

These highland cattle are mainly watercolour pencil washes with just a little pen work.

A few friends chatting in a Tuscan courtyard give scale to the trees.

Including people in any urban scene makes it come to life.

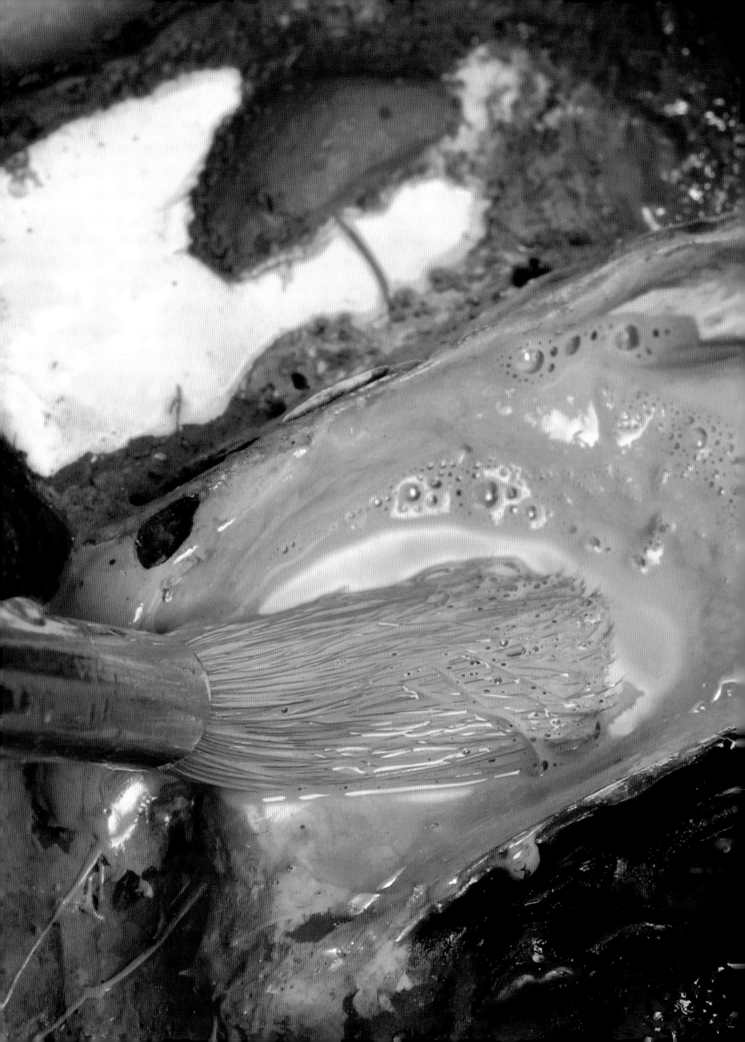

Exercise: *People and Animals*

Life drawing is something that terrifies many beginners, but it is really easy to add basic people and animals to your scenes if you keep them small and in the middle distance, as these exercises show.

Couple and Dog

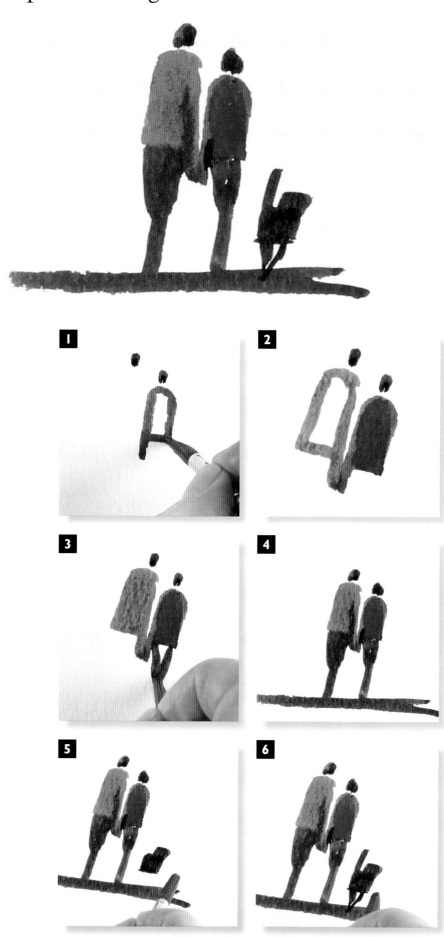

There are lots of methods used to paint people, but I reckon that if you can paint a 'Y' and a 'P', you shouldn't have any problems with painting people. As a free gift, here's a dog as well.

1 Using a small round brush and any colour you like, put two full stops on the paper. Leave a little gap below the stop on the right, switch colours and add 'P'.

2 After filling in the empty part of the 'P', change colours again and paint a reversed 'P' under the left-hand stop, once more leaving a tiny gap.

3 Fill in the second body and then change colours and draw the letter 'Y' under the first figure, this time joining it up to the bottom of the body.

4 When filling this in, leave a tiny bit of white paper to suggest the gap between the thighs. Paint the next 'Y' and fill it in, before making a few strokes to show the ground.

5 For the dog paint a square and a smaller square on top on the right.

6 Then add two sticks joined on to the larger square below and one above, and there you are!

Sheep

For sheep, you don't need to see four legs, two ears and a wagging tail – all you need is a loaf of bread with a lump on the end! Here's what I mean.

1 Start by drawing the loaf and the lump at one end, with a bit sticking out of the lump for an ear. Note that you don't even need to draw the lines right down to the ground.

2 Using a No. 8 round brush, put a few dabs of yellow ochre along the top of the loaf, going up to the drawn edge. Then put a mix of French ultramarine and burnt sienna at the right end of the loaf and a line to make an incomplete 'V' below.

3 Using the same mix, colour in part of the bottom of the loaf.

4 Now add a few dabs of the second mix to the yellow at the top and switch to a dry brush to mix the two washes together.

5 After mixing the French ultramarine and burnt sienna to a black, colour in the lump at the end of the loaf. A few strokes of green for grass, and there's the sheep grazing away contentedly.

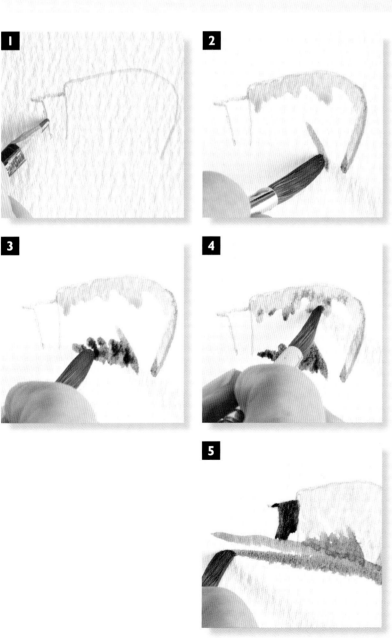

Cow

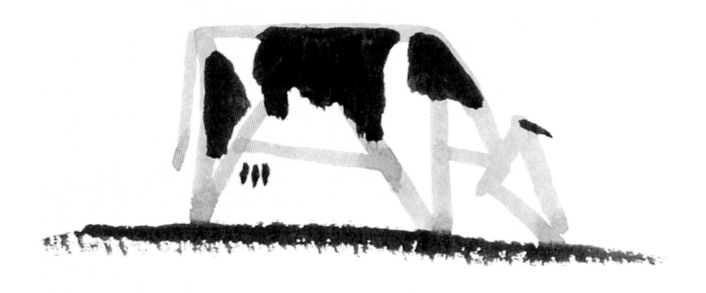

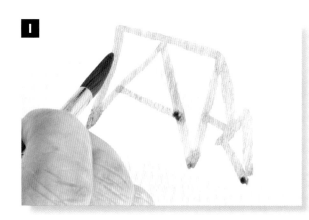

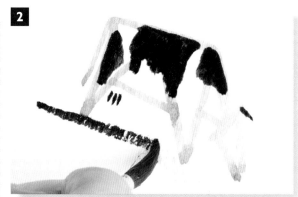

With all the animals here, you need to make them small and put them in the middle distance or even further away – we're not talking about the cover of a farming magazine!

1 Start by mixing a light wash of French ultramarine and burnt sienna to make a grey, and then use a No. 8 round brush to paint a series of triangles as shown. Don't forget the tail, which hangs off the back triangle.

2 With a black mix of the same colours, colour in parts of the triangles in cow markings. Then it's just a matter of sticking an ear on and some dangly bits underneath, a line to represent the ground, and there's your cow.

Horse

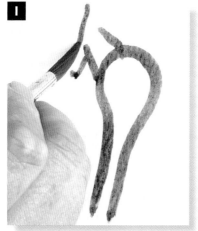

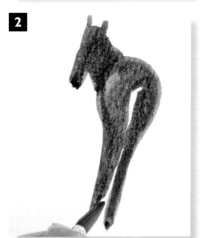

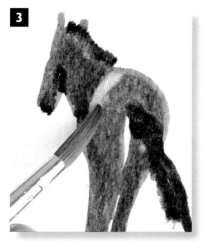

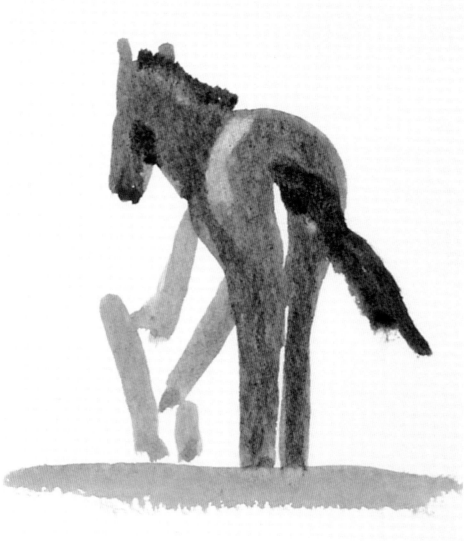

Traditionally, horses are among the most difficult things to paint, because they are complex. But if your horse is in the middle distance, all you need is a light bulb.

1 Making up your horse colour from raw umber, paint a thin light bulb and add two sticks off the top and a block at the end of them to make the head.

2 With the same mix colour the horse, leaving a little white paper as a highlight.

3 Use a darker version of the mix for the mane, tail and shadows, then rinse and squeeze out the brush to take off paint for contours. If you want the horse to be grazing, simply angle the sticks and head of step 1 downwards (as shown above).

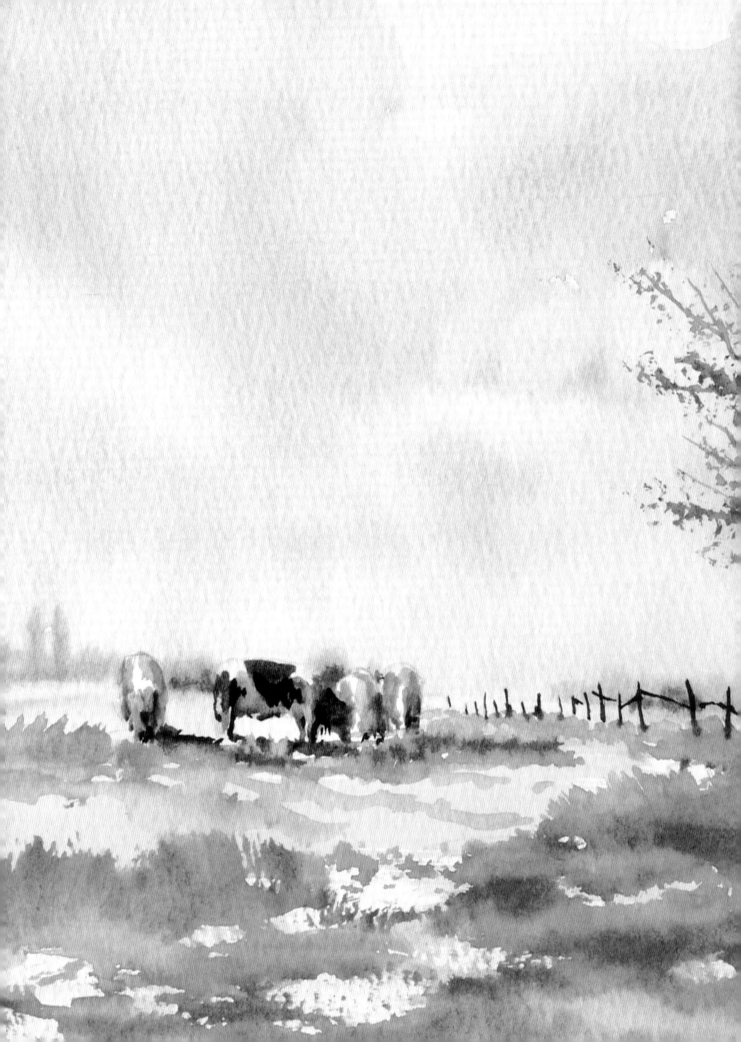

Project: *Cows and Sheep*

A pastoral scene with grazing animals is always attractive – and cows and sheep usually stay still long enough for you to paint them!

Compared to the finished painting shown on the previous pages, the initial drawing here may look a bit bare and lacking in detail – but that's all part of the plan. If you aren't completely bound by pencil lines, you have more freedom to use techniques such as blending and softening, drawing out paint and so on.

1 After masking the edges of the paper, I make the initial drawing as a guide to get me started. I then apply a very well watered-down wash of yellow ochre, using a ¾in wash brush, over everything …

2 … with the exception of the shapes of the cows and sheep. I'm not using masking fluid for this because there is nothing else happening, so it is easy.

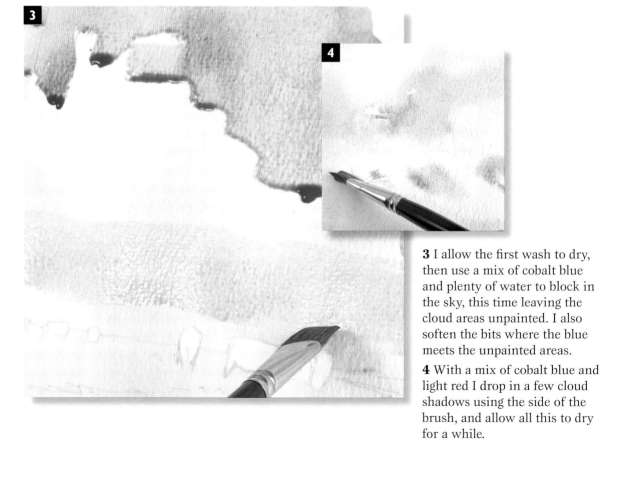

3 I allow the first wash to dry, then use a mix of cobalt blue and plenty of water to block in the sky, this time leaving the cloud areas unpainted. I also soften the bits where the blue meets the unpainted areas.

4 With a mix of cobalt blue and light red I drop in a few cloud shadows using the side of the brush, and allow all this to dry for a while.

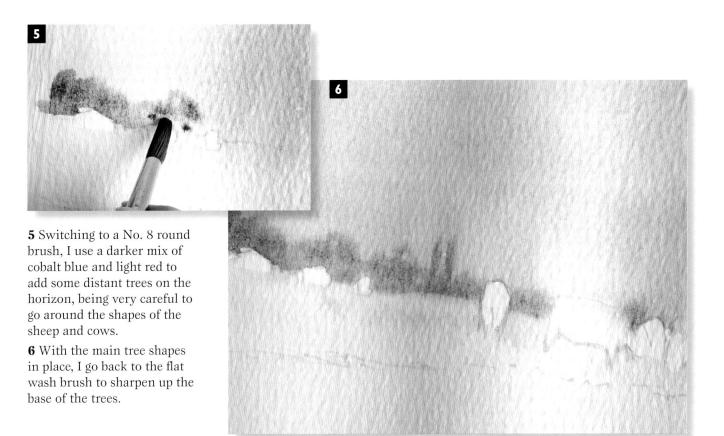

5 Switching to a No. 8 round brush, I use a darker mix of cobalt blue and light red to add some distant trees on the horizon, being very careful to go around the shapes of the sheep and cows.

6 With the main tree shapes in place, I go back to the flat wash brush to sharpen up the base of the trees.

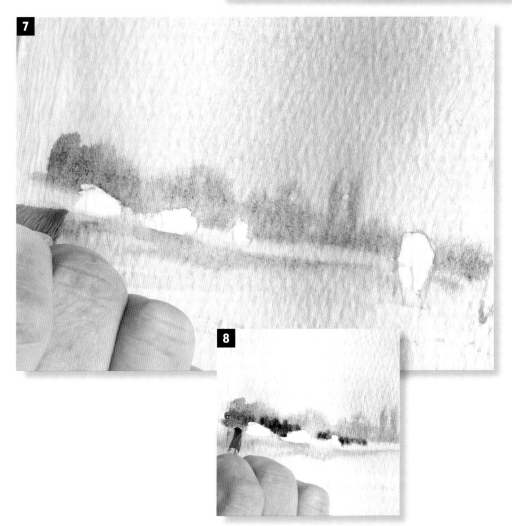

7 I now use the flat brush to drop in a light wash of light red across the ground in the middle distance, allowing the original wash of yellow ochre below to show through.

8 While this wash is drying, I switch back to the No. 8 round brush and use quite a dark mix of cobalt blue and light red for the darkest trees on the far left of the picture. Here, my aim is to have a dark enough area to accentuate the white patches that are the sheep.

9 I make up a black with a mix of French ultramarine and burnt sienna, and drop this as a first touch of colour on what will become the main cow in the picture. While this is drying, I make up a mix of raw umber and light red, and use this to add colour and shape to the cows on either side.

10 After mixing Hooker's green and burnt sienna with plenty of water to make a nice watery green, I switch to a No. 3 rigger brush for the leaves on the right-hand foreground tree. I use the brush on its side to create bunches of leaves, and make sure not to carry surplus water on the brush, which could run and make too large a mark.

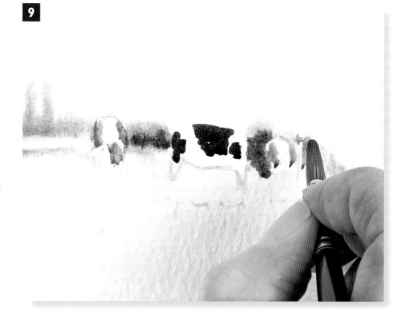

top tip

Keep looking over the whole picture regularly – standing back helps. Even when you've decided to work quickly, taking frequent overviews can be invaluable.

11 With a mix of cobalt blue and light red, I use the tip of the rigger brush to make branches that link the green splodges of leaves.

12 I wash and almost completely dry the brush, and then use it to add tiny touches of shadow colour created with a mix of burnt sienna and French ultramarine – nowhere near as strong or dark as the mix I made with the same colours for step 9.

164 People & Animals

13 However, I do use the black mix of burnt sienna and French ultramarine for small blobs that I shape to make the heads of the distant sheep.

14 Still using the rigger brush, I add a touch of yellow ochre on to their backs. I let this dry a bit and then put a tiny touch of a light mix of French ultramarine and burnt sienna for the shadows.

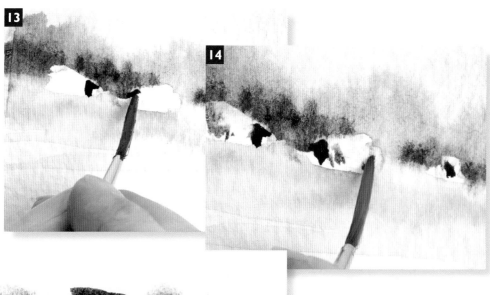

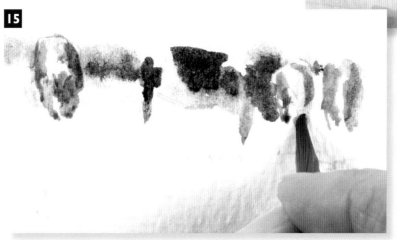

15 With the same shadow mix, but after watering it down to make a very weak mix, I go back to the cows; to capture light on the top and on parts of the sides, I leave some areas unpainted.

16 I make a mix of light red and burnt sienna and use the No. 8 round brush to add a few marks and flicks on either side of the main right-hand tree.

17 Sticking with the same brush, I make up a sepia from burnt umber and French ultramarine and make a few more flicks upwards underneath the tree. I use the same combination to create small branches and twigs at the side of the trunk.

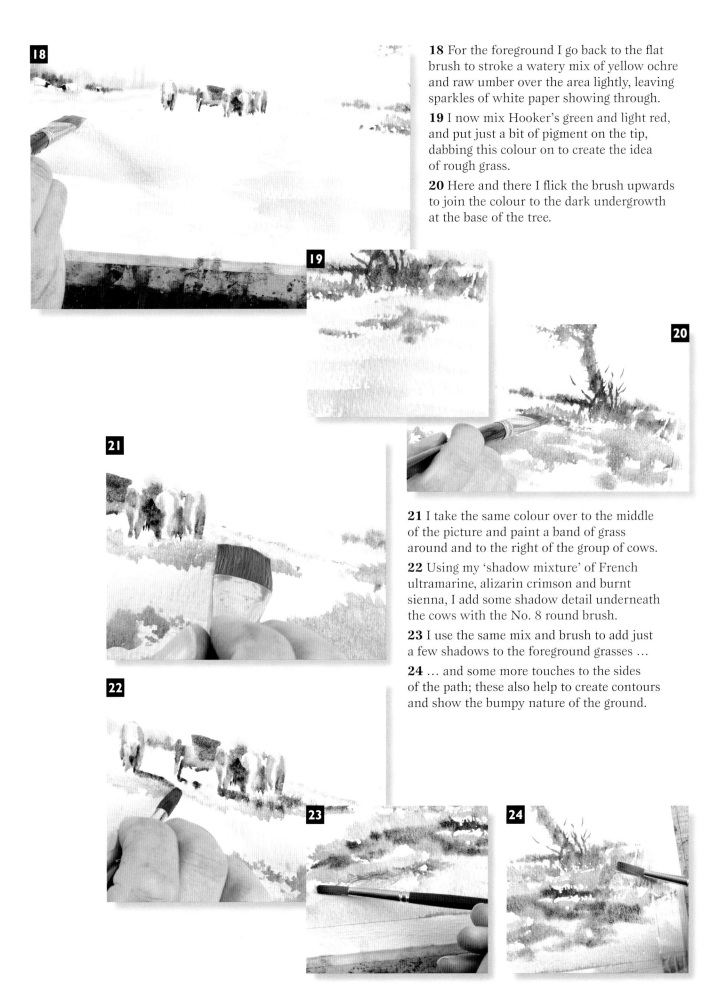

18 For the foreground I go back to the flat brush to stroke a watery mix of yellow ochre and raw umber over the area lightly, leaving sparkles of white paper showing through.

19 I now mix Hooker's green and light red, and put just a bit of pigment on the tip, dabbing this colour on to create the idea of rough grass.

20 Here and there I flick the brush upwards to join the colour to the dark undergrowth at the base of the tree.

21 I take the same colour over to the middle of the picture and paint a band of grass around and to the right of the group of cows.

22 Using my 'shadow mixture' of French ultramarine, alizarin crimson and burnt sienna, I add some shadow detail underneath the cows with the No. 8 round brush.

23 I use the same mix and brush to add just a few shadows to the foreground grasses …

24 … and some more touches to the sides of the path; these also help to create contours and show the bumpy nature of the ground.

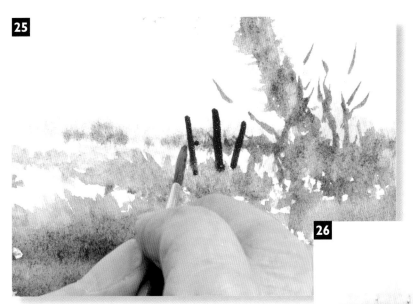

25 I think this picture needs a few verticals to add a sense of depth and recession, and to make the whole thing feel more complete. So I make up a mix of raw umber, burnt sienna and French ultramarine, and use the rigger brush to add some old wooden fenceposts.

26 Any kind of vertical is a great aid to creating depth and distance. I make sure that the posts get smaller as they go away from the foreground, and join them up with irregular horizontal strokes – a brand-new, uniform fence would distract the eye from the main focal points and make the painting look regimented.

27 It's all nearly done now. When everything is dry, I take a good look at the whole painting and make the decisions for the finishing touches. Here I go back to the darkest black mix of French ultramarine and burnt sienna and put in a very few darker markings on the black and white cow.

28 With the darkest markings in place, I just reinforce some of the shadows beneath the cows – and that's it!

Project: *Pet Dog*

People often don't even start to draw animals because of the problems they imagine go with trying to put in every hair and whisker, so my task now is to show you that it is possible!

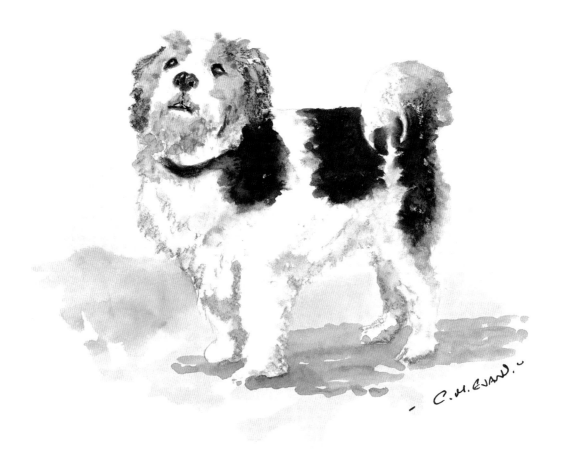

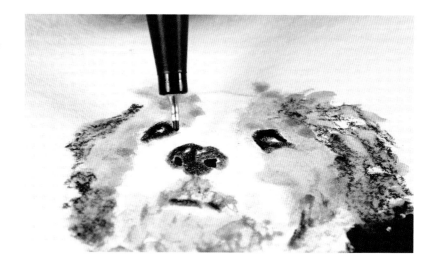

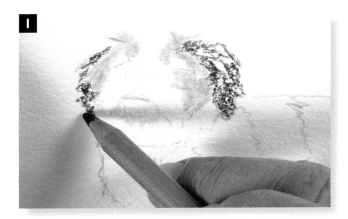

1 I start on the sides of the head with a few touches of yellow ochre, and then draw in the ears with some sepia. When drawing or painting your pet, think of rough, not straight, edges of hair and break up the outlines with scruffy, scratchy marks – this helps to add character.

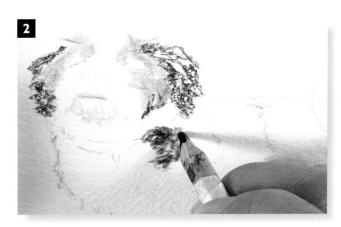

2 Next I use Mars black to draw the black patches on the body, pressing harder for the more solid areas of colour, and more lightly for where the black fur meets the white. As before, I use scribbly, scratchy pencil marks, as the rather ragged, blobby results give the best indication of fur.

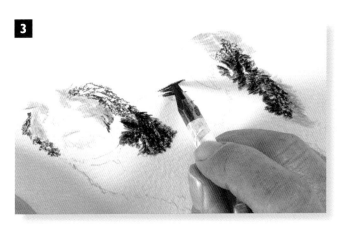

3 Continuing with the Mars black, I move on to the back: I press fairly hard but make sure there are small parts of the paper showing through.

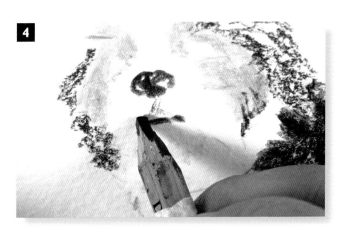

4 I use the same technique for the mouth, using the paper highlights to indicate a little moisture. Moving to the collar, again I press hard, but make a flat line, not a ragged one.

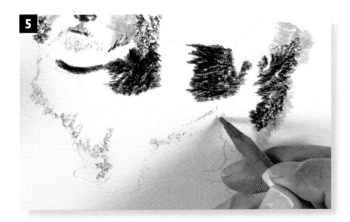

5 A lot of Sophie's fur is white – but as we know, not all white is white, so I add tints of blue-grey to the shadow areas of fur underneath the body. When I get to the legs, I press a bit harder to deepen the shadow.

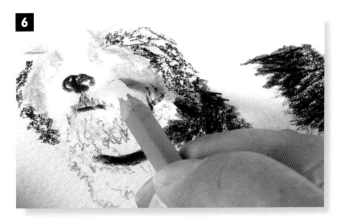

6 With the shadow parts in place, I then put in the extreme white of the fur with titanium white, scratching it strongly into the paper and working it into the other colours on the head, particularly where the light catches it on the top …

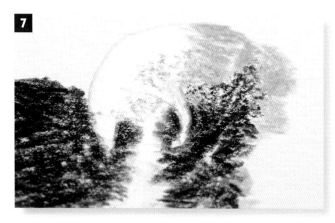

7 ... and then do the same on the body and along to that cute little curl at the top of the tail. Where the white meets the blue-grey of the shadow colour, I work both colours together dry to knock back the tone.

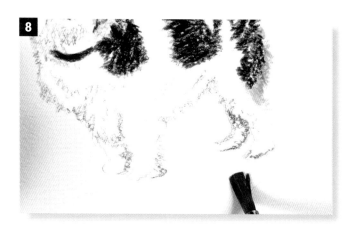

8 It's time for a bit of undefined background to put the dog into context. I wet a No. 4 round brush and take a tiny bit of cerulean blue off the pencil, then put this below the dog, being careful not to touch the drawn parts.

9 Then I dab some raw umber on to the blue while this is still wet, again taking the colour off the pencil with the brush. I work quickly, merging the two washes together.

10 Cleaning the brush frequently, I use clean water to start merging and softening some of the pencil marks – the colours only at this stage, not the white – but not all of them: here I'm wetting the area of the mouth but not the nose, which stays as solid drawn pencil.

11 When I put water on to the black patches on the body, this makes them a deeper, more solid black, which makes the white areas stand out in contrast.

12 On the tail, I stroke the black gently into the yellow ochre, merging and blending the colours to give a soft edge that still has the raggedness of the pencil marks.

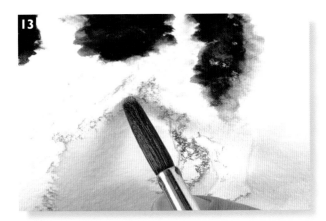

13 After rinsing the brush thoroughly to get rid of all the black, I use clean water to go into the white; I blend it a little with the other colours, and dab and tap into the blue-grey shadows to keep the effect of scruffy hair.

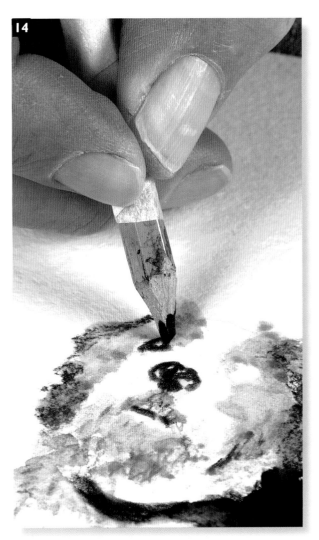

14 While all the wet areas are drying, I turn the picture upside down in order to avoid smudging them, and then work on the eyes with the Mars black pencil. I make sure to leave a catchlight in each eye …

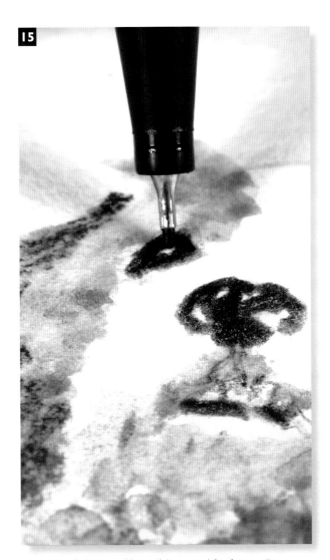

15 … and then, still working upside down, I reinforce the outlines with a fine black fibre-tip pen. I do the same with the pen on the nostrils and mouth.

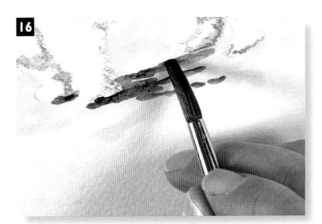

16 To finish, I stroke some Mars black on to the brush and add some shadow beneath the body to anchor it to the ground and stop the dog floating in the air. And there we go – Sophie in all her glory!

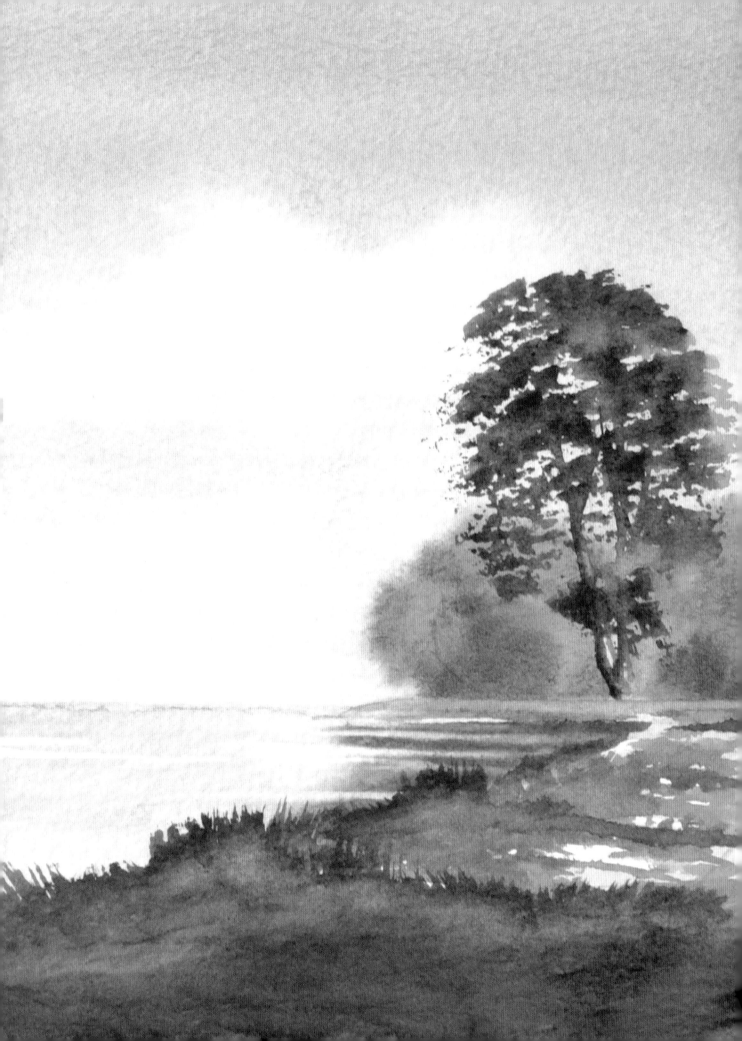

Project:
Landscape with People

The still trees and calm water give a tranquil feel to this view. But there's a storm brewing, just look at that cloud shadow in the foreground.

A fter masking the picture area, I make a simple outline drawing: first a squiggly line for the middle-distance trees, then a bank coming down on one side, out of the picture area. Next, the path comes in from the middle distance – here, the key thing is to make sure it is wider in the foreground. I add a few sticks to indicate the most prominent trees, followed by the water line and the bank on the far side of the river, and then I complete the drawing with a couple of poplars on the left-hand bank.

1

2

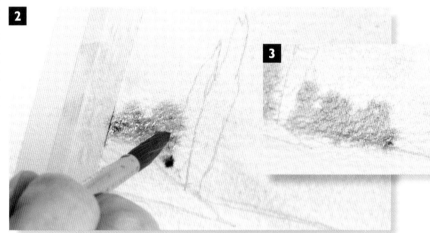

3

1 I wet the whole sky area with lots of water, then use a mix of alizarin crimson and yellow ochre, again watery, in the bottom third of the sky, all applied with a 1½in wash brush.

4

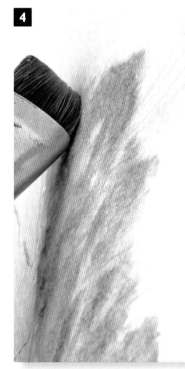

5

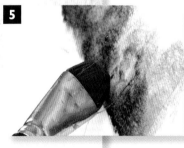

6

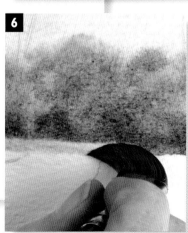

2 Using plenty of colour and a 1½in wash brush, I paint a mix of French ultramarine and light red right through the other washes down to the bottom of the sky area.

3 I finish this part by using an almost dry brush to mop up the bottom line, and then squeeze out the brush and suck out the clouds.

4 To get a hazy, distant feel to the trees in the middle distance, I use the ¾in wash brush to dab yellow ochre, followed quickly by a mix of Hooker's green and burnt sienna, using the side of the brush.

5 I make a purple with French ultramarine and alizarin crimson, then knock this colour back with burnt sienna, and paint over the trees.

6 I mop up along the bottom of the trees to make a sharp line.

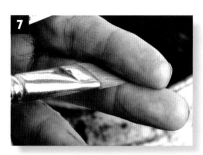

7 With the tree washes in place and still wet, I squeeze the ¾ in wash brush firmly between my fingers to dry it out.

8 One of the myths of water-colour is that once you've made a mark you can't undo or change it. Rather than painting around the closer tree shapes, I simply use the dried wash brush to suck out the wet paint where the trees need to go.

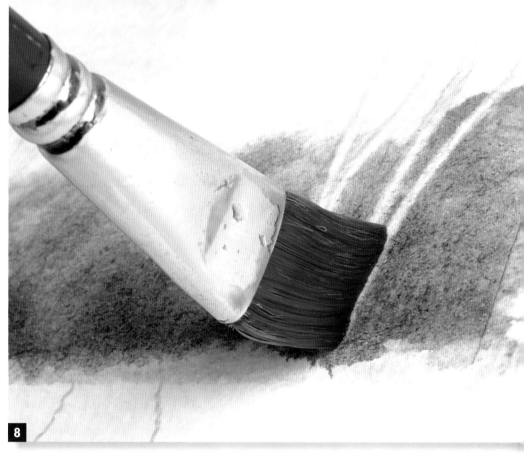

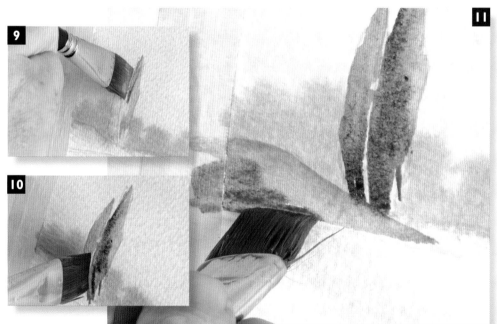

9 For the poplar trees on the left, I put a daub of yellow ochre on each tree, and follow this up by splashing on a mix of Hooker's green and yellow ochre.

10 I then add a touch of my shadow mix – French ultramarine and alizarin crimson – to the left-hand side of each poplar to finish these trees.

11 Next I repeat the same mixes in the same order for the bank between the poplars and the water; and that side of the picture is now complete.

12 Going back to the trees on the right side, I paint them in with yellow ochre using my No. 3 rigger brush, as I showed you in the tips and techniques on pages 34–39.

13 Using the same brush, I add raw umber to the left of the yellow ochre.

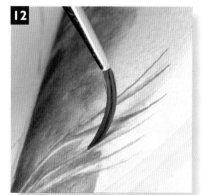

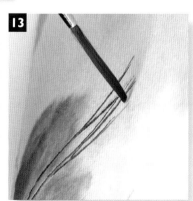

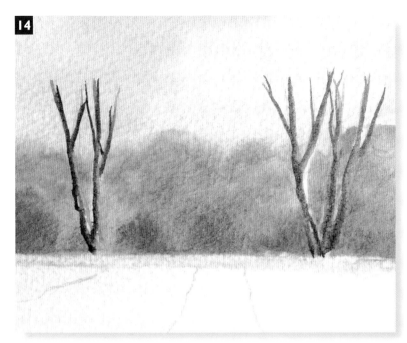

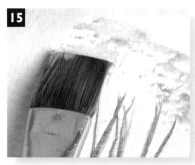

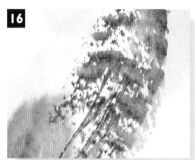

14 Next, I use the rigger brush to add the mix of French ultramarine and burnt sienna to the left of the raw umber, and then let the colours dry.

15 With the top edge of the ¾in wash brush, I start the foliage with dabs of yellow ochre.

16 While this first wash is still wet, I dab on a mixture of Hooker's green and burnt sienna, and then add the shadow mix among the foliage.

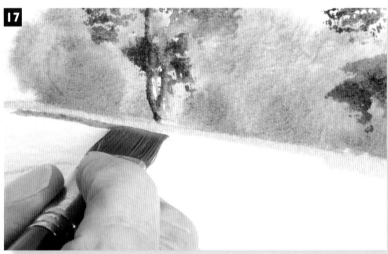

17 I load yellow ochre on to the same brush and use this to make the bank in front of the right-hand trees, and then add a mix of Hooker's green and burnt sienna below that to make it look as if the trees are standing on something. The next stage is to let all this dry.

That's the top half of the picture complete. Now I'm going to treat the water very much like the sky wash, and I expect to finish it in a few minutes, while the paper is sopping wet. I'm not intending to attempt perfect reflections, but to echo and capture the colours of the land features in the water. Usually, it's a good idea to make the reflection darker than the object itself.

18 First, I put lots of water into the water area, then drop a nice dark mix of Hooker's green and burnt sienna under the trees in the middle distance, using the ¾in wash brush, then put some of this mix under the poplars on the right.

19 I then drop a touch of French ultramarine into some of the green reflected areas.

20 A touch of green mix goes nicely under the poplars.

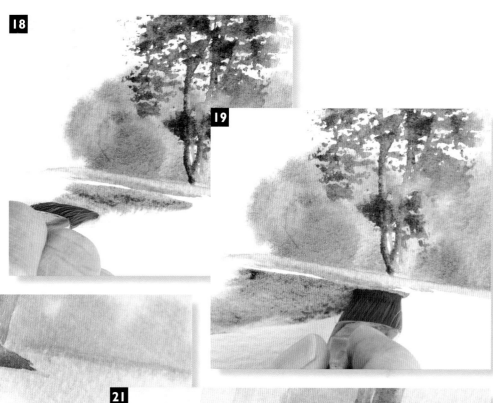

21 A touch of yellow ochre sits next to the green mix to show the reflection of the lighter side of the poplars.

22 Using a mix of French ultramarine with a tiny amount of light red, I fill in the middle parts of the water. Although I am moving the paint around on the wet paper, I make sure to go in one direction only – going in with the pigment and dragging out the ready-painted reflections only muddies the colours.

23 I mix the colours in the water by stroking the blue mix over the reflections.

24 Before the washes dry, I rinse, squeeze and shape the bristles of the brush and use it to draw out the pigment along to the right of the water area. Again, this effect can be spoiled if it's overdone, so I aim for just a few horizontal lines of highlighted white paper.

25 Having decided I want to add a couple of people to the picture, even though the right-hand trees are dry, I use clean water to dabble a wet round brush to suck out the paint and reveal lighter areas where I will place the people.

26 I put washes of yellow ochre on the path, lighter in the distance and a little stronger in the foreground, and then use the tip of the wash brush to show the rounded contours of the ground on the left, using a little raw umber mixed into the yellow ochre.

27 Sticking to the ¾in wash brush, I repeat this for the ground to the right of the path.

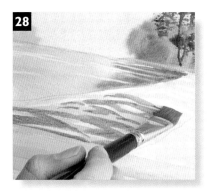

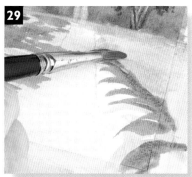

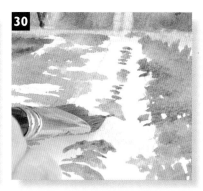

28 For the grass by the water's edge I use the wash brush to slap on a mix of Hooker's green, yellow ochre and a touch of French ultramarine, plus plenty of water; I'm not after much detail.

29 I break up the edge of the path with a few flicks of the green mix, using the ¾in wash brush for the ground contours; again, I avoid putting in too much detail.

30 To add patches of grass to the centre of the path, I rock the wash brush backwards and forwards, creating a rough effect.

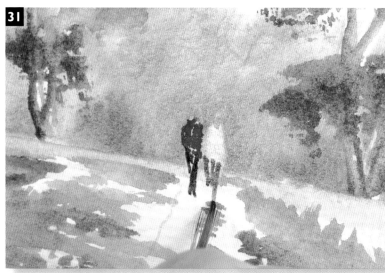

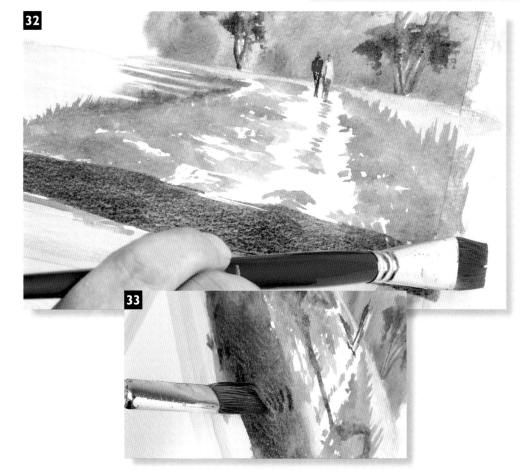

31 While the green dries, I go back to the people with the rigger brush. I place a couple of blobs of a mix of yellow ochre and alizarin crimson for the heads, add some alizarin crimson for one top, then a mixture of French ultramarine and burnt sienna for the legs – and the blobs become people.

32 Now I do something really scary: I mix French ultramarine and alizarin crimson, knocking it back with a bit of burnt sienna and plenty of water, and then pull big strokes of this over the whole foreground area with the wash brush.

33 I finish by inventing shadows for the people, plus one for a thin tree, and then add some dark tones within the dark areas to establish the edge of the path. That's it; all done.

Project: *Classical Life Study*

Life studies seem scary so a lot of people don't attempt to draw or paint from life. Here's a tip from a landscape painter – just think of the body as another landscape with hills and valleys and there's no need to be scared.

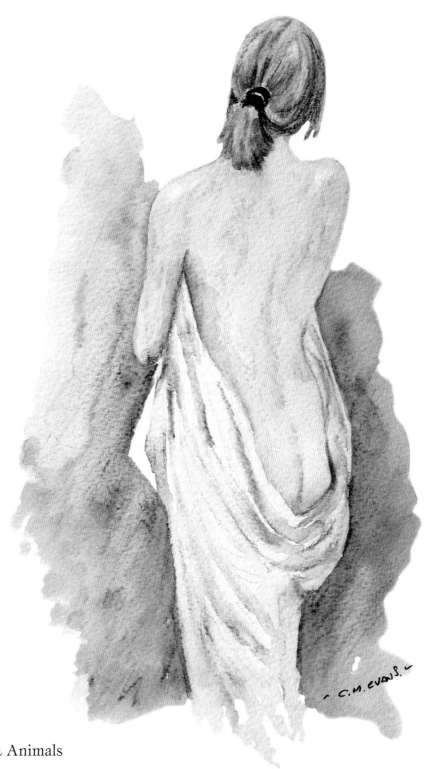

1 By way of getting started, I make a simple outline drawing with light grey, working on blue-tinted Bockingford watercolour paper. Using this colour pencil means that once I apply water, the outlines disappear.

2 This is what's called negative drawing, where I start by dropping in the background behind the model. I literally just scribble on blue-grey, taking care not to go over the outline of the body …

3 … and follow this with a little Vandyke brown on top of the blue, again stopping at the outline. This is one of the advantages of pencils – it's a lot easier to stop at a certain point than it is with watercolours.

4 I then use a No. 8 round brush to stroke clean water over the background colours, merging and blending them together to make a lovely soft, out-of-focus backdrop.

5 This is what I meant by negative painting; and it's not difficult to imagine that this is a landscape – how many times have you worked on the sea and sky, say, before putting in the land in the middle? Well, that's how I'm working here.

6 Once the background is totally dry I start on the model. First I work on the hair using yellow ochre, making long, curved strokes that follow the line of the head; then below the hair band I use shorter strokes.

7 Hair is never one single colour; I add a few strokes of Vandyke brown to the yellow, again being careful to follow the lines of the head.

8 Like hair, skin tones are different across the body, so although this next bit is like filling in the spaces, I keep a close eye on the variations and differences. I start with a flesh tint light pencil at the neck …

9 … and as I go down the back, I alternate this with some flesh tint dark. The pencil strokes catch on the top of the watercolour paper, leaving patches of the tint showing through and stopping the colour from becoming too solid.

10 As I go down I'm careful not to go over the robe with the skin colours, working just up to it.

11 I'm doing all the hard preliminary work now – for shadows I use blue-grey, working the pencil quite strongly into the larger shadow under the arm …

12 … and much more lightly along the backbone, where the shadows are smaller and less distinct.

13 As I put in the shadows I'm still looking at the skin colour, and add a few light strokes of light red for warmth.

14 With white paper, I use the paper colour for highlights; on tinted paper, I use a few touches of titanium white instead. That's the drawing done, and it's time for the magic …

15 … which, of course, is water! Using a No. 8 round brush and clean water, I stroke into the hair, again following the line of the head.

16 After cleaning the brush thoroughly I work on the body, using quite a lot of water to soften and blend the colours.

17 As I go down the arm and then the back, I concentrate on the direction of the brushstrokes and the contours of the body.

18 I rinse the brush regularly so that I can pick up the areas where the blue colours were drawn on strongly, and use this extra colour for contrast with the rest of the skin tone.

19 Even though the colours are made more solid with the water, the texture of the paper still allows the tint to show through.

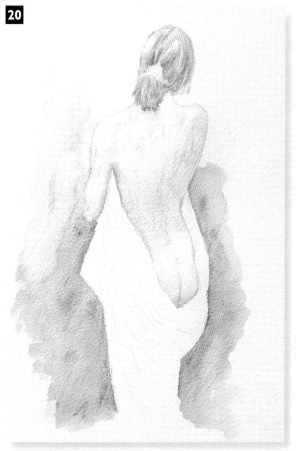

20 That's the body completed; now I can take a look at the last large bit of negative space – the robe – with the tones I need set by the skin and the background.

21 As we all know, white is not white – at least not in the shadows, folds and creases – so I draw these in with blue-grey. I'm not trying to get in every fold, but to follow the contours of the robe as it hangs from the body, as well as where the two meet.

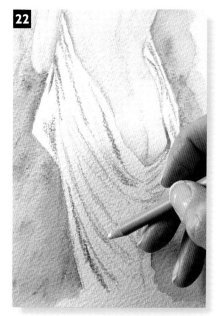

22 For the lighter and shallower shadows I switch to a light blue pencil, again following the folds.

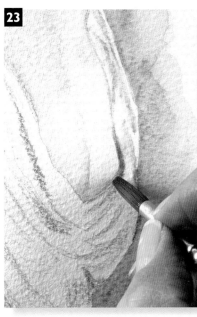

23 When I put on the clean water, the darker blue-grey gives me deep, emphatic shadows, such as where the robe meets the body …

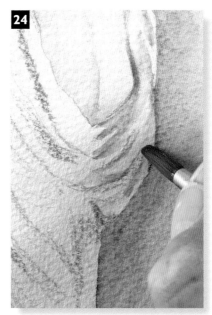

24 … while the light blue gives paler shadows on the surface of the robe. The main thing to look for here is the direction and swirl of the fabric around the body beneath it.

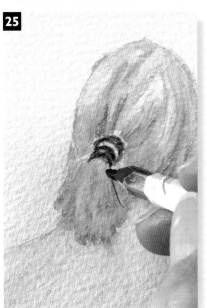

25 There are just a couple of things left to do now. I colour the hairband quite strongly with a Mars black pencil, leaving some tiny specks of the titanium white I put on earlier as highlights …

26 … and use the same pencil, only this time very lightly, to put some more shadow below where the arm meets the body. I then use a lot of clean water on this part to add just a hint of extra shadow.

27 The finishing touch is to use a small amount of water to solidify the hairband, again leaving the white as highlights. Against the rest of the colours, this area now stands out strongly. And that's my life study done.

Project: *Mallards*

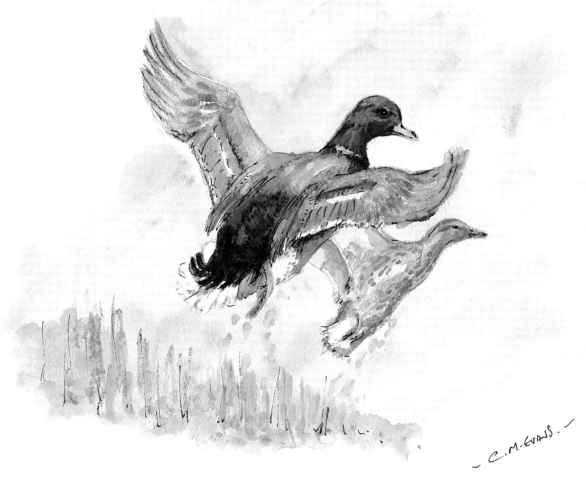

~ C. M. Evans ~

I always find it strange that the birds I see most often when I'm walking through the fields are the most beautiful ones. Here are a pair of mallards, startled into flight from the water – perhaps by me.

top tip

I used cool grey pencil for the initial drawing on oatmeal-tinted paper, and left in some small missed lines as usual; these will disappear when I stroke on water, and they also add character and movement to the birds.

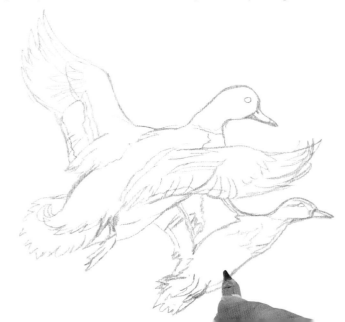

1 With the pencil drawing of the birds completed, I start on the sky area. Taking some Prussian blue off the pencil with a No. 8 round brush, I quickly apply a wash, taking care not to go over the outline marks of the birds.

2 While this is still wet, I take a tiny touch of olive green off a pencil and drop this into the bottom part of the sky, as an indication of the ground from which the birds are rising …

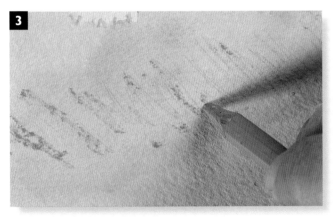

3 … and while this blue-green blend is still wet, I go in with the olive-green pencil and draw in a few lines for grasses. Because I have drawn dry on to wet, when the washes dry these marks will be immovable under further washes.

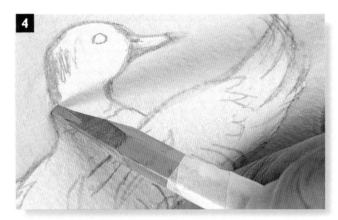

4 For the head of the drake, I start with manganese blue pencil, applied lavishly; the male of the bird species is often highly coloured.

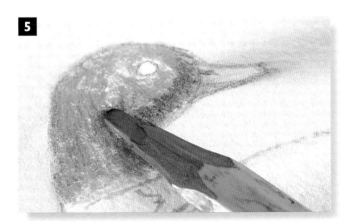

5 I scratch over and into this, first with Hooker's green and then with some blue-grey in the shadow areas. At this stage it looks a mess, but I trust my artistic instincts.

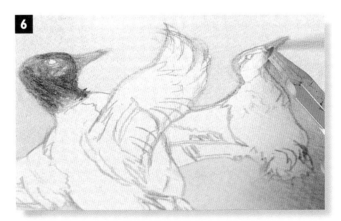

6 I draw on small strokes of yellow ochre for the beak, and then do the same for the female's. I finish this stage with a tiny touch of sepia at the end of both beaks.

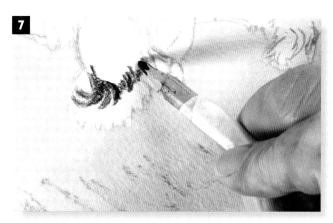

7 I use Mars black on the drake's tail, working positively and strongly for the most part, and then feathering less hard as I come up towards the wings.

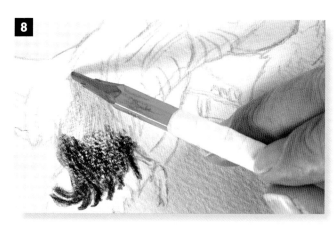

8 Next I put in some blue-grey, starting at the top of the back and working up the body, only this time applying it much more lightly than I did with the black – just stroking the pencil on.

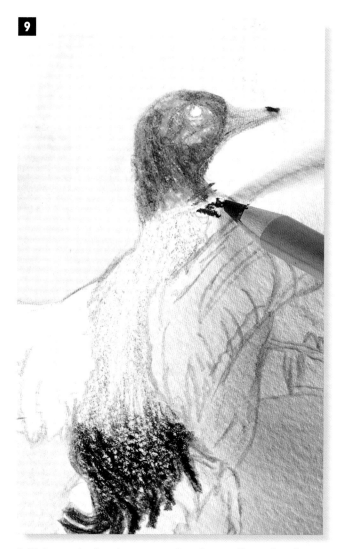

9 Using quite hard pressure, I make small marks of sepia on the drake's breast just below the neck with the tip of the pencil. I then reduce the pressure and colour on the shoulder, using the side of the pencil.

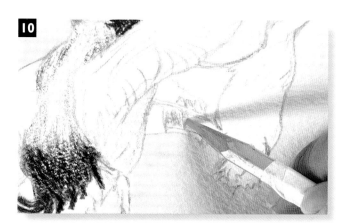

10 Using manganese blue again, I put some marks on to the female's wing – because she's further away than the drake, I go more lightly than I did on him. I add some stronger marks on the drake's wing.

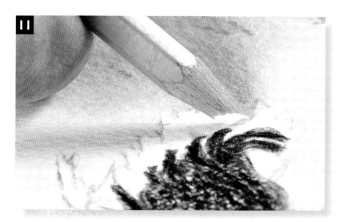

11 For the white of both tails I apply the titanium white pencil quite strongly, again using more pressure on the nearer drake; then I work it into the back of the drake's wings, once more quite firmly.

12 I start the outer edges of the drake's wing using a cool grey (the colour used for the outline drawing), and then reinforce this with blue-grey. To give a feeling of movement to the wings, I keep the strokes fairly wispy.

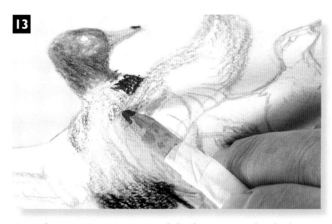

13 After putting some Vandyke brown on the drake's wings, I switch to yellow ochre for the legs of both birds and for an overall scribble on the female's head, body and wings; on the latter, I reinforce this with a touch of raw umber. A little Mars black on the wings, and that's done.

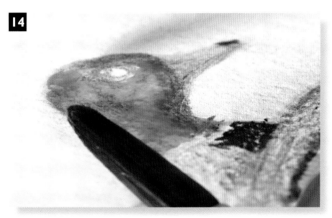

14 Now it's time to start pulling everything together. Using clean water on a No. 8 round brush, I merge the colours on the drake's head: this is a fabulous feeling, as a scribbly drawing becomes a painting.

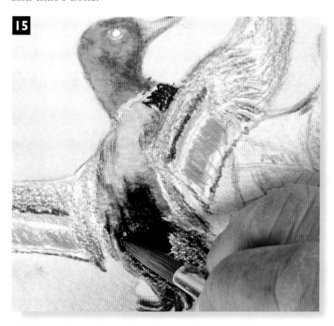

15 Bluey green is a very strong colour, so I make sure to wash the brush out thoroughly before I move on: all the colours are waiting, so I work with impunity and, above all, don't fiddle. I work into each colour block by block, merging in places, and washing out the brush between colours.

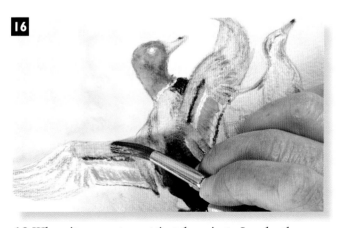

16 When it comes to wetting the wings, I make the brushstrokes follow the line – not vertical or horizontal – and tail the strokes off before I get to the wing tips, keeping these parts very wispy with light touches of the brush.

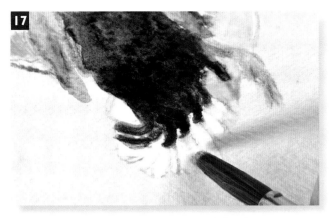

17 When I come to the tail, I'm careful to keep the intense white of the pencil clear of the black areas next to it. I also make sure not to bring water on to the legs.

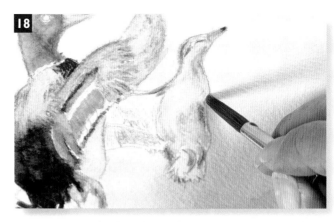

18 Moving to the female, I dab water on to the head and body with quick strokes, just to merge the colours and settle the base. Because she is further away, she requires less detail than the drake.

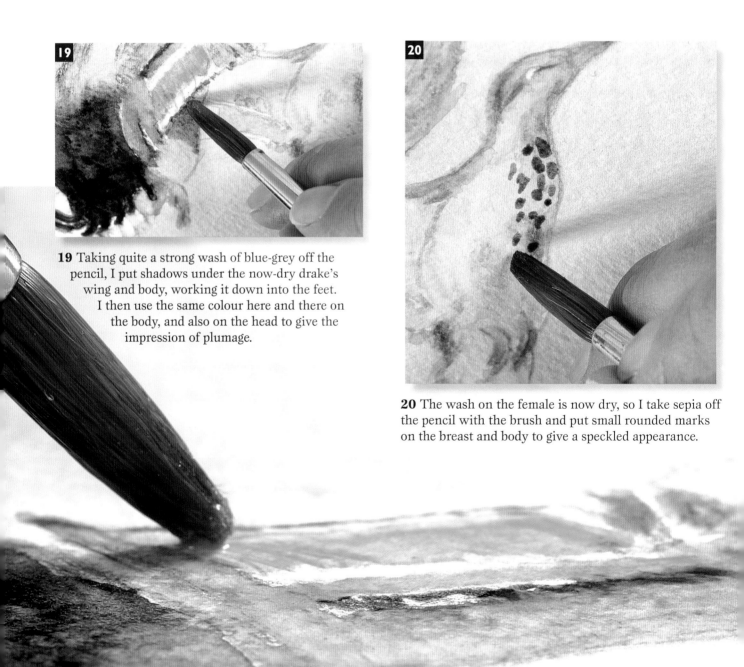

19 Taking quite a strong wash of blue-grey off the pencil, I put shadows under the now-dry drake's wing and body, working it down into the feet. I then use the same colour here and there on the body, and also on the head to give the impression of plumage.

20 The wash on the female is now dry, so I take sepia off the pencil with the brush and put small rounded marks on the breast and body to give a speckled appearance.

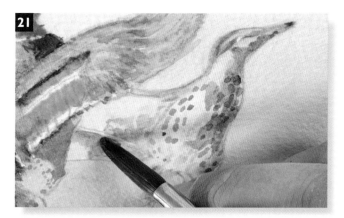

21 When the sepia is dry, I take a little blue-grey off the pencil with a lot of water and add light shadows to the female as I did to the drake; because she's further away, these shadows should be paler and less detailed.

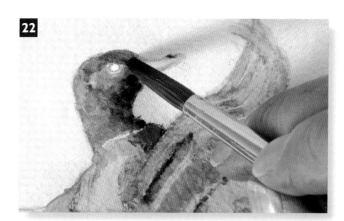

22 Now both birds are painted, I can check for colour strength; I add a little Mars black to the drake's head with the brush, just dabbing on tiny marks to darken what's already there, not to make a solid black.

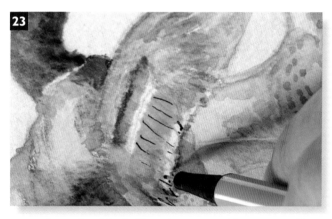

23 Using a fine black fibre-tip pen, I add some small touches to tighten things up on the birds – mainly to suggest a few bits of plumage and the edges of the legs, both using broken lines. I also put a few light strokes to reinforce the upright growth of the grasses beneath.

top tip

Always remember that watercolour pencil colours can look different applied dry and wet, so try them out before you start.

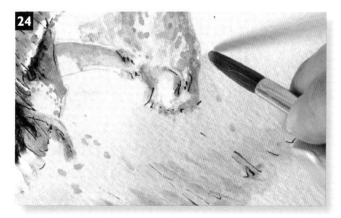

24 The mallards have just taken off from the water, so I take some bright manganese blue off the pencil and put in a few drops coming from the legs and bodies.

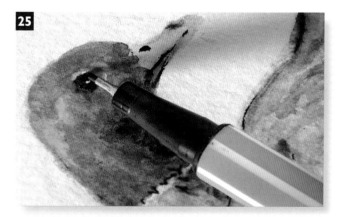

25 To finish, I go back to the heads with the pen and add the last details: the eyes with catchlight, the nostril and beak, and some plumage at the neck. And that's it.

Index